CHICKEN-FRIED WOMEN

CHICKEN-FRIED WOMEN

FRIENDSHIP, KINSHIP, AND THE WOMEN WHO MADE US THIS WAY

MELISSA RADKE

WORTHY
— PUBLISHING —

NEW YORK NASHVILLE

Worthy
Hachette Book Group
1290 Avenue of the Americas, New York, NY 10104
worthypublishing.com
@WorthyPub

First Edition: April 2025

Worthy is a division of Hachette Book Group, Inc. The Worthy name and logo are registered trademarks of Hachette Book Group, Inc.

The publisher is not responsible for websites (or their content) that are not owned by the publisher.

The Hachette Speakers Bureau provides a wide range of authors for speaking events. To find out more, go to hachettespeakersbureau.com or email HachetteSpeakers@hbgusa.com.

Worthy Books may be purchased in bulk for business, educational, or promotional use. For information, please contact your local bookseller or the Hachette Book Group Special Markets Department at special.markets@hbgusa.com.

Library of Congress Cataloging-in-Publication Data

Names: Radke, Melissa, author.
Title: Chicken-fried women : friendship, kinship, and the women who made us this way / Melissa Radke.
Description: First edition. | New York : Worthy, 2025.
Identifiers: LCCN 2024046318 | ISBN 9781546008248 (hardcover) | ISBN 9781546008262 (ebook)
Subjects: LCSH: Women—Conduct of life—Anecdotes. | Southern women—Anecdotes.
Classification: LCC BJ1610 .R33 2025 | DDC 646.700820975—dc23/eng/20250113
LC record available at https://lccn.loc.gov/2024046318

ISBNs: 9781546008248 (hardcover), 9781546008262 (ebook)

Printed in the United States of America

LSC-C

Printing 1, 2025

For Mary Louise

Contents

From Melissa:

An Introduction

I HAD PROBABLY WATCHED LUCY SHOVE THOSE CHOCOLATES IN HER mouth a thousand times, and I never laughed.

Maybe I was just more of a Jack, Janet, and Chrissy kind of girl. I really didn't ever get the appeal of Lucy. Not even the famous chocolate factory scene.

Hailed as one of the best episodes in all of television. Lucy and Ethel go to work in a chocolate factory to prove a point to their husbands about all the spending they do. What should have been easy work turns comical when the chocolate conveyor belt starts going a little too fast.

It didn't matter how many times we saw that episode; my mom laughed every time. But not me. I just didn't find it funny. No matter how many times I saw it.

A couple of years ago I was in a hotel room in Montclair, New Jersey, when I woke up early, took my shower, and turned on the television. It was Lucy and the dadgum chocolate factory. *Blurg*.

I went into the bathroom and brushed my teeth, put on deodorant, and slipped into my Spanx…and without even realizing it, and for the first time ever, I started to laugh. (If you saw me trying to put on

Spanx, you'd laugh, too.) But I was laughing at the TV. I stopped what I was doing and walked into the bedroom. I sat down on the end of the bed and watched the entire scene, and I laughed.

And I laughed.

And I laughed.

I lay back on the bed in my Spanx and laughed until I cried. Which, if you've ever worn a full-body compression girdle, you know is hard to do.

I discovered the problem. What I saw on that cold New Jersey morning may have never even stood out to the television critics. But you know what? I bet it crossed Lucille Ball's mind. When she was developing the show and writing out the stories, she added something into that scene that few people ever give enough credit to.

Ethel.

Lucille Ball could have managed that scene on her own. She could have shut the place down with her antics and her faces and her timing. It would have probably still been known as one of the best scenes in television history, even if she had been all by herself.

But she didn't choose to play it that way. And why? Because Lucy knew something in that moment that I wouldn't realize until that cold New Jersey morning.

Lucille Ball knew that anything funny that happens is a hundred times funnier when it happens with another woman.

A friend.

A family member.

A ride or die.

A bestie.

What struck me was what they were doing *together*. Their chemistry. Their relationship. I believe it was Eleanor Roosevelt who said, "A woman is like a tea bag—you can't tell how strong she is until you put her in hot water." But it was Melissa Radke who said, "Put a woman, alone, in hot water and she's a tea bag. But put her in hot water with her bestie and they'll call it a hot tub and ask to speak to a waiter."

Lucille Ball knew this centuries ago. That's why she has a star on the Hollywood Walk of Fame, and I have a skin tag on my neck.

Some of my most favorite movie and television moments are of women together.

If Lucy hadn't included Ethel, we might not have moments like Cristina Yang telling Meredith Grey, "You're my person. You'll always be my person."

Like Leslie Knope committing to Ann in *Parks and Recreation*: "Hoes before bros. Ovaries before brovaries. Uteruses before duderuses."

We wouldn't have Blanche admitting that she'd enjoyed hanging out with Dorothy and Rose, "and there wasn't even a man in the room."

Friends tell us the truth. Like that time Monica told a runaway bride named Rachel Green, "Welcome to the real world! It sucks. You're gonna love it."

Or when Karen told Gretchen in *Mean Girls*, "Gretchen, I'm sorry I laughed at you that time you got diarrhea at Barnes and Noble. And I'm sorry for telling everyone about it. And I'm sorry for repeating it now."

We have Laverne and Shirley singing on the sidewalk, Romy and Michele attending their high school reunion, Rory and Lorelai talking a million miles a minute, because one day Lucille Ball decided that everything was funnier if *her person* was involved.

Don't get me wrong—Lucy is funny, and Ethel is funny. But mainly they are funny...*together.*

In my first book, *Eat Cake. Be Brave.*, I wrote over twenty chapters of pure genius. It was on so many bestseller lists that I am not even going to take the time to list them all, okay? But trust me, there were a lot. People seemed to love that book, and I'm glad they did, but there was one chapter that seemed to stand out to most readers. It was called "Chicken-Fried Women," and it was an entire chapter on a conversation that was held in my mother's kitchen with a few of the women who make up my life: my mom, Annette; my Aunt Melba; my cousin Meridith; and my Granny.

As I traveled across the United States on a book tour, women would come up to me and tell me how much they loved this chapter. I thought it was odd that people liked it so much because there were clearly better chapters that focused mainly on me. (Please stop reading now if you cannot handle sarcasm, as this book is flush with it.) But the feedback was clear.

Women in Atlanta loved Chicken-Fried Women.

Women in Birmingham raved about Chicken-Fried Women.

Tulsa? Give us more Chicken-Fried Women.

Cincinnati wanted me to do a tour with Chicken-Fried Women.

West Virginia was really put out when they realized the book signing was just me and not the Chicken-Fried Women.

You must know I took this all to God.

But then it hit me. I realized why that chapter and that topic reverberated with women so much.

Because every woman I have met—whether it's been on the road, on the radio, on social media, or in the grocery store—has known, or is currently living their lives with, their very own Chicken-Fried Women. That's why people loved it: because they *understood* it.

They *got* it.

It *rang true* to them.

It *reminded* them of them.

We are always drawn to what we know. And if there is one thing a smart, sassy, opinionated, outspoken, strong-willed, God-fearing woman knows, it's a line of smart, sassy, opinionated, outspoken, strong-willed, God-fearing women who have come before her. They're the ones who raised her, have Girls Nights Out with her, babysat her, worked beside her, made up her family, or completed her circle. It's the women who come to her baby shower, pick up her midnight phone calls, sit at her table.

When I first submitted the idea for this book, the title was not much different from the one you see on the front of this book. It was entitled *Chicken-Fried Women: Friendship, Kinship, and the Women Who Made Me This Way.*

Notice the difference? It's hard to spot because it's one single word. It's the word: *me*.

Me made the book seem like I was going to tell one million stories about the women that helped make *me*, raise *me*, and mold *me* into the woman I am today. (And that's not too far off, because there are a lot of stories like that in this book.)

But as I looked at that title over and over and over again, I kept coming back to the word *me*. It just didn't seem to fit. But why?

This book is about *me*.

These women do belong to *me*.

I do like most things to begin and end with *me*.

So what was the problem?

Well, I'll tell you…I realized I am not the only woman who was raised by strong women. I am not the only woman whose greatest memories involve the women who sit around her table. I am probably not the only woman who could fill up a book with the knowledge, escapades, shenanigans, and mishaps that she has gotten into, thanks to the women who make up her life. I'm not the only woman to travel with my women, fight with my women, pray with my women, eat with my women, gossip with my women, and work it all out with my women. I cannot be the only woman who has accidentally peed from laughing at my women.

I've traveled to a lot of places. I've signed a lot of books. I've hugged a lot of necks. I may not have a ton in common with the women I met in Durango, Colorado. The ladies in Fort Smith, Arkansas, may not dress anything like me. The women in Charleston, South Carolina, might not wear their hair like me. The women in Chicago probably don't laugh, obnoxiously, at their own jokes like I do. And I bet there's not a woman in all of Santa Barbara who stuffs free restaurant peppermints in her bra. And yet! We all have this one thing in common: ***our people***.

So I changed the book title to *Chicken-Fried Women: Friendship, Kinship, and the Women Who Made **Us** This Way*.

Us.

Isn't that so much better?

Because these women didn't just make ME this way—they made YOU this way, too. They raised you and prayed for you and humbled you a notch or two every now and again. They bought you your first bra and taught you how to pluck your eyebrows. They spoke the truth to you so much, you wanted to scream and run away. They told you your skirt was too short, your boyfriend was a zero, and cankles ran in the family. They stayed up late waiting on you after you snuck out of the house. And they carried around a wooden spoon when they had to take you into town. They have encouraged you and teased you, chastised you and mortified you. They've had your back. They've shut down your haters. And they star in over half of the memories that make your story so beautifully unique.

These are not just *my* women.

They are *yours*, too.

And they have made us who we are. Good or bad. Right or wrong.

While I'm here, I might as well tell you why I call them Chicken-Fried Women.

In Texas, where I live, anything can be deep fried. Have you been to our State Fair? You have to buy a ticket and have two stents put in before you can enter. This is because everything from Oreos to banana pudding to pickle pizza and gumbo balls is served deep fried. There is even something called chicken-fried bacon, which I have never had personally but sounds delightful.

Texans didn't invent frying chicken, of course, but we have made a killin' off selling it. Sometimes I wonder who the first person was to ever think of dropping chicken into hot oil. Whoever she was, she certainly wasn't the last. The women in my life have been in hot oil for as long as I can remember.

In and out of trouble.

In and out of relationships.

In and out of debt.

In and out of quarrels.

If it was hot and you could get into it—they have.

And battered? Man, have they been battered. Cancer, grief, divorce, unemployment, betrayal. The list goes on. But here's where it gets so strange to me: it seemed the more battered they were on the outside... the more tender they became on the inside.

That's the thing about women: throw them in some hot and sticky situations and they almost always come out better than they were before.

And let's not forget the seasoning. When you bury a husband, when you take your child to their chemo appointment, when you lose a parent, when you check in to rehab, when you file for the divorce, all of it becomes part of the flavor that make these women up. Some are sweet, some are salty, and some are too spicy for words. That's okay. That's part of what makes them so unique.

Someone asked me the other day if I could describe what a Chicken-Fried Woman was in one sentence. I thought about it for a moment and here is what I said:

She is battered and bruised on the outside, but tender on the inside, she is salty and sweet and more than a little bit spicy... she really is the best of both worlds...and she gathers the ones she loves around the table because she is both their comfort and their community.

Was I on fire when I said that, or what? Man. I can talk a good game, can't I? Speaking of talking a good game, the women in our lives also like to talk. A lot. And to anyone who will listen. *Or is that just my people?* If I had a quarter for every time I've had to step on my mother's foot underneath a table in an effort to keep her from giving away our family secrets to a waitress we'd never even met before, I'd be able to afford that nose job I've always wanted.

Which brings me to one thing you will see throughout this book. Between the chapters, you'll see what I have affectionately referred to as *Chicken Nuggets.* They are short, small, little nuggets of wisdom, wit, and weirdness from within my family tree. They have absolutely nothing to do with the chapter that follows. They will not be on the test that is given at the end of this book. And absolutely none of them

can be found in Scripture. But I provided them, nonetheless, because I shouldn't be the only person who gets to live with these gold nuggets. These are life-giving, my friend. So before you even go there: You're welcome. Seriously, you're so welcome.

But I digress...

Who are these women in your life? Who are the Chicken-Fried Women that you grew up with or grew up under? Do you have friends who became family or family members who became friends? Who are the women that make up your life, your memories, your yesterday, or your today? Who are the ones who have been there with you, for you, beside you? Who has eaten the chocolate with you as fast...as...they... possibly...could?

Let me tell you the first of many stories: Years ago I signed up at church to attend a Bible study. I was relatively new to the church and to the town. I thought this would be a good way to meet new people. I had no idea what the Bible study would be about; I was just there for the "fellowshipping."

When I walked into the living room where the study was being held, I saw the host passing out books to all the women in attendance. I promptly looked around the room and saw that there were about nine women in attendance and not a one of them looked to be under the age of sixty. I was twenty-four at the time. *Ughhh.* What was I supposed to do? Do I take a book knowing I'd never come back? Could I say, "Oops, wrong house," and just walk out?

The Bible study leader came over and introduced herself to me and handed me a book. Please don't google this book because I have no idea what the name of it even is, and I don't want to offend anyone, but the cover of the book had a caricature of a woman laughing and then under her face it said, "Laughter doeth good like a medicine."

I wanted out.

I laughed a lot in my life; but never to the point that it had healed me. I had been cheerful. I have had joy. But it's not what got me over strep throat, I can tell you that.

This book looked cheesy, and these words sounded cheesy, and I wanted to run!

And then a woman from across the room spoke up. "Glenda. Are you sure about this book? The picture of this woman on the front looks like a nut job. And since when is laughter like medicine? When I have a headache, laughing is the last thing I want to do."

Glenda spoke up. "Hush, Pat. You always have to say something about the books I choose, but you sure keep coming back."

The other women started laughing.

"I keep coming back hoping surely you'll have picked a better book."

Glenda threw her head back and laughed at this comment and continued to pass out books.

"Besides, Glenda, you've been my best friend for four hundred years, and laughter hasn't always been like a medicine...You sure have...but not laughter."

"Well, maybe that's what the book is about, you old geezer. Maybe I wrote it. Maybe it's about me. And how wonderful I've been to you all these years."

"No, it ain't; that woman on the front doesn't have nearly the wrinkles you do."

I wondered what that medicine had been like for the two of them. Had they grown up together, or had they met in the cubicle next to each other? Had they been neighbors who commiserated over play dates and snow days? Did their husbands know one another? Was one of them single? Had one of them stood in the hospital room while the other one kissed her love goodbye? Had one made a lasagna when the other called and told her about yet another miscarriage? If Glenda had been a medicine for Pat for all those years, what had been the sickness? What had been the brokenness? I'm not sure.

But I stayed in that group for the next eight weeks. I never missed a week.

"Laughter hasn't always been like a medicine...but you sure have."

Look, I'm no theologian. (In fact, many of you who know me are literally shuddering at the thought right now.) But it makes me kind of wonder when Solomon wrote Proverbs 17:22, "Happiness is good medicine, but sorrow is a disease" (ERV), if he maybe broke for lunch too quickly.

If you want to say a "merry heart doeth good" or "a cheerful spirit doeth good" or even "laughter doeth good," go for it. Fill that in with whatever translation you want. But in the end, none of it comes by being alone. We weren't created to be alone. We aren't supposed to do life alone. And nowhere in Scripture does it say, "Joy comes when you do it solo, *bruh.*"

Over those eight weeks I watched Glenda and Pat fight and laugh, cry and giggle. They had done a lot of life together. And their joy was contagious. And since I was new in town, and since I had very few friends to my name, I figured I needed some of that joy. But what I witnessed was that I wouldn't come by it all alone. I also needed people. I needed friends. I needed women.

So do you.

Welcome to *Chicken-Fried Women*. Welcome to the (mostly) true stories of the women who have loved me, hated me, hurt me, healed me, molded me, scolded me, made me, and raised me. My greatest desire is that as you read about the women in my life, you will be reminded of all of the women in your life, as well. The ones who are gone. The ones who remain. And the ones you haven't even gotten to meet yet.

May you find that the chocolate is so much sweeter—and hilarious—when you're shoving it in your mouth with someone you love.

Pull up a chair.

Melissa

This Might Be
Why I Am the Way I Am

"ARE YOU EVEN WEARING A BRA?"

Stop.

If anyone in your family ever asks you that question, I beg you: STOP.

Think. Think long and hard about how you want to answer that question. You see, I didn't think. I was only fifteen years old. Young Melissa never thought about how she would answer a question like that. She just spoke.

Without thought.

Without regard.

Without discernment.

She just word-vomited all over the place. Because she was fifteen and she was carefree. But not after this day. After this day, young Melissa grew up. She had to. Poor young Melissa.

"Of course I have on a bra."

"Let me see."

My heart breaks at even telling this story. This was *my Granny* asking me these questions. My *grandmother*. My *mother's mother*. Wasn't she supposed to be baking something? Why wasn't she like any of the

other grandmothers I saw on TV? They never asked their grandchildren about their *bras*. They bought them toys and gave them lots of sugar to eat. They called them things like "angel" and "sweetie." My Granny referred to me as "Melissa" or "Big 'Un." This was not the sweet, doting, gray-haired woman who came out the front door with her arms held open wide when I came to visit. This was a feisty, sassy Southern Granny who yelled "YOU'RE LETTIN' THE BUGS IN" when I came to visit and once told me that "people who put clothes on their animals have no business voting for our next president."

"Granny, I am not pulling up my shirt for you."

"Let me see."

You didn't try to outlast her. I had learned that from her daughters. They were as stubborn and spirited as she was, and they gave in to her demands almost immediately. So what does that tell you?

I pulled up my shirt.

"My God, Melissa Paige, that's the worst thing I've ever seen. Get in the car. We're going to see Mrs. Pratt."

I had no idea who Mrs. Pratt was or why she would be interested in the bra I was currently wearing, but no one ever said no to Granny, so I headed out to the car.

Granny and I climbed in her brown conversion van and began to pull down the driveway. At the same time, a car full of women in my family pulled up. My mom was driving.

"Did y'all find some good garage sales?" Granny asked.

"We did. We've got a trunkful."

My mom eyed me in the front seat, "And where are y'all off to?"

My cousin Meridith was asleep in the back seat.

"I don't know. Ask Granny. She looked at my bra and now I have to go see a woman about it."

"MRS. PRATT?" Aunt Melba and my mom, Annette, asked in unison.

Meridith bolted up from the back seat.

"Mother, you are not taking her to Mrs. Pratt..." my mom started.

My Aunt Melba butted in, "Yes, yes…take her. Take her. It'll be good for her. And we can go and watch."

The more they talked, the wider my eyes got. Who was this person? Why would this be good for me? I pulled out the neck of my T-shirt and looked down at my bra. It wasn't *that* bad. My mom had bought it a few months ago from a garage sale "of a big-chested woman who died recently. So it's kind of like new, Melissa." This was how she tried to pass it off to me. I took it back to my room and tried it on. Underwire. Twelve snaps. And the scent of Charlie by Revlon. Oh, well. It was mine now.

"I'm taking her and I'm buying her a bra. This thing she has on doesn't even fit right."

"I just bought her that bra from a garage sale of a big-chested woman." My mom continued, "Mother, if you take her, I'm coming, too. I'm not making her face Mrs. Pratt alone."

"Fine, turn your car around and come. Who's stoppin' you?"

Granny pushed down the pedal in her conversion van and we tore out. As she rolled up the window, I got a whiff of Charlie…and oddly enough, beef vegetable soup.

Mrs. Pratt's Dress Shop was a small, little shop about twenty minutes outside of town. When we pulled up, there were only two cars there. I would learn that one of them was Mrs. Pratt's and the other one belonged to the poor soul that worked for Mrs. Pratt, Paula.

We walked in. The store was small and smelled like fried okra and Marlboro Reds. There were rows and rows of bras you could look at that sat atop drawers that were overflowing with more bras in bigger sizes. I suspected I would spend most of my time in these drawers.

There weren't really a whole lot of dresses for a business that was called Mrs. Pratt's Dress Shop. There were three round clothing racks with dresses on them. On top of one sat a metal sign with a piece of construction paper in it with the word REGULAR written across it. On top of the other sat the same kind of sign, but with the words MORE TO LOVE written across it. The third round rack had no sign on it at all. I

guess that was for people who were not entirely sure what group they fell into.

Right in the middle of the room was a La-Z-Boy recliner that had probably started off as ivory but had turned into Marlboro Red *grayish* over time. In it sat Mrs. Pratt, wearing a muumuu and sandals. Let's just say that if she went shopping for dresses, she would shop from the MORE TO LOVE rack. She balanced a glass ashtray on the right arm of the chair.

"Mary Willmon," she said to my Granny. She began to cough. "How have you been? I haven't seen you in a while."

"I brought my granddaughter in today, Mrs. Pratt, because I want you to look at this mess." Granny pointed to my chest.

"Yep, saw that when y'all walked in the door. These girls don't know how to buy bras anymore, do they? I see you brought the troops with you."

My Aunt Melba, her daughter Meridith, and my mom had walked into the store and were combing the racks for some new church dresses. I won't tell you which rack they were at. (They asked me not to.)

"They come whether I want 'em to or not. But I want you to look at this!" At this, my Granny yanked my shirt up and I thought Mrs. Pratt was gonna hock up a lung. I saw my Aunt Melba's eyes get big as she whispered to her daughter, "Meridith, come watch. This is the good part."

"I sold a bra just like that about six months ago. Helen Strinden. Mary, you know her. She dropped dead as you please at Mr. Ray's buffet."

"We're familiar with the story," my mom quickly replied.

"I'm not!" I shot back. "What do you mean she dropped dead at a buffet?"

Mrs. Pratt blew out a puff of smoke wrapped up in a snort of laughter. "She was walking off with a tray of soup and dropped dead right there on the floor. Heart attack."

Let me guess, beef vegetable. I shivered.

My mom saw my face and silently shook her head "no"—as if to say, *Don't worry, baby, you are not wearing a used bra from an elderly*

woman who died at a buffet. But—and I can say this because God and I both know it to be true—my mom was a liar.

"I don't think it fits Melissa right. I wanted you to take a look and find her a better one."

Finally, Mrs. Pratt got up from her chair. She stubbed her cigarette out in the ashtray and turned to face me. "My God, her tits are huge!" She exclaimed this as she cupped my right breast in her hand. *Ha. Joke's on you, Mrs. Pratt, my left one is the biggest.*

I would also like to note that at the age of fifteen, I had only heard someone use the word "tits" one time. It was at Mary Grace Klein's birthday party when she ran in her living room with a VCR tape that she found under her parents' mattress. I would watch exactly four minutes of this movie before I called my mom to come pick me up. When my mom answered the phone and I told her what kind of movie was being played, her exact words were, "God told me I shouldn't have let you go to that party. This is my fault. I wasn't listening to the Holy Spirit. I'm on my way. Tell them you have diarrhea and go hang out in the bathroom." This is exactly what I did until my mom pulled up and honked, exactly seven minutes later. I snuck out the door and no one even noticed. Everyone was glued to the TV. Mary Grace's parents were smoking on the front porch when I ran out. "You leaving so soon?" they asked. "Yes, ma'am. My mom told me I have diarrhea."

I got in the car and sobbed because although I hadn't seen anyone having sex, I did hear a man say "tits" and it sounded crass. "IT IS CRASS," my mom agreed. "But Melissa, her family isn't like us, baby. Her dad's in the military. He's seen things."

While Mrs. Pratt cupped my boob, my mom, Granny, Aunt Melba, and my seven-year-old cousin, Meridith, all stared at me. Their expressions said a lot. Except for Meridith, who was laughing hysterically, no one seemed surprised that this was happening. Mrs. Pratt man-handled me for a few seconds and yelled, "Paula! Get me a Playtex! Double D. White. You like flowers?" I nodded blankly. "With flowers. And make it an eighteen-hour. This baby's got its work cut out for it."

For the next thirty minutes I tried on bra after bra that poor Paula had to bring to me while Mrs. Pratt barked out orders to her. The entire time I did this, the women in my family hung around outside my dressing room like they were hoping I would *Say Yes to the Dress.*

"Melissa, make sure when you put one on, you let us see it."

"Mom. Why do you have to see each bra I try on?"

"Because it's funny!" my Aunt Melba said.

"I'm ain't payin' for nothin' I don't see first," Granny added.

"I need to make sure it doesn't ride up in the back," Mom yelled back to me. She lowered her voice and whispered, "*She gets her boobs from Gene's people.*" Gene was my dad. I'm sure he was flattered to know that his family was the root cause of my double D's.

"Mom, there's a curtain between us. *A curtain.* I can hear you."

"I don't care if you hear me! I'm not talkin' out of school. Your daddy knows his sister's big-chested." She turned to Mrs. Pratt. "You can spot Gene's sister walking into a room five minutes before she gets there."

"Annette," Melba said, "do they know why Helen Strinden dropped dead?"

"Well, Melba Joy, she was eighty-eight!"

"I know, but she was in pretty good health; she was still going to buffets."

"I had recently sold her a bra," Mrs. Pratt chimed in.

"*WE KNOW,*" we all seemed to say in unison.

"You know I bought that exact bra from the Strindens' garage sale. Did Melissa tell you that, Mrs. Pratt?"

Inside my curtained room I hung my head.

Aunt Melba asked the question I had been thinking: "Why would they sell her bra? Didn't she need it for the casket?"

My Granny spoke up. "HA! Helen Strinden didn't have an open casket. So they didn't put a bra on her."

"Wait, *what*? You can choose to go *braless* in your casket?" Melba asked.

"I guess so. One of Gene's aunts did. She wanted a closed casket, so they took her bra off. Otherwise, they would've never been able to shut the top."

"Well, then y'all bury me without a bra on. I'll go closed casket."

"YOU'RE NOT BEIN' BURIED IN A CLOSED CASKET IF I'M STILL ALIVE," Granny asserted.

Her girls looked at her, shocked. "Why not?" Melba asked.

"Because it says something about you. It means you're hiding something."

"What was Helen Strinden hiding?"

"Liver spots. Her hands looked like a topography map," said my Granny.

I pulled back the blue sheet that acted as a curtain and walked out in my bra. It was at that moment that I lost any pride I had or ever would have.

We left the dress shop that day with two new items. My Granny bought me a bra called Beautiful One from the Playtex Cross Your Heart Collection. It had tiny roses on the all-white fabric, and something called *comfort straps*. I would come to appreciate those straps pretty quickly. She also bought my mom some kind of girdle called the Playtex Panty Leg. After she paid, she handed them to us and said, "Y'all sing on the stage at church, and you've got problems." She handed me my boxed bra. "Hopefully this will fix your top problem"—and she chucked my mom's new girdle at her—"and this will fix your bottom problem."

Granny was like Shakespeare with her words.

Some say the day you fall in love is the day you become a woman. I disagree. I think it's the day you wear a dead woman's brassiere and get felt up by a chain smoker.

That night, I went into my mom's room as she was laying out her Sunday church clothes. "Mom, what's the deal with Mrs. Pratt? You all seemed to know her."

"Of course we do. Mother has taken each of us to her over the years, many times."

"Does she always grab your boob?"

"Yep."

"Does she always scream your bra size as loud as she can across the floor and blow cigarette smoke in your face?"

"Always. And God help you if she's drinking a Coke. She'll belch right in your face." She sat down beside me. Brushed a piece of hair behind my ear. Looked into my eyes. "There are certain rites of passage that all young girls must go through. I wish yours was a coming-out party or a debutante ball, but it's getting cupped by Mrs. Pratt. Sorry, Big 'Un."

"Yeah, super fun. Super fun day. I especially liked it when she screamed, 'HER TITS ARE HUGE'—that was probably my favorite part right there..."

"Well, I can't identify with that part. For that, you'll need to talk to your daddy's people."

"I'm not trying to cast aspersions...
but...she weighed a lot of weight."

—My mom, telling me that my dad flirted
with a woman in "the Hobby Lobby"

I Can Get Anywhere
from a Taco Bell

I WISH YOU COULD HAVE HEARD ME TELLING MY TWO TEENAGERS about how we used to get directions.

"Well, first we had maps."

"Do you mean a *mat*?"

"No, I don't mean a *mat*. I mean a *map*."

"Oh, like a globe. You carried a globe around in the car?"

"What? No. We had maps written out on paper. With landmarks and street names and—"

"Look, Mom. If you're gonna just make stuff up, we don't want to listen."

That was how well it went.

Then I tried telling them about the advancements in paper maps—which was the Garmin.

"Seriously, y'all. Garmins were cool. Do either of you even know what a Garmin is? No, I knew you didn't. That's because they didn't even have them when you were born. But when they came out in stores, we thought they were the coolest thing we had ever seen.

"You see, a Garmin was about the size of your iPhone, but it was as thick as the Old Testament portion in the King James Version. And

you would buy this handy-dandy holder that would stick to your front windshield and extend out like a snake from its hiding place."

"Like the holders we have now so that we can make videos in the car?"

"Yeah, kinda like that."

"Did you video yourself on it, Mom?"

"You didn't video yourself. It only gave you directions."

"Mom! That's hysterical. Hey, Rocco, imagine having something in your car that only gave directions and didn't make TikToks."

"Dang. If I didn't have TikTok, I wouldn't even want to get out of bed and go anywhere. So it wouldn't matter if I had directions or not."

"Oh, brother."

Should I even bother telling them the rest? Like, that if you told Garmin you wanted to drive to New Orleans, then it would take you to New Orleans. But it wouldn't tell you about any road construction or flooding. It didn't know how. So you just had to know that even if it normally only took five hours to drive to New Orleans, it might take twelve hours because Garmin didn't know about traffic or fallen trees. In fact, sometimes, just for fun, the Garmin would lead you right into an eight-hour standstill due to a pileup on 57. Garmin didn't care. He was funny like that!

There was no such thing as a shortcut because Garmin didn't know what the word "shortcut" even meant.

What's that, kids? Could our Garmin talk like Keith Morrison? No, no, it couldn't. And that's a crazy question. Why would you even ask…Oh, because yours can? It can talk like Keith Morrison from *Dateline* or give you directions while singing like a nineties boy band? Did you say that, depending on the season, it can even talk like Santa Claus or the Easter Bunny? Well, isn't that fun. No, my Garmin I bought for my husband didn't really say anything, it just pointed left or right, and God forbid you were scratching your nose and you missed it—because then you had to drive back to the beginning and start over.

To be honest, I didn't want a Garmin. I didn't need a Garmin. David did. He had trouble getting around places, but me? I had a

foolproof system. A system that had been taught to me by my mother and her mother and her mother's mother. A unique method that I believe is known only to the finer sex. Sure, there were times when I struggled, but overall, this technique has held up beautifully. Let me explain...

When David and I got married in 1994, we moved to Arlington, Texas. I suppose that, as a new resident of this Dallas suburb, I had a little trouble getting to places.

But as I explained to David, "I just need to get my feet wet. Give me some time."

"You call me every day at work to ask me how to get to the donut place."

"Okay, you're exaggerating. I don't call you *every day* for donuts. How could I be built like a goddess if I ate donuts every day? Personally, it's insulting because how do you know I'm not witnessing to the lady that works there?"

One year later, we moved to Nashville, Tennessee, and started our final years of college at Belmont University. I'd be lying if I didn't say that it also took some time to adjust there.

"Put the Garmin up in your car!"

"I don't need it, David! I get to Belmont just fine. It's the exit right after I see the sign for 'How to Notice the Symptoms of Heart Disease.' I take a left at the White Castle. And it's a block past the convenience store that looks like they sell drugs out of."

"This is the weirdest way I have ever had someone give me directions."

And then I had an epiphany! An epiphany so large that if I were to share it with the world, I would probably be written up in new magazines and Oprah would want to sit under that big tree in her backyard and "pick my brain."

This is why men won't ask for directions.

You put a man and a woman in a car, with him driving, and it will be three and a half hours until they reach Outback Steakhouse. You put two girlfriends in a car together and they'll have you there with a

piping hot onion blossom in seven minutes. Because women get—and give—directions completely differently than men. And I'm starting to think it's a language that men just don't speak. Maybe it's not their fault.

We grew up listening to directions being given by our mothers and our grandmothers and we know how it's done. I once watched my mom and Granny drive out of town to a flea market based off of these words: "Mary Helen said it's in Apple Springs next to the new Dollar Tree. If you get to the Methodist church with the broken sign, you've gone too far. And if you haven't seen the elementary where the principal was arrested, you haven't gone far enough." We didn't have a single issue. But if I gave David Radke those directions? He would stare at me like I had three heads. But women just know. I'll give you two examples that I was blessed to sit in the back seat and be a witness to.

Example 1. The Lees go to a wedding.

In 1982, I witnessed one of the most horrific events a child should never have to watch. I sat in the back seat as my parents drove out of town to a wedding. And got lost.

And not the kind of lost where you pull over for gas and an old country farmer talks you through the directions while you each fill up your tank, and then your dad skips out of the store with your mom's favorite candy and says, "Just a little snack for you, my dear, from your hero!" And then he proceeds to get you there in five minutes.

No, this was being lost out in the middle of nowhere with our car getting hot and my dad having to turn off the AC and roll down the windows so the car wouldn't overheat. It was the kind of lost where you drive for hours and don't pass a Chevron or a Texaco or even an old man selling watermelons out of the back of a trailer. This was the kind of lost where—more than once—I heard my mother say, "If we aren't there in five minutes, Gene Lee, you are going to turn this car around and take me back home and I will make you miserable every single second of the way." And him replying, "Oh, that isn't what we're already doing? I had no idea."

This four hours in the car brought about the now-famous line that we credit my dad with saying, "I don't know where we're going, Annette, but we're making great time."

They fought. She cried. He rolled down the windows. She held on to her hot-rolled hair while screaming at him. He played Chicago really loud. She turned off the radio and said, "At least I know what to play at your funeral." And when they did find a store, he made the mistake of running in and just getting something for himself. (Up until then I didn't know you could make a U-turn in the middle of the road.) He yelled. She yelled back. And when my nine-year-old self finally made a sound, I asked, "Are y'all going to get a divorce?" To which they screamed back different answers at exactly the same time. (I'll let you guess who said what.)

At nine years old, I knew only a few things. But of this, I was sure: never drive out of town with a man. It's a losing battle. But then again, this was the eighties and maps were on paper.

I think it's important to note that we never made it to the wedding. We had to just turn around and head home. When we got to the house, my mother unwrapped the wedding gift. They still use that gravy boat to this day.

Example 2. The women go to Catherine's.

David and I left Nashville in 2009 and moved back to my hometown of Lufkin, Texas. We had two small children at the time and wanted our children to grow up around grandparents and cousins. I'm glad every single day that we made this move, but returning to your hometown is not an easy thing. People have changed. Places have changed. It felt like starting over, all over again. But unlike those early, lonely days in Nashville, I had my family with me now. *God help me.*

"Melissa, would you take me to Catherine's? I have been wanting to go and take Granny, and I think it would be fun if you took a Friday off from work and went with us. If you drive, I'll pay for gas."

After sixteen years in Nashville, I had missed these moments with my family. I can't tell you the number of times I would call my mom,

only to hear the women in my family cackling in the background. I had missed home and I had missed them, so obviously I said "yes," and made plans to drive my mom and Granny to Catherine's.

Oh, what is a Catherine's? It's a store for plus-size women, if you must know. They have things like white capri pants that you can pair with white crocheted cardigans. My mom and my Granny could go hog-wild in that store. You've never seen so many leopard print kimonos in one place.

On Friday morning I pulled up to my Granny's house to pick her up. My Aunt Melba and my mom were already there. My cousins, Meridith and Michelle, pulled in and parked their car. This was going to be a family affair.

Everyone piled into my car. Granny sat up front with me, my mom and Aunt Melba sat in the captain's chairs, and Michelle and Meridith made their way to the tiny third row. After a few minutes of us laughing at them trying to squeeze through to the back, we were off.

"I don't even know what a Catherine's is," Michelle said. "I've never been to one."

"They have really pretty stuff like capri pants and swim dresses and…" my mom answered.

"It's modest! Which means you probably won't like it!" said my Granny.

"Thank you, Granny," answered Michelle.

My Aunt Melba tried to cover for my Granny. "She didn't mean that, Michelle. She just likes to go because they have nice blouses, and they also have bras and slips that Momma likes. Don't you, Mom?"

"I don't even wanna go. Y'all are making me go."

"No one is making you go, Mother. We just know you like their clothes, and I wanted to get you some pretty tops for summer," my mom responded.

"I'm not buying another thing for my *BODY*. I don't want another top. I don't want another pair of pants! I'm almost ninety years old. Every time I go to Walgreens, I get travel-size toothpaste. I'm ready to DIE."

This time, I tried. "Granny, do you have to talk like that? It's morbid."

"It's not morbid. It's truth. There are far more people that I love up there than there are down here."

"Oh, we know," said Aunt Melba. "Listen, Momma, you don't have to buy anything for your *BODY*. We'll buy something for us and you can keep wearing that same orange top every single day."

"Fine, that's exactly what I'll do then."

We were off to a great start!

"Okay, y'all, I have never driven to Catherine's," I said. "Who's giving me directions? I'm not sure how to get there."

Meridith said she would help me and gave me my first bit of directions.

"Melissa, drive down to the three churches and turn right. Well, it's not the three churches anymore because one burned down. So, at the two and a half churches, go right."

"Did any of you hear how that fire started at that church?" my mom asked.

"I bet they were frying something!" answered Granny.

"What in the world makes you think they were frying something, Mother?"

"Melba, they had taken to selling fireworks. That's what someone told me. A man had come and set up a firework stand out in the front."

"What in the world does that have to do with frying something, Mother?"

"A lot of teenagers started hanging out there! I bet they were trying to feed them and one thing led to another."

"This is how rumors get started!" said Michelle.

"Okay, I just turned right at the two and a half churches. Where to now?"

"Melissa, just go straight...past the Wimberleys' old house...until you get to the red light."

"Did the Wimberleys die?"

"They wish!" my Granny said. "They're gonna live to be a hundred and ten or until they kill each other. They just moved into a smaller place."

"So back to Michelle not dressing modestly," I said.

"Shut up, Melissa," Michelle yelled from the back.

"I just don't think any of you young girls dress very appropriately."

"Oh, great. Now it's all of us," said Meridith.

"My generation wants to look at ladies who dress like ladies. And who are sweet and demure."

"What the heck is demure?"

My mother patted Meridith's hand. "Well, baby, if you have to ask, then you probably aren't demure."

"Melissa, slow down, this is a curve. And you're gonna stop at the red light, beside the corner store."

"Oh, the store where we always got the burgers?"

"Yes. But you're thinking of when it was a food truck; now it's a store because you know that food truck 'burnt down,'" my Aunt Melba emphasized with air quotes. "It 'burnt down' when you were still living in Nashville."

Air quotes always intrigue me. "Oh, reeeeaaallly?" I asked.

"It really did burn down, Melba Joy. You know the lady that owned it, her husband is our mail carrier and he told me that they left the funnel cake fryer on," said Granny.

"Dang, they had funnel cakes?"

"Can someone please tell me if I am going left or right at the light?"

"Melissa, you are going to turn left and drive down 94 past the church that that idiot took over and ran into the ground. And then past the people that put their trampoline in the front yard..."

"Melba Joy, not everybody has a backyard. They have put that trampoline there for their grandbabies."

"Mother, they have a backyard."

"No, they don't. He has a bunch of cars parked back there. He tells her they're classic cars, but they're just junk! If I was her, I would put gargle syrup in his coffee."

We all hollered.

"Gargle syrup? What the heck is that? Granny, you would kill someone for parking a car in their backyard?"

"Him, I would. I think he steals those cars."

"Mother, please change your attitude before we get to Catherine's. You're making me regret this little outing."

"I didn't even wanna come. Y'all are always trying to dress me like Edith Polk."

"Mother, we are not trying to dress you like Edith Polk. Edith Polk wore furs everywhere she went. We are just trying to get you to match."

"Who wants to match? I wanna go to Heaven!"

"Granny! For the love! Mom, am I about to turn by Kellie's old place?"

"Yes. Melba Joy, you know she's in a home, didn't you?"

"Kellie is? Is she still doing hair?"

"Melba, I just said she is in an *assisted living home*. No, she's not doing hair."

"Mom, remember when she told you that she had a new style she wanted to try on you, so she wrapped that rope around your head?"

"Lord, yes, I do! I trusted everything she said, like an idiot."

"Turn right here, Melissa. And then go slow because there's a big curve coming up. And then you're going to go all the way down to the stop sign beside the home of 'they who will not be mentioned.'"

"AACK!" My Granny made a noise. "I don't even want their names spoken in this car," she said. "They're dead to me."

Dang. I knew exactly who she was referring to. We all did.

"I'm gonna turn left and then I'm gonna drive down to the house that the man sold pork butts out of, right? And then I'll turn left?"

"Yes. And then you'll go straight until you pass the house where the old woman—"

"Sells marijuana out of!" my mom answered.

I couldn't help but think that as much as I use the Waze app for my directions, not even the voice of Keith Morrison could keep me as interested as these women could.

Meridith piped up, "Did y'all know they're building a new rehab center beside the old Taco Bell location?"

"I don't wanna get my tacos next door to dope heads."

"GRANNY!" we all shouted.

Meridith corrected her. "It's not a drug rehab, Granny. It's like a physical therapy rehabilitation center."

"I was wondering what that was. It's beside the old Taco Bell, right? Not the old *old* Taco Bell?"

Aunt Melba informed us: "No, the old *old* Taco Bell has a car lot beside it. The new one is next to Catfish King and the old one is where the rehab center is coming up. And it's gonna be a nice rehab center… They're gonna have an elevator inside."

My mom piped up, "Why don't we drive by it and look at it later this afternoon. Y'all know I can get anywhere from a Taco Bell."

"I bet I'm taking this left by the Dollar Store, huh, Melba?"

"No, you're thinking of the Family Dollar that's right beside that Everything Under a Dollar Store. You're gonna go all the way down to the Dollar General."

Suddenly it came to me. "Wait. Wait. Is Catherine's the dress shop next door to Shannon's?"

"Shannon's isn't there anymore. She shut it down after she had an affair with the fire chief. She lives in San Antonio now," my mom informed me.

"Y'all know Shannon's dad was the pastor at the church that burnt down at the end of our road, don't you?"

"The one that was selling firecrackers and funnel cakes to wayward teenagers?"

We all laughed but Granny just rolled her eyes.

"Michelle, I don't think you're right about that. That church was Baptist, and he was a Lutheran."

"I'm just telling you what Melinda Farmer that works the front desk at my doctor's office told me," Michelle answered.

"I wouldn't trust Melinda Farmer as far as I could throw her!" Granny answered.

"Back to my directions, please! I'm at the Dollar General. Now where do I turn?"

"Good grief, Melissa Paige. You lived in this town twenty years. Drive down till you see Popeyes and turn left. Go down until you see that sign for the old Farmer's Market that is hanging upside down. Turn right there and drive to the first Shipley's Do-Nuts you see. Make that right and then you're not gonna stop until you pass by Frieda McClendon's house; she's the one with the obese dog. She's right next to the land they cleared for the putt-putt golf course, but they never ended up building it. Go about two miles down to the shopping center with the tacky sign and it's in there."

"Thank you, Mother. Now why didn't someone just do that for me to begin with?"

"And keep you from all this interesting information? Why would we do that?"

My Aunt Melba said, "You know Frieda McClendon stole my coat. We went to that estate sale over near the Huntington Red Barn and she picked my coat up and walked off with it."

"Why would Frieda McClendon want your coat?" my Granny asked, "She's petite."

"Thank you, Mother."

We pulled into the parking lot of Catherine's and proceeded to get out. There had been a dozen turns, fourteen lights, just as many stop signs, a lot of gossip, and zero issues. And this is how women get around.

Maybe in big cities you can program your Waze to have Liam Neeson tell you where to turn, but in small towns you listen to your women. They just know. Their directions are built off a never-fails three-step system:

1. Know people.
2. Talk about them.
3. Arrive.

I once drove the women in my family to a catfish restaurant, forty-five minutes outside of town, with this simple instruction:

"Melissa, it's right past the girl's house that wrote that thing in your yearbook that year."

I found my new doctor's office from my Aunt Linda telling me:

"Turn by the Dairy Queen your daddy got diarrhea in. And don't stop until you see the dentist office who had to leave Lufkin because he was taking his own gas. And then it's in between that and that Taco Bell/KFC."

Easy peasy. Because as we have proven time and time again, women can generally get anywhere from a Taco Bell.

"You can have guns. Or you can have whiskey. But only an idiot has both."

—Granny, when asked what advice she would give to newlyweds learning to live in the same house together

This Must've Been Exactly
How Marcia Clark Felt

I HAD AN AUNT NAMED MARGI. I SAY *HAD* BECAUSE SHE LIVES IN Heaven now. *We think.*

Now Jesus has to listen to her list off all the things that ache.

We loved Aunt Margi. She was small and cute and a lot of fun to be around when it wasn't about to rain. No one ever called her if the weatherman said we were getting rain. We knew we'd never hear the end of how bad her knees were hurting and her back was aching and how she should have had her wisdom teeth taken out but it was during the Great Depression and dental care wasn't an option.

Aunt Margi wore the same hairstyle for forty-seven years. I'm not kidding. That's not just a number I made up. She married when she was eighteen, and the hairstyle in those pictures was the hairstyle she still had on her head in 1998, when at the age of sixty-five, she walked into a beauty shop and said, "Give me the Rachel Green."

I would love to have been a fly on the wall when she told her hairdresser that she wanted something different—something that attracted men other than her husband and didn't flare up when the temperature dropped. All I know is when Aunt Margi walked out of that beauty

shop, heads turned. Not because she was a statuesque woman who warranted the attention. But because for the first time in forty-seven years, birds didn't try and land on her head.

She called the women in the family over for a lunch of chicken salad, white bread, and peach cobbler. I walked in the house with them as, one by one, their mouths dropped.

"Margi, you look so good."

"Oh, Margi, this takes ten years off you, girl."

Over and over, the comments and compliments poured in until poor Aunt Margi just couldn't take it anymore. "Stop! I can't hear another thing about my hair! If this new 'do has taught me one thing, it's that I must've looked like a MONKEY for the past forty years!"

No one said a word about her hair after that. Within a month she had grown it out, teased it up, and called it a day. When she died, as we made our way past her open casket, I heard my Granny whisper, "You know what's so sad? This is the best her hair has ever looked."

In the South, hair ranks right up next to God and family. In fact, I would wager to say that on a list of things that are important to a Southern woman, they are as follows:

1. God
2. Family
3. Hair
4. Hairspray
5. A beautician who can keep a secret
6. Spanx
7. America

Maybe I'm wrong, *but I'm not.*

Hair means a lot to the women in the South. We want it big and we want it thick. We want it to hold up in the humidity, without looking like we tried. We want it sleek in the winter and textured in the summer. We want it to look like we just got out of the ocean even

though we live in a landlocked town. We want it to look like we just had sex, but not rough sex, for cryin' out loud, but demure, dignified, age-appropriate sex. We want it to shine with the sheen of a thousand sheens. But we don't want it so shiny that it's oily. And we want it to be colored, and often. We do not, under any circumstances, want our roots to show—unless, of course, roots showing are all the rage, then we definitely want our roots to show.

And as important as all of that is to a woman in the South, it is even more important how *other* women wear their hair.

There is no other topic that Southern woman want to talk about more than another woman's hair. I will fight anyone who says differently. And before women in the South get mad at me and say things like, "How dare you! We talk about politics and women's rights and the educational system!" I'm not saying you don't! I'm simply saying that those types of conversations come to a screeching halt when a woman over fifty walks by with braids.

I once sat at a table full of women, in a tea room, who were celebrating a pregnant friend, and they were all offering up their best advice and favorite hacks and sweetest memories, and every single woman at the table was crying and the mom-to-be was wiping tears from her eyes, when everyone stopped what they were doing because the woman who sat at the table next to them had just had a permanent. For the next forty-two minutes, we forgot our friend was even pregnant as we regaled her with stories about color jobs gone wrong, perms gone bad, and of course, the time Sheena VanPay got bangs.

I'm not sure how hair became such a topic in the South. I would love to give you the history of it, but I'm not that kind of writer. Besides, is there a history of it? Probably not. It probably stems from women in the South being raised by women in the South being raised by women in the South. Meaning, long before my mom told me to "Fix your hair, Melissa, it looks like a rat sucked it," her mom was telling her the same thing. And long before my mom gave me a perm, her mom gave her a perm, and so on and so forth for a thousand generations. When I hear

people talk about *generational curses*—I assume this is what they are talking about.

The moment I knew hair was a big deal was the night my Aunt Melba got engaged to my Uncle Donald. Aunt Melba flew down to our house as fast as her silver Chevy Nova could drive and dumped twelve *Brides* magazines on our kitchen table. I was nine, and I was in tulle heaven listening to my mom and Aunt Melba comb through colors and trains and sprigs of this and that. I listened intently as they discussed who would do what and what they would wear while doing it when the subject of the flower girl came up. I had no idea that there might be a job at a wedding that involved so little skill, the world "girl" was attached to it. Aunt Melba opened a magazine that had been dog eared and pointed to a picture of a girl a little younger than me, walking down the center aisle, preparing the way for the bride. Tossing flowers to the right and the left, this cherub stole the hearts of all those looking on. You could see from the faces in the crowd how pleased they were at her performance and yet I couldn't help but think that, if given the chance, I could really stick it to this kid. I knew I could do that job in my sleep! Pick me! Pick me, Aunt Melba!

"Do you want to be the flower girl in my wedding?" I heard her ask. I couldn't say "yes" fast enough. In fact, looking back on it, I probably said it too fast. It might have been smarter of me to have asked a few questions first, like "I don't know. What will I be wearing? How will you fix my hair? Do I get to wear makeup?"

But I didn't. I was needy. And needy is never good, friends. Needy means that as you get up from the table, your little fists of fury pumping in the air, you will inevitably hear something like, "We'll get you sized and have a beautiful dress made just for you. Oh, and Annette, I want to put baby's breath in her hair so can she get a perm?"

I froze.

A perm is something you can do to the little girl on the dog-eared magazine page. She was probably six! Her cheeks took up half of her

face! Due to my insane jealousy of her appearance in a national magazine, I figured she was a total dumb-dumb, and yet even I could see how adorable she was! You put a perm on a kid like that and shove some baby's breath circa 1981 in her hair, you've got the makings of a layout. But you put a perm on a nine-year-old with bad posture and an elderly gentleman's nose, and you've got problems.

And yet my mom agreed to it.

It will go down in history as one of a million different things my mom signed me up to do without consulting me first. Even now I cannot ever remember being in another wedding where getting a perm was a stipulation. But it was a must if I wanted an entire church full of people to turn their heads toward me and beam with delight like they did to the little girl on the dog-eared page.

Spoiler Alert: No one beamed with delight. And who knew that a perm could accentuate a nose so shockingly?

My cousin Jill gave my Aunt Linda a perm once. Well, sorta. Jill had recently enrolled in cosmetology school and insisted on trying everything out on her mother. I had never known my Aunt Linda to care much about makeup or hair or anything remotely fancy, as she mainly just spent her days working in her garden or frying something for dinner, but in the first few weeks of Jill's schooling, I had seen my Aunt Linda wearing glitter eye shadow, glue-on lashes, and a burn across her chin where Jill had let the wax get too hot. You would think that after applying Neosporin to her face for a week, she might put up a fight when Jill suggested a perm, but she didn't. And here's why: In the late eighties, people quit calling it a "perm." I mean, it was a "perm." Everyone knew it was a "perm." But perms were reminiscent of tight curls atop Grandma's head, or a stocky flower girl with self-esteem issues. What was cool in 1988? A body wave.

Boooodddddyyyy waaavvvvve.

I mean, look at those two words: Body. Wave.

Who doesn't want that? Who doesn't want their body to have some wave, some movement? I do! (I realize that having a firm body seems to

be all the rage, but if I wait long enough, bodies with jiggle and move-ment will come back into style. Y'all just wait and see.)

If someone walked up to me right this minute, even as I type these words, and offered to give me a "body wave," I'd say I had to pray about it, but I wouldn't. I'd say yes!

Body wave suggests that our body has been at the beach and that the waves had their way with us. It denotes sand, surf, and sexiness. A body wave is just like a perm but with prettier words and looser rods.

Until Jill.

For weeks she hounded her mother. "Let me give you a perm!"

"Jill, my hair is too short."

"It's not either! They teach us in cosmetology school to say: 'Your hair is not too short; it's the perfect length *for what's next.*'"

"Oh, brother…"

"Mom! Please! I know what I'm doing. Your hair is hard to curl and has no bounce. Don't you want to be able to wake up this summer and just brush it and go, because it has body and life in it? That's what a booooooddddy waaaaaavvvve will do for you."

"What's a body wave?"

"Oh, it's the naughty little sister to the really boring permanent. A perm is like, 'I have to go to the library and do my taxes.' But the body wave is all, 'Don't wait up. I'm going to see Bon Jovi and I'm wearing this Catholic-school-girl dress to do it.'"

I don't make this stuff up. This is exactly how the conversation went.

And then, like all good moms who paid for their daughter to go to cosmetology school, Linda wrapped a towel around her neck, turned on *Unsolved Mysteries*, and took a seat at her kitchen table. For two solid hours Jill wrapped, rewrapped, dropped, started over, dropped again, picked up, and wrapped again, her mother's hair. Every time some of Linda's hair was wrapped around a rod, Jill would soak it in solution and move on to the next one.

"Jill Suzanne, my nose hairs are burning off. You've been at this for two hours."

"It takes a while, Mother. Your hair is so short!"

"I told you that before you started. And aren't you supposed to get it all wrapped up and then you put on the solution?"

"If you want to do it like that, with no originality, go and pay some old lady to give it to you. This is the new way to do perms, Mom."

"I thought this was a body wave."

"Whatever."

I wasn't at my Aunt Linda's house that day so I'm not sure who threw the first punch. I was, however, at my house when my Aunt Linda came over to borrow something from my mom but refused to get out of the car.

Her hair was shorter than my dad's. And for the record, he's almost bald. The top of her hair was curled so tightly that she had lost any imaginable length that she had even had. The back and sides weren't curled at all. When my mom asked why the rest of her hair wasn't permed, my Aunt Linda said it was because Jill got a phone call in the middle of giving her the perm and ran to her car screaming, "I'll be right back, Momma. Kasey said she thinks she just saw Willie Nelson at the Brookshire Brothers!"

Southern women just have ideas. We have ideas about what we should do with our hair, yes. But mainly we have ideas about what *you* should do with *your* hair. There is not a single heartbreak I have ever experienced that my mom didn't think a good haircut would fix. This may be the one thing on this earth we agree on!

Gained too much weight? Color your hair.

Did you just get a divorce? Perm your hair.

Did someone die? Cut your hair off.

Starting a new job? Add extensions.

Lost a significant amount of weight? Hot rollers.

Did your neighbor run off with your husband? Brazilian blowout.

Blind date? Flat-iron it.

New in town? Get some bangs.

See how that works? For each and every problem, there is a hair solution. I didn't make up these rules! Life did.

For the last forty years of my life, I have held to two truths. These truths do not waver in months or years, pandemics or election seasons. These truths hold fast no matter who the current president is, whether Meredith Grey has COVID, or whether *Bridgerton* gets another season. They are heart-shifting and life-giving. I will share them with you now. Are you ready? Pens up!

- We need Jesus.
- But you need bangs.

That's my moral compass, in two sentences. I have found both of these things to stand the test of time. First and foremost: We need Jesus; so y'all better check your heart! Get it right, my lovelies, because He ain't got no time for you to try and make up your mind at the last minute.

Second: You have had your hair hanging in your eyes since God was a boy. Do us all a favor and cut those things. You know what happens when you get bangs? You cover up that forehead your daddy gave you and you might even take off a year or two on your age. The best guessing game in town is a woman's age when suddenly her bangs are hiding the evidence.

Now hear me! I am not suggesting you give yourself bangs. Please let a professional handle this. Let's say your marriage was on the rocks, what would you do? Would you try and handle the problem on your own? Or would you go to Chili's and sit down for a margarita with your friend Tina who is on her third husband? For some reason you would go to Tina. You and I both know you would.

So please handle your bangs as delicately as you would handle your marriage and your margarita; that's all I'm saying.

In 2010, something happened in my family that was so devastating, we rarely talk about it to this day. I'm not kidding! When we sit around and tell family stories and laugh until we cry, this story never comes up. We just don't talk about it. Like my Uncle Dean's second wife, we just pretend it never happened.

In 2010, my mother got extensions.

It was the worst day of my life.

In 2010, extensions were still pretty new. You just couldn't walk into a salon, all willy-nilly, and get extensions. Extensions were for Hollywood types and divorcees. My mother was neither of those things. She was a grandmother who wore too much Cheetah print and silently judged people. For a woman like that to make a decision like this, many many things should have happened first. A council would need to be called. A casserole of some sort (or at the very least a seven-layer salad) would need to be presented. Pictures from Pinterest should be passed around the table and everyone present should be heard. Everyone should have their chance to speak!

But is that what she did? No. She went her own way.

She went rogue.

She walked into my birthday party at Catfish King and no one moved. No one said a word. She showed up twenty minutes late to my party, and within eight minutes the whole place had cleared out. They had to! No one knew what to say! She had gone from a short, sassy cut to what I like to call the Cocker Spaniel. Her hair hung stick straight all around her head and touched her shoulders. I had only seen my mother's hair this length in pictures. She had no bangs. She had no wave. She had no body. She had no movement. She had no chance.

Only one person said anything about her hair. A guy named Rusty, who was not batting a thousand in the social cues department, spoke up and said, "Did you do something to your hair?" Everyone else put their coat on and exited gracefully.

I sat across from my mom and looked deep into her eyes.

"You really know how to shut down a party."

"Melissa…"

"Mom, do you remember when Hugh Grant went on Jay Leno after he was caught in his car with a prostitute named…"

"Melissa Paige…"

"…Nope, she wasn't named Melissa Paige, she was named Divine Brown. Remember that? The man was dating Elizabeth Hurley, for crying out loud. Why did he need to be in a car with…"

"Melissa. Hush."

"...a hooker named Divine Brown? But I digress. Remember when he went on Jay Leno? Do you? What was the first question Jay Leno asked him? The. Very. First. Thing. What was the very first thing Jay Leno said?"

"'What the hell were you thinking?'"

"That's exactly right: 'What the hell were you thinking?' I might ask you that same question today. On this, my day of birth. What the hell, Mother, were you thinking?"

"I wanted to surprise your daddy."

"You know what else surprised my dad? The heart attack he suffered in 2006. See? Some surprises aren't good surprises."

"Is that why everyone left?"

"Yes. They didn't know what to say."

"This must have been exactly how Marcia Clark felt."

"What?"

"When she walked into court and everyone stared at her. They say that she lost the O. J. Simpson case over her hair. Can you believe that?"

"If her hair looked like this, then yes, I believe it."

My mother had spent $300 on extensions just to walk in her house and have my dad say, *"Whoa."*

She removed them three days later. We still aren't allowed to talk about it.

This would have never happened with a solid set of bangs. That's all I'm sayin'.

This Is How Grown
Women Handle Things

A COUPLE OF YEARS AGO I WAS ON A GIRLS' WEEKEND AWAY WITH SOME friends when we decided that the latest Brad Pitt movie wasn't going to watch itself. (This is how we feed the economy, so don't start with me, okay?) The four of us grabbed our tickets and our popcorn and our candy and our Diet Cokes and then butter for our popcorn and then napkins and then just a little dollop of more butter and then a dash of popcorn salt and then oh-my-gosh-I-didn't-know-they-had-white-cheddar-salt-to-put-on-my-popcorn, followed by well-if-you're-going-to-stand-in-line-anyway-grab-me-some-Milk-Duds and then we went and took our seats.

I don't live in a town with an IMAX theater, so my girlfriend was excited to get to take us to a movie where she promised that we were going to get to see Brad "as up close and personal as God."

As the trailers were playing, a group of teenage girls came and sat right directly behind us. "Oh man, that's my daughters' friends," my friend said. "I hope they don't see me in here."

"Why? Is this movie bad? Is there nudity? I'm staying no matter what. *Who are you to judge me?*"

"No, it's not bad. I just don't want to see someone I know. 'Cuz then you have to be all like 'How is your mom? I saw your prom picture. Yes, you looked skinny.' I don't have time for all that."

Let me tell you what else she also didn't have time for: those teenage girls talking. I will admit, it was distracting. I was very invested in watching a trailer about some sadistic doll who liked to dance when it was overshadowed by who was dating who, who broke up with who, and one of them had come in drunk the night before, but her parents didn't know because they couldn't hear anything; "they wear, like, totally loud CPAPs."

But considering Brad Pitt was seventeen stories high, I could get over it.

My girlfriend? She could not.

Their full-on conversation had gone on for about fifteen minutes when she turned around and shout-whispered, *"Can y'all please stop talking?"*

I lowered myself in my seat and said, "Kenda, those are teenagers! Don't poke the beast."

"What are you talking about?" she asked. "Are you scared of teenagers?"

"Absolutely! They will wait outside for us and call us fat…they use words like *rizz* and *yeet* and you don't know if they're talking good or bad about you…they'll reference my facial hair, so help me, they will reference my facial hair."

All at once the girls started giggling. *Oh crap.* The girls were giggling. The movie was starting and they were giggling and…

Before I could even blink, Kenda stood up, leaned over her AMC Luxury Reclining Seat, and said these words:

"I know exactly who I'm talking to. I can see it's you, Hannah. Listen to me, if you don't shut your mouth, I will be forced to do something I never like to do. I will tell on you…"

They laughed.

"And I won't go to the manager. I won't even call your mother because that would be too easy. Instead I will put up a vague post on Facebook

about how a spoiled rotten teen was sitting behind me and interrupting my Brad Pitt movie and I will write about how rude and disrespectful they all were and I will end it by saying that parents should really have more control over their teens these days because this particular child had already come in the night before stone-cold drunk and that her parents were already asleep and didn't even notice because THEY BOTH WEAR A REALLY LOUD CPAPS..."

In unison, they gasped.

"...And then I will say, 'If you want to know if this was your child, DM me,' but then no one will because they never do they'll just start asking right there in the comments which will force me to eventually tag your mom just to make it less confusing for everyone you know and I'm afraid that will be really embarrassing for her don't you think?"

Kenda sat back down.

Our friend Theresa leaned over and whispered, "That was very rizz, Kenda!"

So, ladies, tell me: Do we fight fair?

I came across a video the other day of a girl, maybe fifteen years old, talking about someone she wanted to fight.

"She used to be my friend, but we ain't even talkin' now. She know what she did. She know exactly what she did.

"Don't you, ER-I-CAAAA? Tryna come up and take my man.

"You just better know when I walk up on you at the mall or if I come up on you in the locker room at school, I am prepared to CUT YOU! Say goodbye to your long, beautiful hair, Erica!"

I snorted. I'm sorry, but *let's stab each other over a schoolyard crush* just seems soooo eighties to me. Women my age have advanced tremendously.

David heard me laughing and said, "You're sick. You think that's funny? That's the age of our kids. That could be someone they go to school with making that video. That's not funny, that's terrifying."

Men.

Remi was walking through the room and asked, "What's terrifying?" I played her the video.

"Dad, that's not terrifying. Watching Nonie and Aunt Melba glare at each other across a table? Hands down the scariest thing I've seen since I went to a slumber party at ten years old and they showed us *The Strangers*."

"Oh, I loved *Perfect Strangers*. Balki was my favorite."

She may not be an adult yet, but she makes a good point. I would rather walk up on TikTok Tricia while wearing a blindfold in a well-lit room than have any of the women in my family mad at me. I have gotten over serious bouts of depression faster than these women forgive and forget.

The way they stare.

The way they don't speak.

The way they make slight, underhanded remarks about your cooking.

My Aunt Melba once said to my mother about a roast she had made: "It's fine…Did you try a new recipe?"

Mom removed Melba's contact information from her phone. Right then, in front of her.

I kid you not, cold chills. All the way down your spine.

David and I moved to Nashville, Tennessee, when I was twenty-one and we moved away when I was thirty-seven. During that time, I had four very close girlfriends. Let me rephrase that: During that time, I probably had twelve or thirteen close girlfriends, but by the time we left, I had around four. I was a very hard person to have a relationship with. A good friend, I was most definitely *not*. I was all the things that people love in a friend: touchy, moody, temperamental, easily offended, sarcastic—and my most endearing quality—I could dish it out, but I could not take it.

Suffice it to say, I didn't do friendships right.

Thank you, baby Jesus, that those four women stuck with me through it all. You know, I've often wondered why our going-away party was so festive, and they all seemed to be so excited! They rented a margarita machine, for Pete's sake. And not one of them even cried. Hmmm. *(I'm figuring this out in real time, people!)*

Little do those four women know that it wasn't until I moved back to Texas and lived on a piece of land surrounded by all my family that I learned a new skill called: *The Art of Not Fighting Fair*.

Before, when I would fight, I would cry or stomp off, not return calls, or not answer texts. And since I know they're reading this book and *taking notes*, they would want me to tell you all that: Yes, I once threw a chair. In a restaurant. During dinner. I'm not proud of this!! But these things are so amateur. This is how little, tiny babies fight. Not real women.

I've matured so much since living in the same town as these friends. I wish they lived beside me now. I truly have changed so much. I've grown in every single one of these areas...

Area 1: I am a better listener.

Area 2: I am more patient.

Area 3: I encourage open communication.

Area 4: I do not feel the need to be right all the time.

Area 5: And even though I am still quite sarcastic, I can appreciate it in others, as well.

Area 6: I don't throw things.

Area 7: Also, I'm on mood stabilizers.

You're probably so proud of me right now and you might even be wondering how I learned to be so mature and friendly and hospitable. Well, let me give credit where it's due: my people. Those are just a few of the things I've learned since living near the women in my family and our family friends. Isn't that amazing? These Southern women are teachers, indeed. They didn't just teach me to be a better listener; they also taught me why it was important. Patience? It's Biblical.

Here are the whats, whys, and wherefores of the abovementioned areas and the way that I—and hopefully someday, you—have acquired them in my life:

Area 1—Listening Skills: I've learned that sometimes the reason we must be so *quick to listen and slow to speak* is so that we can use your very own words against you, later, in a court of law.

Area 2—Patience: Sometimes we exhibit patience, so we show—firsthand—that we are a better person than someone else. And if, by some strange chance, the person isn't noticing our patience, then we throw in some things like my Aunt Melba does, like, "The Bible says we will know them by their fruit, Melissa Paige, Matthew 7 says we will know them by their fruit. And I don't see a single fruit in your life! But me? I'm exhibiting long-suffering right this minute."

Area 3—Open Communication: This is really so important, isn't it? And in our family, loud, vocal, self-righteous, and open communication is most welcome anytime the family is all gathered in one place or on a sacred holiday. It is not welcome in private places such as: quiet coffee shops, closed cars, or local libraries. (What fun is that?) It is not suggested that it happens on the phone, or face-to-face between the two central parties, as therapists might suggest. No, we firmly believe that there should always be between three and seven people there to "moderate." Speaking of parties, parties are a great place to have the type of "open communication" that may make us feel immensely better but often makes guests feel awkward and want to leave early.

Oh! I almost forgot. If one prefers not to have *any* open communication, it is best displayed by still attending all family functions, sacred holidays, or parties, but standing very still in the corner while ice runs through your veins hoping that people will continually ask you, "What's wrong?" so that you can mournfully look at them and say, "Ask Melissa, she knows what she did."

Area 4—Who's Right? Who Cares? I've learned that it doesn't matter who's right or wrong as long as *your* immediate family—those you are married to or are attempting to parent—know *you* are right, and the other person is wrong. Rules state that they should be willing to defend you to the death were they ever to be called on to do so. We call this the "As for Me and My House" rule. Facts don't matter; blood does.

Area 5—Welcoming Sarcasm: How thrilled I was to learn when I moved back home to Texas that almost everyone in my family is sarcastic. It's a welcome trait in our family. But please note that I used the

word "almost." I will give you a completely made-up example. None of this example rings true; I don't even know why I'm using my cousin in this reenactment.

But let's just say my cousin Meridith could not take a joke. Naturally, you would think that this would make her the target of most of our jokes. And you would be right. And let's just say that every time Meridith went on a vacation, she got hurt: sprained ankle, broken arm, sunburn, E. coli, etc. And let's just pretend that whenever we planned a family vacation, we told her that it might be best if she stayed home to watch all our dogs. And let's just say she didn't laugh.

Because she never does.

But that just provokes us to then say: "Y'all, she can't help it. She's an Enneagram 1—they can't handle sarcasm."

And this is my example of how you take a completely pretend situation, turn it around, throw in something about the Enneagram, and make it sound like we really care about her, when really, we just meant that whole Enneagram thing, sarcastically. See? Win-win.

Area 6—Throwing Things: It doesn't take a genius to know that throwing things is not the mature thing to do. A distinguished, genteel, refined Southern woman would never act in such a way. In fact, might I give you an example of what you could do instead?

The mature thing to do when someone has wronged you is to buy an entire chicken from the grocery store and then put it in the very, *very* top cabinet of, let's say, your mother's kitchen. Because you know she is far too short ever to check that cabinet and because you know it is August in Texas.

And then, once exterminators have been called and hundreds of dollars have been spent on fumigating the house and the Bath and Body Works candles have been purchased...and when finally your poor dad has checked every single inch of the property looking for what he thinks is a dead mouse in the air-conditioning vent... and when finally the rotting bird has been found, and the heat and humidity have caused the plastic it's wrapped in to pull tight

and almost burst, inevitably flooding the place with enough raw chicken juice to kill a grown man...your mother has your cousin, *Bubba*, place it in the trunk of your car, where you will drive to an out-of-town speaking engagement completely sick to your stomach until you have to pull over in Fort Worth and vomit on the side of the highway.

Make a note, my lovelies: this is how grown women handle things.

Area 7—Mood Stabilizers: This can be a rather undignified term used to describe any number of medications that make you feel like you can go to a PTA meeting without keying someone's car. In my family we do not call them "mood stabilizers" as this can lead people to think that we might be "unhealthy," and we generally like to let our weight speak for us in that department. Instead, we call them Nerve Pills. Nerve Pills are often used to treat anxiety, backaches, toothaches, depression, mood swings, PMS, heartbreak, insomnia, and more. Nerve Pills come in all shapes and sizes and are most often handed directly from my Granny's purse into our hands. They are not caplets; they are nondescript; they are not labeled with an identifying name. They are old, they are prescription, and they are all mixed together like a mason jar full of buttons. We don't Google the pill; we just take it and are then told to "eat something and get a nap." Nerve Pills are held in prescription bottles labeled NERVE PILLS, written with a Sharpie in my Granny's handwriting.

Truth is, I am not a super-confrontational person. No one believes me when I say it, but it's true. For most of my life, the only people I could truly confront were my parents. I had lived with them—as an only child, no less—for eighteen years, so yeah, confrontation was easy.

But confrontation in high school? College? Even marriage?

I'm not a fan of it. I like everyone to get along. I like peace. My friends in Nashville might suggest otherwise, but you don't throw a

chair because you like confrontation—you throw a chair because you have a temper problem. And those are really two different things.

A road rage incident stems from a temper problem.

Finally getting your bestie to wax her eyebrows stems from the ability to confront a situation.

So do I like confrontation? No. Have I worked on my temper? Yes. I've had to. I have children. And nothing will cause a person to CHILL THE HECK OUT more than watching two of your spawn belly-wrestle in the dressing room of a Target while you try on swimsuits.

As someone who spends a lot of time on social media due to my job, allow me to tell you that social media is one of the places women don't fight fair. The keyboard is such a huge place to hide. It's hard to imagine how something so small, which only holds seventy-eight keys, can make even the smallest voice feel so big, so seen, so heard.

Women (and sadly it's always women; rarely ever is it men) have ridiculed my hair, my weight, my personality, my dreams, my passions, my hopes, my family, and my Christianity. They tell about instances where they've met me and I've kicked their puppy or slit their tires or burned down their house, knowing full well, even as they type those words, that we have never met. They take shots below the belt in the name of Jesus, and they sleep like babies after doing it. And you know what? So do I.

You see, those comments would have killed me in the past. I would have fixated on them and dreamt about them. I would have been riddled with anxiety. I would have stopped working and hid in my closet. I would have gotten off social media altogether. But then I moved to Texas and bought a house on eleven acres of family-owned land.

But then I wore a swim dress around my family.

But then I forgot to bring the queso to a Super Bowl party.

But then I told my mom her roast was dry.

But then I told my Aunt Linda that her perm looked bad.

But then I heard my Granny tell my cousin Diane that her eyes looked no different after she had some "work" done.

But then I saw Meridith walk out the door and slam it after I told her she should pick up some Mexican vanilla the next time we were in Cancún and it would make her chocolate chip cookies taste better, followed by, "Oh, I forgot you don't get to go on vacations with us anymore." (But in fairness, she's an Enneagram 1.)

But then I had children.

Listen to me: These things will change you. They will sharpen you, toughen you up, make you smarter, make you quicker. Whenever people leave me mean comments on the internet, I just chuckle and think about how the women in my family fight and suddenly it makes all of the mean comments seem like an episode of *CoComelon*.

I've talked to a lot of women about what makes them—*Ding! Ding! Ding!*—put their gloves on and come out of their corner. And sure, there were a few comments about road rage, rude service, or being lied to. But the overwhelming majority of women said that the only thing they will not tolerate? You mess with our kids.

God bless the day someone tries, *AmIRight?*

You cannot talk about my kids. I can. And I do.

Their daddy can. And he does.

But anyone else? Buyer beware.

Now this is where things get a little sticky in this day and age; you see, if my kid is talking loudly during a movie after you've asked them nicely to shut it…I want to know. If my kid is disrespectful to you and you are an authority figure in their life? Tell me, because *Imma handle it.*

The youth from our church went on a missions trip, and I later found out my daughter was the only one who preached hell during the day and then raised it at night. But I'm glad they told me. I chased her all over the house with a spatula, and now she is no longer called to be a missionary.

Our children seem to be the sacred ground in which no woman can fight fair, ever. Is this a good thing? Is this okay? I'm not telling you—I'm asking. Can we be rational when our kids are the star of the story? You tell me.

You think Kenda got mad at those girls in the theater? You think that was Kenda *at her worst*? Her son is a young, handsome actor out in Los Angeles. He stars in movies with the world's biggest celebrities. But with that comes criticism. Several of us have had to start a private GoFundMe just for the moment—which will inevitably come—when she needs bail money.

My girlfriend Rhonda has a son who was carjacked at gunpoint! Was she mad? Was she scared? Absolutely. But if I were Rhonda, I wouldn't just want those men to just be prosecuted; I would wait until they were asleep at night and then whisper mean things in their ear. I would be the kind of mother who found out their deepest, darkest fears and then had them played on repeat during movie night in the state prison. Let it be known that *this* mom's anger reaches to their children and their children's children. This is one of them good *Biblical* rages.

Several years ago, my parents lost a deep, loving relationship with a couple they had been best friends with for many years. They raised their children together and went to church together and played cards together until the wee hours. Even I loved this family so much after all the years they had been a part of my life. But unbeknownst to me, something came between these two sets of friends: me. I was caught in the crosshairs of something I didn't even know about for quite some time. My mom wouldn't tell me because she feared it would hurt me. My dad didn't tell me because he was too angry. Years have gone by and neither of my parents have spoken to their old friends. And I can't help but feel somehow responsible.

A year ago, we ran into them for the very first time. It was at a wedding and there was a buffet. *Honestly, has anything good ever happened at a wedding buffet?* Table numbers were called, and without looking up and realizing it, my mom was in line right beside her old friend. My mom didn't speak a word. Sure, the other woman tried—but my mom

did that thing where she looks out the window and hums. They might as well have been strangers.

I asked my dad later if it had been awkward. "Yes, it was awkward. But I don't disagree with your mom. She said she has nothing to say to them until they apologize to you. Over thirty-five years of friendship, Melissa. And she's thrown every second of it away—for you. And she has zero regrets."

I'm fifty years old and my mom is putting on her gloves in the ring, for me—the girl who hid a chicken in her kitchen for eight weeks in 102-degree Texas heat.

I'm reminded of a scene I watched in a movie several years back. The movie was called *Taken*, starring Liam Neeson, and if you haven't seen it, all you need to know is that it is essentially about parenting: what to do, what not to do, how your kids will one day be the death of you, etc. Just like any of us, the poor dad in this movie was having trouble with a sneaky teenage girl. And he said these words to someone who had been really mean to her and I loved them:

> *"I don't know who you are. I don't know what you want. If you are looking for ransom, I can tell you I don't have money, but what I do have are a very particular set of skills. Skills I have acquired over a very long career. Skills that make me a nightmare for people like you. If you let my daughter go now, that'll be the end of it. I will not look for you, I will not pursue you, but if you don't, I will look for you, I will find you, and I will kill you."*

Maybe you watched that movie, too. And maybe after that speech you turned to whoever was sitting beside you and said, like I did: "That would have been much more believable coming from a woman."

"What's Venmo? Is that just for, like, high-level prostitution?"

—My Aunt Melba

Melba Joy: The
Nashville Hot and Spicy

I'VE WRITTEN ABOUT A LOT OF WOMEN IN THIS BOOK. I'VE MENTIONED a lot of different names. But it's important to me that as you read about my Chicken-Fried Women, they become more than just names to you. I want you to really know who they are.

What they do.

What they say.

How they can somehow fix their hair the exact same way for the last thirty-seven years. (I know. This seems impossible, doesn't it? But trust me, it isn't.)

And it isn't because my women deserve any kind of fame or glory. It's because I want you to figure out who that woman is in your own life.

Who's the strong one?

Who's the tender one?

Who's the sassy, opinionated one?

Who's the brave one?

Hopefully, my women are stand-ins for the celebrated women in your story.

Ever been to Prince's Hot Chicken in Nashville? Prince's is famous for their Nashville Hot Chicken and they *ain't playin'* with that name. I went once. I ordered the Mild and left the restaurant crying. So if you can order the Nashville Hot, you are tougher than I am.

And that is what my Aunt Melba is. She is the Nashville Hot. She is made up of a different kind of batter. She has been cooked in a different kind of fire.

There are so many stories about my Aunt Melba that I want to share, but this book would be way too long. I want to tell you about the time she ran over an alligator but thought it was a telephone pole because she can't really see to drive at night. Or how she once forgot an entire gallon of milk in her trunk throughout the hot summer but blamed it on me by saying, "You smell that? I think you threw up in my car and didn't tell me. That sounds just like something you would do!" Or how one time, at work, she went to the restroom and then buttoned her body girdle *over her clothes* and went half the day before realizing it. I want you to feel like you know her, like she's part of your family, or she reminds you of someone in your circle or your tribe, *God help you.*

Or heck, maybe she just reminds you of you. Maybe *you're* the Aunt Melba.

Maybe you're the spicy one!

But I'd be lying if I didn't admit to one more reason.

I described my Chicken-Fried Women as being a little battered on the outside, a little worse for wear. And it's important to me that as you hear the stories that make up the fabric of their lives, as you laugh and maybe even cry at what life has brought to them, as you see the strength that makes them who they are, you are reminded of the strength inside you and your women.

You see, I'm all about writing a funny book, but I'm even more about writing one that means something.

Not too long ago I found myself sitting at my Aunt Melba's kitchen table, looking through some old photo albums. I would turn the pages of any given album and find another picture of my mom in a crown. My mom was every kind of queen that a student body could bestow on a young girl: prom queen, homecoming queen, Most Beautiful, you name it. I made a comment about this, and Aunt Melba said, "Yeah, you'll be able to spot the difference between me and your mom in these pictures, because she's the one always holding roses or wearing a crown. And I'm the one with the bangs. Your mom liked to play this fun little game with me where the night before school pictures she would talk me into letting her 'play with my hair.' She ended up making it so that I looked like Buckwheat and she looked Raquel Welch."

Sisters.

They loved each other, though. They still do. Maybe it's because half of the things they've been through—they've been through together.

When my mom was the piano player at our church, she rarely had time to go to the restroom in the time between when one service ended and the next one started. But on one particular Easter, she couldn't wait. She had to go and she had to go bad. But this was before the days of Skims or Spanx or anything that was somewhat easy to pull up. This was when body girdles were tight and thick and hot. It was when they had between six and eight snaps at the crotch.

Time was ticking down, the Easter service was about to start, and my mom could not get that girdle to snap. Maybe if she was wearing a dress, it wouldn't have mattered, but she wasn't. This was the late eighties and she had worn a cutting-edge pantsuit to Easter service. There was no leaving it unsnapped. Mom had to send word to people in the bathroom that she needed her sister. Women began calling for Aunt Melba in the halls.

Melba eventually made her to my mom's stall. The two of them stuffed into that stall like clowns in a tiny clown car. Melba had to get onto the ground, reach up under my mom's crotch, and bring the girdle and the snaps together. "Annette, this doesn't fit."

"Yes, it does. It did this morning!"

"Well, it doesn't now. Lean back on the toilet and maybe I can get more leverage."

"Like this?"

"No. Stand up, and just lean back. Let your back rest on the lid."

"The commode lid or the tank lid?"

"The tank lid, Annette! How in the world would you ever be able to lean back onto the commode lid? Are you a contortionist?"

"Don't yell at me!"

"I'm not yelling, Annette. I'm sweating all my makeup off and I've got to get to the choir loft."

"Just what exactly do you think you're going to do in the choir loft without a choir director? AND I'M THE CHOIR DIRECTOR."

At this point, service had been delayed seven minutes because no one could find the piano player. My dad knocked on the women's bathroom door and slowly made his way in. "Annette, are you in here?" To this day he says all he saw was Melba lying on the floor like a mechanic underneath a car. She was on her back and sliding backward under my mom. They were both laughing so hard, they were crying. And all he could hear was Melba saying, "I can't help it if it pinches. A lot of bad things are going on down here, Annette, and I have zero help."

He backed out of the restroom as quietly as he had come in.

This describes their sisterly relationship to a T.

When I was in the eighth grade, my Aunt Melba and I had a cartwheel competition in our front yard. Her kids, Meridith and Bubba, stood on the front porch rooting their mom on! My mom stood on the front porch calling us both "idiots!"

"Melba Joy, you are gonna break something. And Melissa Paige, this is going to end with you in tears. Mark my words! Don't be idiots. Come back inside."

"No! She doesn't think her old aunt can turn a cartwheel, so I'm gonna show her."

And she did show me! She went running across our yard like the world's fastest land animal. She turned a pretty darn good cartwheel,

too. And no one would have laughed or screamed or maybe even said one word if her shirt had not come up, revealing that she was still wearing maternity pants. Her youngest was eight. No one has ever let her forget that.

To be honest, stories about my Aunt Melba are the stuff legends are made of. She has been a part of stories that we still sit around and tell, to this day.

Melba married her high school sweetheart. He was two years younger than her and about thirty-five pounds smaller. Whereas he was short and scrawny, she was what my Granny once referred to as "corn fed." They met in the youth group at church. The first time they realized there was a spark was when the youth group went to Dairy Queen after service one Sunday night, and everyone piled into one car because it was the early eighties. Poor little, scrawny Donald ended up having to sit in my Aunt Melba's lap. My mom said when she saw them crawling out of the back seat of that car, it looked like a single mom was taking her son out for ice cream. But no one could deny there were sparks.

When they got married, they lived on the same piece of land as her parents. In fact, my grandparents were their landlords. This was not Donald's favorite thing, as you can imagine. But that was nothing compared to the day he complained that the plumbing was backed up. So in the interest of teaching them how to fix things themselves, my Pawpaw took them both out to show them how to flush the pipes. Imagine the young couple's shock when condoms began spilling out of the "backed-up" pipe. Not just a couple. Not even fifty. Legend has it that hundreds of condoms began pouring out of the pipe at the foot of their "landlord." My Pawpaw never took his eyes off them. He didn't even blink. Everyone went back to their homes, and no one ever spoke of it again.

My Aunt Melba is made up of stories like this. I could go on and on. This book isn't big enough for the stories and mishaps and trouble that this woman has somehow found herself in. And remarkably, gotten herself out of.

And I will admit that sometimes when I look at her, all I see are these crazy stories and hilarious predicaments written in the lines of her face. I see years of laughter and fighting and eye rolling and name calling. I see holiday memories and cartwheel competitions. I see all of us gathered around the dining room table doing ear candles because she thinks it's fun to unroll them afterward to see what came out of everyone's ears, like it's a competition. I see the New Year's Eve service that she and I sang in together when my candle lit her sheet music on fire; she blew between every word she sang. I see how self-righteous she gets about ridiculous things like tattoos and her grown adult children using the word "pissed."

But then I see her watch every Twilight movie and even wear a Team Jacob T-shirt to the final one. I see her inability to laugh without peeing so much that it ruins a chair. I see her undying love of Mexican food. And her unfounded belief that if she had a few minutes to warm up, she could still do a toe touch. I think about the one Sunday, in the nineties, when my Aunt Melba showed up to church with the blackest hair you've ever seen. I kid you not. It went beyond jet-black. We all called her Melvis for the next four months.

But there are other times when I look at her and all I see is what I saw on the last night my Uncle Donald was alive. When I walked into the hospice room as she sat at his bedside, holding his hand, and asking…

"Do you want me to sing your favorite song? Can you hear me? You always loved this song, so I'll sing it in case you can hear me…"

Be still my soul, when dearest friends depart
And all is darkened in the vale of tears
Then shalt thou better know His love, His heart
Who comes to soothe thy sorrow and thy fears
Be still, my soul: thy Jesus can repay
From His own fullness all He takes away

She was never sure he could hear her. But we do know this: She sang him this song and moments later she let go of his hand, because

he was gone and she knew it. We have always thought it was because he wanted to hear her sing one more time. And once she did, he was at peace; he could go. Meeting Jesus is probably not as intimidating when the only love you've ever known is singing you into His arms.

And this is what I mean when I say Chicken-Fried Women. This is what I mean when I talk about women who are battered on the outside, but tender on the inside. I mean the women in your life who hold happiness and hurt, memories and misfortune. They have been gifted with both love and loss. These are the women who know it's possible to hold gratefulness and grief in the same hand.

When my Aunt Melba found out her daughter, Meridith, was diagnosed with Stage 3 cancer, we didn't see her cry. We know she did. But I'm not sure I ever saw it.

Because this kind of Chicken-Fried Woman comes with life experience in one hand and strength in the other. This woman may feel like she's been through the ringer, but the ringer only made her stronger. It only proved what we already knew: she is strong and unshakable, secure and immune, and she is fiery because she was formed in it.

I, for one, appreciate these types of women. I appreciate their willingness to press into God when we can't. I like knowing that when my strength is low, theirs remains. And I am reminded time and time again that when it comes to their relationship to Christ, to their family, and to their people: they will not be moved.

I tell her that all the time. "Aunt Melba, write the book...sing the song...teach the women." But she just shakes her head and says, "Why would anyone want to hear from an old woman like me?"

If she only knew. In a world as shaken and quivering as ours, it would be nice to hear from the ones who cannot and will not be moved. Who have attached themselves to something or some One greater and stronger. Maybe I'm only speaking for myself, but I want to know how to last. How to stay firmly planted.

We tease my Aunt Melba because she's been a widow for many years now and it's not because no one has wanted to date her. In our

town, my Aunt Melba is a hot commodity. She will probably be as flattered as a prize hog when she sees that I titled her chapter "Nashville Hot." And don't get me wrong, once we got her to try a new hairstyle and to stop wearing maternity pants at fifty-three years of age, she is one hot Cheeto. But that's not the kind of spicy I'm talking about.

What I appreciate most about her is that she never shied away from a challenge. She never tucked tail and ran away from a wildfire. Certain that it would hurt, sure that it would bring her to her knees, she kept going. Women who walk through fire are just made of something a little different, aren't they? I admire that in all of you Nashville Hots who are reading these words. Thank you for walking through what some of us could never face. Thank you for going first. Thank you for allowing it to change you. For the better.

I'll wrap up my Aunt Melba like this:

When I was a teenager, I spent many nights with her and my Uncle Donald. They were so much cooler than my own parents (so every fifteen-year-old thinks). She had some framed Scriptures hanging on the wall in her kitchen, and one night after I grabbed a snack, I stood and read each one of them.

"Why do you have all of these?" I asked her.

"Because they are all of my favorite Scriptures."

"But is one of them your hands-down favorite?" I wanted to know.

"Yes, one of them stands out to me more than the others."

"Which one?"

"Well, which one do you think is my favorite?" she asked me.

I read them all again and pointed to the flashy ones. Surely it was "I know the plans I have for you…" That's everyone's favorite. But she shook her head no.

"I love that one. But it's not my favorite."

Then I pointed to "Better is one day in your courts…" Wrong again.

Then she pointed to the very last one I would have ever guessed. There was nothing exciting about that one. Nothing showy. Nothing poetic or romantic or dramatic.

"Why is that one your favorite?" I wondered aloud.

"Because it's the hardest to do, but the most important."

Her favorite? "Be still, and know that I am God."

I would be reminded of this moment years later, as I stood outside a hospital room and listened in as she sang those exact words over her husband. *"Be still my soul…"*

Be still.

Unmovable.

Unshakable.

Unflinching.

Through death, through grief, through life. Through fire.

Oh God, make me this kind of Chicken-Fried Woman.

"YOU'RE saying that to ME? Your hair looks like a rat sucked it. Besides, I'm not running for office."

—Granny, when Annette told her she needed to brush her hair before going in public

Lilly: A Play in Five Acts

WHEN DAVID AND I MOVED BACK TO TEXAS, REMI WAS THREE AND Rocco was one. One of the first things I did was sign Remi up for preschool. You might think sending a child to preschool at three is a little early, but that would be because you never babysat Remi Radke. I've never watched a single documentary on the BTK killer that mentioned whether he went to preschool, but I'm betting his mom also needed a big, fat break.

One of the things preschools do that I, personally, love is theme days. They tend to do theme days on any day that ends in *y*. But I'm not complaining. Nothing has brought me greater joy—and lower self-esteem—than figuring out a way to dress my child up like an apostrophe, the letter *Q*, and a potato. Remi loved theme days, but then again Remi really took immense pleasure in anything that seemed to cause me great pain. When Remi was cast as Mary in the Christmas program, all our family could say of her performance was "She did so good. She really captured the pain of childbirth." They weren't wrong. How do we know Mary didn't look at one of the shepherds and loudly proclaim, "YOU HAVE A FAT NECK!" like Remi did to little

Tommy Watson, huh? None of us were there, so we don't know. It's called method acting.

During Remi's PreK-four year, the teachers really went all out. Apparently, PreK-four is like *senior year* for babies, so it was just one festive day after another. If I'd wanted her to *Dress Like You're 100* and eat cupcakes all day, she could've just stayed home with me, for free.

One time they had the 4K Circus. Why? These kids couldn't even spell "circus." But at this circus, the kids could choose to be lions, tightrope walkers, acrobats, clowns, jugglers, mimes, or the strongest man on earth. Only one child raised their hand and asked to be the ringmaster. Guess who it was? She stood in the middle of the ring with her hands on her hips, screaming, "MOVE IT OR YOU'RE GONNA GET A SPANKING!" at the four-year-olds who dressed as lions. You may not know this because a circus performer seems to be a dying art, but dressing like a ringleader isn't easy. There are tights and boots and a whole lot of sequins. You have to find a really tall hat, and that hat has to fit a really tiny head. Ringleaders hold sticks and whips and other things that she had been forbidden to play with since the time I caught her juggling butter knives in the kitchen. But it was *senior year*, baby!

Things started to die down closer to the end of the year. We had only a few theme days left: Grandparents Day, the Pet Parade, and the endless string of What Kind of _____ Are You? days.

What Kind of Plant Are You? We took a cactus.

What Kind of Fish Are You? We took a shark's tooth.

What Kind of Toy Are You? We took a spanking spoon.

Look, we were tired. Did you think I was the mom who brought an apple tree, a parrot fish, and an $800 Lego replica of the *Millennium Falcon*? I most certainly was not. I was doing good to put her in pants, okay? I just needed to get through this so my "senior" could ditch this place and stay up partying all night.

For Grandparents Day, my parents went to lunch with Remi and then visited her classroom. My mom has never really known how to dress around small children. She wore pearls and a sweater with fur around the collar.

"I felt like I was on trial, Melissa. They all just stared at me and then took turns petting me. I'm pretty sure two of 'em had the pinkeye!"

I gave her zero sympathy. I was simply trying to get to May. I was counting down the days—field day, zoo day, "throw a pie in the headmaster's face" day, ice cream day, roller-skating day—until all we had left was taking the dog to the Pet Parade. Our dog, Nashville Tennessee, was a five-year-old golden retriever. Golden retrievers were born for pet parades. That's literally in their job description.

How hard could it possibly be?

ACT I

"I don't want to take Nashville."

"What? Why would you not want to take Nash? He's beautiful. He's playful. He knows how to shake hands. Think of how cool that will be."

"Everyone is taking a dog. And Cole's dog does tricks. Nash doesn't do anything but eat our underwear."

"That's not true. He barks...and he—"

"That is not impressive."

"Fine. We'll take the cat. But she is going to hate it and no one will want to get near her and I'm not taking her out of the little cat kennel."

"I'm not taking Frankie Jane either! She hates people."

"Well, you're fresh outta luck, kid. Looks like we won't be going to the Pet Parade, because we got no more pets!"

If you were watching this on television, I would tell you just to fast-forward through this part. It's just a temper tantrum. It lasts for several minutes. Then I would laugh and say, "Look at the screen. It's funny in fast motion. You can see her lying on the floor kicking and screaming. And Remi was upset, too. Okay, stop it here."

"You want to take a what?"

"A lamb."

"I'll see what I can do."

And that's the part of the story where I lied to a four-year-old. I wasn't going to "see what I could do." I could do nothing. I didn't own a lamb and I wasn't friends with people who did. I would live my life like normal, and then, a few days later, when she was sitting in the bathtub, I was going to pick up my phone, hold it to my ear, walk in the bathroom, and speak very loudly to absolutely no one on the other end of the line. And that's exactly what I did...

"Yes, yes! That was me that has been calling you and leaving messages. Thank you for answering my call. I am very excited to talk to you about all of your sheep. Lambs. So do you think I could rent one from you? I can't! Why not? I won't take 'no' for an answer! Please, sir. This is for a child! I promise we won't hurt the lamb. Sheep. We will feed it and love it and take great care of...Sir, please stop threatening to come to my house and beat me up."

I looked at Remi out of the corner of my eye. She was listening to every word. She was glued to my conversation.

"Sir. You are scaring me. I don't think I should be doing business with you. I don't think anyone should be doing business with you. I am about to hang up, sir. Fine, I won't come get your animals or sheep or whatever. Because you are horrible. Goodbye to you."

She looked up at me from the bubbles. "Well? When do we pick it up?"

Act 2

I sat around the table with the women. We were eating lunch at my Granny's. Lunch at my Granny's was always very odd. She would just find whatever was in her refrigerator and pantry and then cook it in bacon grease. Did it go together? No. Did she care? Also, no. Lunch on this particular day consisted of one large box of Popeyes chicken, three broiled wieners, some cut-up onion, a carton of cottage cheese, some tomato basil soup, and fresh cantaloupe.

"...the last time I spoke to her was the last time, I'll tell you that. I'll be a monkey's uncle if I can figure her out. She is one of the weirdest people I know. And she has no reason to be! Her husband is precious."

"Annette, do think he's attractive?" My Aunt Melba asked this question far too often about far too many men. We could be talking about Genghis Khan and she'd ask if any of us ever found him attractive. Once, when a picture of Newt Gingrich came across the TV, she turned her head just slightly when all of us screamed at once, "NO. WE DON'T."

"Melba Joy, why do you ask me things like this? I don't feel comfortable answering it unless they're widowed. Or a movie star."

My cousin's wife, Kylie, jumped in. "Oh! Speaking of movie stars, Netflix has a new Classic Movies section, but Bubba won't watch any of them with me because none of them are Jason Statham movies. So the other night when he was gone, I sat down and watched this movie called *Legends of the—*"

The whole table erupted.

Seven Southern women began to "ohhhhh" and "Good Lord..." and "I watched it again the next night," all over the place. My cousin Michelle took a swig of her iced tea so hard, she spilled it down her shirt. My Aunt Melba unbuttoned her top button. Even my Granny said, "I'm glad Roy was already dead when I watched it."

We talked about Brad Pitt for another couple of minutes when Meridith said, "It looks like that movie was shot in the exact same place *Yellowstone* is sho—"

Again, the whole table.

Every table full of Southern women needs a Kevin Costner minute. It's like a moment of silence, but the exact opposite.

We finished our lunch and asked Melba to button her shirt back up. We chatted about Rip and Casey. Melba told us how attractive she has always found Rip. We talked about how beautiful Casey's wife is even though we all find her to be so whiny. Melba talked about how she once watched *The Lone Ranger* four times, just for Tonto. Our talk turned to Beth when suddenly a few of the women got their

self-righteous stools, climbed up on 'em, and said things like, "She's the reason I don't watch it anymore."

"She's just trash."

"Who even talks like that?"

"She reminds me of that woman Daddy used to work with. Remember, Momma?"

My Granny glared at my mother and said, "Your daddy had to retire early because of that woman. And retirement made him crazy. Remember how he started wearing leather motorcycle vests?"

That seemed as good a time as any to stop this portion of the conversation, so I interjected with, "Guess what we have next week? Remi's Pet Parade at St. Cyprian's."

"Nash will be so cute. Y'all need to have him bathed and groomed before then."

"Yeah, we aren't taking Nash. We aren't going. She says everyone will have a dog and she wants something different."

"What does she want to take?"

Okay, so here's the deal: I answered that question because logic told me that no one in my family had lambs. Or sheep. We weren't lamb ranchers. (Is that a thing?) We were a simple people, we had dogs and cats, except for my Aunt Susan, who had a pig named Piggy Sue that she let sleep in her bathtub.

Oh, but you see, this was my mistake. I listened to my head. And not my gut. My head said, "Tell them. No one has a lamb, so there's nothing to worry about." But my gut? If only I had listened, I would have heard my gut telling me, "There is no problem that a collection of Southern women cannot fix. They know everyone. They have connections that run deeper than Tony Soprano on his best day. They can call in a favor to any person in a sixty-mile radius on any given day of the week and the favor will be granted."

Jersey may have the Mob. But the South has Women.

Kylie spoke up. "Oh my gosh! I can get her one. When do you need it?"

"I don't need it. I don't need it and I don't want it. I want her to think that I can't find—"

"Remi, baby? This is Nonie. Nonie found you a lamb. Aunt Kylie helped me find one for you. Yes. Yes. You're welcome, angel. Bye." She hung up her cell phone. The room was quiet.

"Your daddy didn't even own a motorcycle."

ACT 3

We picked up Lilly the Lamb at 7:30 a.m. on a Friday morning.

She looked like an angel. But then again, so did Remi.

I pulled up to a farmhouse after a long drive that had taken me completely off-the-grid to a place called Ruby Ridge. I had no cell service. I was nervous, because I didn't carry a gun. And although David had offered to buy me pepper spray one time, I told him no one kidnapped plus-size women because it was too much work. But now I had no idea who was going to walk out that door. All I knew was that he was a single guy who lived alone and had recently lost his job for "reasons unknown."

I imagined the introduction: Remi, Leather Face. Leather Face, Remi.

The front door swung open and out walked a man with a lamb on a leash. I figured I was in the right place.

"Hi, I'm Melissa and this is Remi."

"This is Lilly. She's nervous."

"Hi, Lilly. Can we pet her?"

"If your skin's not too hot."

Wait. *What?* That was an odd answer. I felt like that was odd. Did anyone else notice that was a really odd answer?

The minute we started to pet Lilly, she nuzzled her sweet little face into Remi's armpit. Remi started to laugh.

"Okay, well, do you have any instructions for us? Do I need to feed her while—"

"Never. Feed. Her."

"Oh. Okay. No food. Got it. Um, will she need water?"

"Ma'am, we all need water."

"Yep. Yep. Yep. That's true. So yes to water."

"If you get thirsty, she'll be thirsty. Just gotta think of it like that."

Maybe I just didn't know how people who evaded the government and its man-made laws normally talked. Maybe this was how people with a "pioneering spirit" answered questions. I had to assume this was simply a normal response for someone who didn't rely on utility companies and had never been to a Sephora.

"So if I need a Starbucks, Lilly will need a Starbucks?" I laughed at my joke.

"Don't even joke like that. Lilly doesn't respond to things the way other animals do."

I checked my watch. I forgot I didn't wear one.

He handed Remi the leash as we walked Lilly toward my car. I popped open the back and looked at the lamb. "Do you have any kind of crate you'd like us to carry her in?"

"Do you like to be in a crate when you ride in a car?"

This guy. "All righty, up you go then, Lilly."

"Well, thank you so much. We'll take great care of her, I promise. Lilly will have a very nice day, and everyone is going to love her."

"If everyone loves you, I 'spect you're doin' it wrong."

If I had not been running late, I might have gone down to his basement just to check and see who he was keeping down there, but I really wanted to go.

As we pulled out of the driveway, Remi begged to sit with Lilly, who, I will admit, was having a hard time standing upright in the back of my car. If we turned left, she fell completely over on her left. If we turned right, well, you get the picture. Her wobbly legs weren't made for standing up in a fast-moving vehicle, so I agreed that Remi could sit with her and try and hold her.

The ride to the school took about an hour and it was full of comments I could barely hear over my music and with all four of my windows

down. I once saw a candle in Target called Lambs Wool and I'm so glad I didn't buy it because it probably smelled like poop. Because lambs smell like poop. Or at least ours did.

I heard things like "Oh my gosh, Lilly."

"Are you okay, Lilly?"

"Lilly, you are being silly."

"Why are you doing that, Lilly?"

I heard giggles and baas, and I was glad that I had actually gone through with it *as if I had any choice at all in the matter.* And I humbly thought to myself how even though there were no winners or losers when it came to Pet Parade, if there were, we would totally win. Everyone else's stupid hamster or cat or wiener dog would never match a freakin' awesome lamb. I put my car in park at the school and the last words I thought to myself were, *Suck it, other four-and-a-half-year-olds.*

And then I popped open the back of my car.

We will take a slight intermission while
I gather myself for what I have to tell you.
Go to the restroom. Grab yourself a Diet Coke.
It's about to get dark.

ACT 4

Lilly had not been fed by us. But make no mistake, Lilly had eaten. Maybe she hadn't even been fed by the Unabomber, but Imma go out on a limb here and say the girl was full. Because a hungry lamb would never—*could never*—produce *that much* feces. It didn't make sense biologically. What I saw defied any explanation. Lilly hadn't just lost a few little lamb pellets here and there. Lilly had lost control of her bowels. Lilly had *come undone.*

"Remi! What happened?"

"Momma, I don't know. She was just sitting here and then she found Rocco's chicken nugget meal from Christmas and then she started making this mess. It just happened, Momma."

"Where did she find a chicken nugget? What do you mean from Christmas?"

"Our car has a lot of chicken nuggets in the seats. It's not Lilly's fault."

Y'all. When I tell you that this precious white lamb, who looked like she could have been on a box of fabric softener, was covered from head to hoof in diarrhea, I am not kidding. She stank so bad that I started dry heaving—which made Remi start dry heaving. The back of my car was covered in spots of excrement; places where she had rolled or dropped or flipped over. Remi had it on her hands and arms and all over the white school uniform top she was wearing. My only option was to just leave. I had to go. There was nowhere at this school where I could clean the poop off a lamb. Plus, parents were already lined up for the Pet Parade, so there was no way I was going to get a good spot. As my mother once said at the end of a very long day, "Let's just call this day a douche." No one ever really knew what that meant—but it sounded like a perfect response for this moment.

But then I looked at Lilly and decided that we were doing the dad-gum Pet Parade if it killed me. I had come this far. I wasn't giving up now. I ran to my glove box and took out a stack of fast-food napkins. I told Remi to run in the gym, clean herself up, and bring me back wet paper towels. I poured my water on the napkins and got to work. My efforts were fruitless. There was no coming back from this. Not to mention that the more I scrubbed her, the more she baaed and the more I gagged. This was not a moment for the faint of heart. This was the kind of moment that makes a woman or breaks a woman.

I grabbed her leash and my lawn chair. I went to the building where the other parents were sitting with their animals. I made a mental note that this was, in fact, not a Parade. This was just a bunch of tired parents and their four-year-olds holding leashes and sitting in lawn chairs

around the cafeteria. This was a Pet Processional. At 10 a.m., the classes would be dismissed to the cafeteria, where teachers would lead their class around to each pet while the 4K student got to explain what kind of animal it was, its name, and interesting facts about their pet.

Remi held the leash while I set up my lawn chair. The last spot I could find was between a beagle named Bevo and a snake named Princess Leia. Both sets of parents eyed Lilly strangely. I introduced myself to them and then said this…

"Look, let's just go ahead and get this out of the way. This is Lilly the lamb. She ate a bad chicken nugget. Now she poops like it's her job. I cannot clean her. I cannot clean us. All of us are just drippin' in it. And now I have to burn my car."

Bevo's dad looked at me and said, "That ain't from one bad chicken nugget."

"Well, I'm not gonna lie, that's a relief," I said.

At 10 a.m. we had our first customer. I will never forget it was the cutest little redheaded, freckle-faced boy named Jack. He walked up to Princess Leia first. He was scared to touch her. Then he walked up to us. He looked at Lilly. He looked at me. He looked back at Lilly. Then he looked at Remi. "What's wrong with her?"

"She ate a bad chicken nugget," Remi answered.

"She smells nasty!"

"Then quit lookin' at her, Jack! You don't even know your ABCs!" Remi answered back.

"Okay, okay, let's not attack him, okay, Rem? He's four. He's also stating the obvious. She looks sick. And she smells sick. He is not wrong. When the other kids get here, let's just say she lives on a farm and got real dirty. Okay?"

"Yes, ma'am."

All in all, Lilly probably met 100 kids that day. Which means that I heard Remi say exactly 100 times, "She wasn't even dirty when we got her from her farm, but then she had an explosion of poop in our car. Now Momma says we're just drippin' in it. So I wouldn't touch her if I

were you." Which means I heard eight different teachers say, "Yes, let's not touch her, class. Okay? Lilly might have a tummyache." Which means I then saw 100 kids reach out and touch her anyway and squeal with delight.

After about 90 kids had seen Lilly and touched her and handled her and screamed things like, "SHE'S MY FAVORITE BUT SHE STINKS!" poor Lilly lay down and took a nap.

Who could blame her?

Act 5

Here's a word problem:

If 100 kids saw Lilly, and 90 of them saw her standing up and baaing, then that means that probably 10 of them saw her…dead.

That's right. Lilly didn't just take a nap. Lilly died.

Lilly the Lamb went and FREAKIN' DIED on me.

She *died*.

As in, she quit breathing and fell over for the very last time. Ever.

As in, she took a walk with Jesus.

The problem is, I wouldn't have known. Do sheep sit? I always imagined them sitting kind of like a chicken that has an egg under it. Do they do that? I don't know! You know that picture of Jesus holding that little lamb wrapped around his neck? Yeah, that's as much as I know about these animals. I know He left the 99 for the one, but I'm telling you right now, that one was not Lilly.

But thanks be to Bevo's dad, who on walking back up from getting a drink, said, "Lilly sure is being still. Have you looked at her… Melissa…Melissa!"

I quit talking to Princess Leia's mom. "What?"

"Your lamb is dead."

"No, she's not. She's exhausted. She just lay down to rest. This animal does not do anything the normal way." I reached down to check on her.

"OH MY GOD! THIS ANIMAL IS DEAD. SHE IS DEAD."
Remi heard me and ran back from trying to get someone's parrot to talk.

"What is it, Momma? What's wrong with Lilly?" She reached down to touch her.

"Don't touch her! Do not touch that animal! She might have something."

Bevo's dad laughed and said, "I'm pretty sure that ship has sailed."

It was right then that the last class of the day walked up. The teacher leading the line had all the children stop at Princess Leia. While the children took turns holding the snake, she looked down at Lilly. Then up at me. "Well, this has never happened at Pet Parade before," she said. Ten sets of inquisitive eyes were suddenly on Lilly. But Lilly just lay there. "Well, class. We got here too late for Lilly. She is exhausted. But Bevo's not. Does anyone want to pet Bevo?"

The class moved veeeery slowly past Lilly. They stared at her like only kids can—like they know something is wrong and they're just trying to piece together what it is, so they can use it against you.

A little boy named Ethan looked at Remi, who was sobbing. "Are you crying because your lamb died? Miss Winters said he's napping. But they don't nap with their mouths open."

EPILOGUE

People always want to know why I just stood there when the last class walked up. My mother asked me why I didn't "do something with it."

Have y'all met me?

I'm not a girl who knows how to fling a dead animal into the back of her SUV, make a quick stop at Target, and then pick up dinner. I'm more the kind of girl who stands still and pretends to be in shock, so someone else will do the heavy lifting.

That night, David and I took Lilly back to Ruby Ridge. When we pulled up, David told me to stay in the car. I looked right in his eyes

and said, "Thank you for coming with me. But know this: If something happens, I'm leaving you here. It's the only thing that makes sense *for me*." He looked me in the eyes and said, "I had zero doubt."

The man walked out of his house just as David was popping open the back. They talked for a while. He looked inside at Lilly. And then he grabbed her up and threw her around his neck, like Jesus did in that picture from Sunday school, only...stiffer.

"Well? What did he say? Was he mad? Should I have gotten out and said something to him?"

"No. He wasn't mad. He didn't say much, actually. He was weird. When I told him about the poop and then her falling over and just dying, he said, 'Oh, man. I bet I gave her the wrong one.'"

"He gave who the wrong one? Me?"

"Yeah."

"Gave me the wrong what? Lamb?"

"I guess. I don't know, Melissa. Did you want me to stay for dinner and suss the whole thing out?"

"Yeah. Absolutely. If it required you eating dinner with him then you should've pulled up a chair. Because, David, I'm not gonna lie. I'm traumatized. I'm going to have to talk to my counselor about this. And saying 'counselor' isn't code for my girlfriends over Mexican food. I mean a real, legit therapist. I'm going to spend hundreds of dollars talking this through on a couch. So yeah, if somewhere over by that red barn is the real Lilly, I'd kinda like to know."

David reached over and grabbed my hand. "Look, it's over now. Just relax. Let's pick up dinner and then I'll draw you a hot bath. Does Chick-Fil-A sound good?"

Blurg.

Note: We have a 2009 Expedition for sale.

Casserole Tears

ON DECEMBER 25, 2005, ON A VERY COLD CHRISTMAS MORNING IN Nashville, Tennessee, a baby was born. He looked just like me, but he was a real loudmouth like his daddy. He screamed and cried at first, but soon, his cries became smaller and smaller. Bless his heart, he tried to cry, but you could barely hear them at all. He fell asleep in David's arms. And he rested comfortably there until David handed him to me. He nestled into me, and I could have sworn I saw him smile. I probably did. Because within minutes, he left me and went to be with Jesus. Who wouldn't smile at that? I would think Heaven, on Christmas morning, would be the absolute best. I'm so glad that was the day he showed up. Imagine all the sweet things he got. I have always imagined that Jesus cut his birthday cake while holding my son. Truth is, babies don't care about onesies and burp cloths; they want someone to sing to them and rock them to sleep. There is no doubt in my mind that as Jesus' birthday was celebrated, my son, Elisha, was passed around to those who had gone before him, and he was endlessly rocked and magnificently loved.

So were David and I. Man, were we loved.

I cannot promise you that every Southern woman is an incredible cook. I cannot promise you that every Southern woman watches SEC football. I can't even promise you that every Southern woman could eat chips and queso first thing in the morning, rain or shine.

But what I can promise you is this: These women know how to care for the broken.

Do they always do it? No.

Are they at times the one responsible for the pain? Perhaps.

But I didn't say, "These women care for the broken." I said, "These women *know how* to care for the broken."

Because all of them have had Southern mommas and sisters and aunts and grandmothers who show up in a crisis and do eight loads of your laundry. They've seen Grandma call her prayer chain and add someone's name to it. They know that when they walk in and Mom's making dumplings, someone has either had a baby or lost a baby. We have seen how to care for the hurting; doesn't mean we always do.

One of my favorite cookbooks is by the epitome of a beautiful, gracious Southern woman, Amy Hannon, and is called *Love Welcome Serve*. I love cookbooks that tell stories about the recipe, and *Love Welcome Serve* not only does this but does it so entertainingly. *Love Welcome Serve* does one other important thing: Amy suggests doubling each recipe as you make it, because someone is always in need of some comforting. Thanks to Amy, I cannot tell you the number of times I've made two chicken pot pies because we wanted one and someone I know had just lost a loved one. I have been known to make two pans of enchiladas because they sound good to us, but also so I could bring one to a friend who just got laid off. The idea of making enough to share with another family is not a new concept; Amy herself will tell you that she didn't come up with this idea. Our grandmothers and great-grandmothers were doing this long before people put brown sugar in their chili.

Because in the South, when someone is hurting or happy, we cry *casserole tears*. Kinda like crocodile tears—but without the bite. I've cried joyful King Ranch Chicken tears over a beautiful new baby and I've cried Steak Tips and Rice tears over the loss of a loved one. I once found out that a friend of mine had just returned home from the doctor with devastating news. It was around dinnertime. So when I ordered from Chick-Fil-A for my family, I also ordered for hers. I showed up at

her house with enough nuggets to keep her children busy, so that we could talk. Later, I told my mother I took Chick-Fil-A and I thought she was going to faint. "This is why you should always have a casserole in the freezer, ready to go," she said.

See? They've shown us how to care. I'm just not sure we always do it.

Casseroles, care packages, and groceries left by the front door are, I fear, a dying art. These tiny ways to show love are so often put off these days. We blame our work, our kid's ballgames, or the tightness of our schedule. We wish we could help! But it's such a busy time. And we make sure they know how earnest we are by checking in on them, via text. *Oof!*

I can tell you that at the ripe old age of fifty, I remember every time someone went out of their way to bless me or love on me or bring comfort to me when comfort was the last thing I felt. I've received flowers or cards and opened my door to The Ultimate Chocolate Cake from Ace of Cakes. I've received invites to a lunch that I thought was being thrown for a friend, only to find out it was for me. I've gotten hilarious T-shirts in the mail, a gift from my Amazon Wish List (that's right, I keep an updated wish list—sue me), and special days planned solely in my honor.

I find that the comfort women give to be the best kind of comfort of all. Why? Because they get it. Doesn't matter if they've battled breast cancer themselves; they know someone who has, so they get it. Maybe they've never gone through a devastating season in their own marriage. Doesn't matter. They still get it.

We hold a superpower in our hand. If we could actually see our ability to provide tenderness and care, a listening ear, or a loving touch—would we withhold it still?

I began this chapter by telling you about Elisha. I had a reason for that.

During this period of time, people came out of the woodwork to love on David and me and in the most beautiful ways possible. But one thing, during that time, stands out to me like no other...

A memorial service was held for Elisha on Tuesday, December 27, at our church in Thompson Station, Tennessee. It was only two days after Christmas, and I hardly expected anyone to be in attendance. But since we had known that Elisha was going to be a very sick little boy, and since we had been prepared for the worst, it had been suggested by our grief counselor that we plan to hold a memorial service in his honor. Elisha was, after all, the baby we finally had after twelve long years of infertility. Elisha was the baby who everyone wanted to be born, be healthy, and be a part of our family forever. People wanted to see a miracle. People from around the entire world had been praying for the health of Elisha Cooper Radke while he was still in the womb. I wanted to be the mom who told the story of this precious miracle who survived when the doctors said he wouldn't. But I didn't get to.

So, on December 27, I walked to the front row of the church in slip-on shoes (for still-swollen feet) and pregnancy clothes (though there was no longer a pregnancy) and pads in my bra (for leaking milk that would never be needed). I walked in with my head down and sat that way for most of the service. Until, at one point during the pastor's message, he said, "Melissa and David, look around at the people who came to be with you tonight."

I lifted my head—which felt like a million pounds—and looked out at over six hundred people who had left their families and their fun, and braved the ice and cold, to show love and healing to two very broken people. But there was something else I instantly noticed.

On the row with David and me were his parents and my parents. Behind us were my Aunt Melba and cousin Meridith, my Uncle Donald and Bubba. There was my Aunt Linda and my Granny, my Pawpaw and more cousins. They filled up an entire row.

And then, I spotted my three childhood best friends.

They were there. They had come up from Texas for the memorial. Their love for me took them twelve hours away from their own families at Christmastime. And pinned to each of them was a small yellow rose.

Before I put my head back down in the position it had been in for days, I looked over to my left and saw my Nashville girlfriends; there

sat Rhonda, Kerri, April, and Kelli. My Steel Magnolias. Watching over David and me, loving us, crying with us, and each also wearing a small yellow rose.

When the service was over and I had numbly hugged hundreds of people, I headed for the exit door of the church, David's hand in mine. My childhood friends, who I called the Golden Girls, walked up beside us as we headed out the door.

"Angela, where did the roses come from?" I asked.

"Your Nashville girls found out we were coming. They had one ready for each of us when we walked in. They said you were the only one from Texas, so you were their yellow rose of Texas. It's tiny and just a little bud because…so was he."

I didn't say another word or ask another question. I went home and went straight to bed.

But that moment has never left me.

One of my friends had remembered who I was. They saw me, not a broken person, not someone barely hanging on, not someone who looked like a hot mess. They remembered who I *was*. And who I would be again. I certainly didn't look like a yellow rose of Texas at that time. But that's who I was to them. It was who I would always be, so they wore those roses to remind me.

But even more than that, they included my childhood friends. These groups of friends had never met before. These worlds had never collided before and, likely, never would again. Someone had to have tracked down the Golden Girls, called and asked if they were coming, and counted how many roses to get. Then they must have introduced themselves to them at the door.

They never brought the roses up to me in conversation. They never said, "Hey, did you see our roses?" Had I not noticed them, they would have gone unspoken, untouched, unmentioned. How thankful I am that I noticed them. Because that small act of love is something that I have never forgotten and, God willing, never will. That kind of love is the kind that women are best known for, especially my women. They love so well, without care for notice or recognition.

Truth is, they are probably reading my thoughts on this topic for the very first time here.

As I was writing this chapter, I texted my Nashville Steel Magnolias and said, "It's a little late to be asking this question, but who thought to bring the yellow roses to Elisha's service?" They told me who it was and it didn't surprise me at all. I don't know if I ever gave her a proper "thank-you." Though a thank-you itself doesn't seem fitting.

What I'd really like to say is...

"Rhonda, thank you for looking past the sadness and the grief of that day, and remembering who I was. Because on that day I wanted to bypass all the pain and all the hurt, I wanted my arms to stop aching from the phantom pains that his loss had brought me. I wanted my milk to dry up so that I wouldn't remember him every time I changed shirts and took Tylenol. But you knew that there was no getting past that kind of grief. You knew the pain had to stick around for a while. And that it would color me and change me, scrape some edges off me, and put me back together in a beautiful, but different, way. You knew that this was life and there is no getting away from the hard stuff. So you made sure that I could look at you and all my other girlfriends and see a small reflection of who I was, who I had always been. And who Elisha was. In your kindness and thoughtfulness, we saw Texas and tenderness and the fragility of rosebuds. I saw where I was from and who I was and what I had and then what I lost. And now that I think about it, I don't think I've ever told you how much that moment meant to me. It has stuck with me all these years. And I will never, ever forget it."

If we knew we held a superpower in our hand, would we do anything about it?

The women in my life—and yours—have the ability to comfort us in our loneliness and brokenness like no one except Jesus truly can. He gifted *them* in this. He gifted *you* in this. He gifted *me* in this. This is not a Southern thing; this is a *woman* thing. This is a Mary and Martha having Jesus over for dinner thing. This is a Mary pouring out perfume for Jesus and washing His feet kind of thing. This is Mary and

Martha grieving over the death of Lazarus and refusing to leave his tomb kind of love.

The women in Scripture who were gifted with empathy, gentleness, and love are still alive and well and reading these words in this book right now. I'm talking about you, friend.

Maybe you never saw care demonstrated. Maybe you didn't come from casseroles and care packages. That's okay. I didn't come from patience and thinness, but we do the best we can with what we've been given. We are never too old to learn to care. We are never too far gone to learn thoughtfulness. It is never beyond us, this graciousness. It is within each of us, given to us as naturally as mood swings and pettiness; we just have to harness it, listen for it, lean into it.

The world and the people around you are crying out for casseroles and tender touches. But are we listening?

We hold a superpower in our hand. It is the ability to care for someone, make them a dinner, deliver them some flowers, keep their children so they can enjoy a date night, sit with them, listen to them, cry with them. Maybe it isn't the coolest thing to do anymore, but it's the kindest. Maybe it seems like care packages and slow moments with coffee and conversation are things of the past, but honey, if mullets can make a comeback, then I'm believing we can bring this back, too.

It just takes some good women learning from good women who watched good women.

It just takes some slowing down.

It just takes some noticing.

It just takes a Rhonda.

But you know what else it takes? It just takes one.

One woman who makes great sweet tea.

One woman who makes a killer chicken salad.

One woman who just texts, "Wanna meet for Mexican food?"

One woman who sends a funny card.

One woman who shows up unannounced at the doorstep of a new mom and says, "Go take a nap and an hour-long shower. I'll be here when you're done."

One woman who sits up at a hospital all night long.

One woman who meets you at IHOP at 2 a.m.

You don't have to have been raised by this woman; you simply must be willing to BE this woman.

And the good news is that this is doable for absolutely every one of us. This is not a difficult test. If you are breathing, you are capable...

Of care.

Of kindness.

And of tiny yellow rosebuds that bloom into a lifetime of thankfulness.

Just do what Effie Bass did! She always cut the Kotex box up and used it as a fan during church because it had roses on it. Bless her soul, she had no idea what a Kotex even was.

—Granny, when her daughters asked her to buy them a fan to use in the summer

Welcome to Swim Gym

IF YOU SOLD ALL THE CATTLE IN TEXAS, ALL THE LAND MY HILARIOUSLY dysfunctional family sits on, and all the jewelry we have among us (which would not be much were it not for my mother), and if you added to that all the money we've ever spent on new hairdos we couldn't fix, pants with elastic waists, and shoes that cut off our circulation, and then for good measure tossed in money we spent on buying cakes at church bake sales, Girl Scout cookies outside Walmart, and drive-thru tamales, it would still not be enough to match what we have spent on our desire to...

LOSE WEIGHT.

Yeah, you knew this chapter was coming.

In the summer of 1999, I drove to Texas from our home in Nashville to visit my family at our lake house. As I sat on a float out in the middle of the water, while my little cousins cannon-balled beside my head, my dad floated over to me and said, "What's on your mind, baby?"

Who asks a girl in a bathing suit, "What's on your mind?" *Duh.* She's on her mind. Every square inch of her.

I looked him dead in the eye and said, "You really want to know what's on my mind? I'm laying here wondering why in the world I'm twenty-two years old and wearing the same swim dress that I saw

Oprah wearing in a recent episode called 'Getting Wet and Wild with Bob Greene and Water Aerobics.'"

"Wow. That's the same one as Oprah, huh? It's nice," he replied. Bless his heart, he didn't know what to say. When women bring up their weight, men are damned if they do and damned if they...Well, you get the picture.

"It's not nice! It's not nice, Dad!"

He started swimming backward.

"It's sad. I'm twenty-two, Dad. She is, like, fifty-two or seventy, I don't know...no one really knows. But this is not nice!"

He swam back toward me, rested his arms on my float, and said words that I will never forget and possibly never forgive. "Why don't you just accept it, Melissa? It's in your genes. My family, your mom's family. We're all big people. Just accept that and move on. You might actually enjoy life better."

I stared at him for a moment before he went underwater and started playing with the cousins.

And then I looked over at the dock. A line of chairs made a half-moon shape across the wooden landing and I looked at my family filling up the chairs. And I mean *literally* filling up the chairs. My dad was right. We were not a small people. If last names were given away based on jobs or attributes back in the 1800s, then can someone tell me how we didn't end up with Widearound, Moretolove, or Badknees? We can only chalk that up to one of God's blessings because I've seen pictures of my great-grandparents and great-great grandparents. And we got out of that by the skin of our teeth.

When I looked at that dock, here is what I saw:

My Aunt Melba was leaning over her chair *trying* to put on her water shoes. I emphasize the word "trying" because she eventually held her foot out and someone had to do it for her. Even in the water I could hear her say, "Hurry. I can't hold my leg up this long."

My Aunt Linda was putting on a lifejacket with zero luck. "Let it out a little more, Jill." Her daughter turned her around, looked her in

the face, and said, "What part of 'I've let it out all the way' are you not getting? Just get in without one. God knows you're not gonna drown."

My mom was reading a *Southern Living* magazine. I asked her where Granny was and she yelled back, "In the kitchen checking on the homemade ice cream! Melissa, you oughta see these summer dip recipes in this magazine. Wanna head to the grocery store with me so we can make some tonight? You'll need to dry off good, though. You know how chapped you get between your legs if you don't dry off good."

I lay back on the float and sighed. And after about five minutes I got out, because y'all know I love a good dip recipe.

Look, I wouldn't say that the South is the unhealthiest place to eat as much I would deem it the hardest place to lose weight. When I travel to Los Angeles for work, you have to look really hard on a menu to find a burger or a chicken tender. When you travel to Texas, you have to look really hard on a menu to find that slices of avocado…cost extra. At one of my favorite restaurants here in my small town, they keep those "avocado slices" in small print on their menu, right beside the words "Please don't pull cash out of your bra. We don't accept sweaty money." This is a true story.

What can I say? People have done it. People in the South have lost weight. I've seen them! Every new year on the cover of *People* magazine in the famous "Half Their Size" issue is inevitably one Southern who is quoted as saying something like, "I grew up putting Ranch dressing on everything but now I weigh my Ranch dressing before I pour it on my green beans. See? You really can have it all; you just can't have it all!" And then there's a picture of a woman walking her dog in her neighborhood with a caption underneath that says, "Instead of bingeing in front of the TV, Amy enjoys summer evenings spent walking her dog."

But lean in close, y'all: Amy's a liar.

And say all you want to about us Southerners, but we can't stand a liar. Ask me how I gained weight and I'll tell you the truth: I was mistaken for a schoolteacher in the sixth grade and everything was pretty much downhill after that.

I didn't date.

I didn't go to homecomings.

I never went to prom.

I was never delivered a Valentine carnation during the last class period, even though they only cost $1 and our sixty-year-old Spanish teacher who refused to wear a bra had a desk full of them.

I was a seventeen-year-old in a forty-five-year-old's body for my entire teenage existence. What do I mean by this? You know how we had a *Cool Coastal Grandmother* aesthetic in 2024? Well, I had *Linebacker Aesthetic* in 1988. It means I was built like Dick Butkus in the fifth grade.

I was not attractive.

I was not confident.

And I was never anyone's girlfriend.

But you know what I *wasn't*, Amy from Tulsa, Oklahoma? I was not a liar.

You say that you enjoy summer evenings spent walking your dog? Lie.

You say that you'd rather walk your dog around your neighborhood than binge Netflix? Lie.

I live in the South, too, Amy from Tulsa, and you and I both know it's 112 degrees in the shade in the summertime. And between the humidity and the heat and your thighs rubbing together—you're just asking for trouble! So instead of starting a fire, you bring Dante the Doberman inside and you watch true crime documentaries on Netflix. Don't be ashamed of this. We all do this, Amy from Tulsa. Let me tell you how I know…

"Welcome to Swim Gym!"

"Are you really going to stand on the side of the pool and talk to us like you're an actual water aerobics instructor? Or are you going to get in this water and work out like we are?"

"Meridith, could you hush and let me lead this class? It's not like you're actually paying me."

Meridith rolled her eyes. "Melissa, I am not going to let my mother fix my hair and I am not going to let you teach me how to get in shape..."

My Aunt Melba whined, "Hey, I can fix your hair. If I had to."

"EVERYBODY, SHUT IT. Your point has been made. I will get in the water. But I'm still the one who googled all the moves so y'all have to do what I say. Okay? Now, who's ready for water aerobics??"

"So we are doing water aerobics? Because the text you sent me said we were invited to Water Erotica. So if this is water aerobics, I'm disappointed," my Aunt Melba said.

"Stupid autocorrect. It was supposed to say water AEROBICS."

"I'm not nearly as interested," Michelle said.

They gripe and moan, but they love it.

Me and my Chicken-Fried Women have been doing Swim Gym in my pool for the past five years. Our numbers are different every year. Sometimes it's just me and Aunt Melba and Meridith and Michelle. Sometimes Granny joins us, but she just sits on the steps and asks Michelle if all the spider veins in her legs hurt. One year I made the mistake of asking two of my best friends, Janet and Ashley, to join, but my family was furious at me. So they formed a new rule that no one smaller than us is ever invited to take part in Swim Gym. Now it's for family only. With the exception of one. My mother. She "doesn't do water."

Her words, not mine.

You never know who's going to show up to Swim Gym, as we attend when it's convenient:

The water can neither be too hot nor too cold.

It cannot be too late in the evening, nor can it be too early in the morning.

You can have already eaten dinner, but not too heavy of a dinner.

You should absolutely come if you have a big summer wedding or party to go to or after you've just gotten back from a (fattening) vacation.

We attend Swim Gym as if we have the capacity to lose tons of weight just from getting in the water and doing a rocking horse. But here we are, five years later, and we all look the exact same.

In case this is something you want to start doing with your women, I will tell you how we do it.

First, we get on Pinterest or Google and we look up water aerobics moves. We don't warm up slowly and then work our way into these moves. No, we just get in the water, splash around, and start kicking our legs like we're fighting for our lives.

At some point someone's swim dress will get in the way of the someone else. We will ask her to tuck it into the bottom of her swimsuit. She will try, God help her, but it's hard because there is so much fabric.

After we have done the hard cardio parts, we will each grab a pool noodle. You are responsible for bringing your own pool noodle. They are available at every Dollar General store that you pass, but Michelle will still say that she was just too busy at work to stop and get hers so does anybody have one she can borrow? This will make us mad because now she owes us $1 and we know we will never see that dollar again.

Next, we move into our noodle work. This can be a tricky part of the workout because it leads to a lot of what we call "dirty talk." This is mostly led by my Aunt Melba. I will say, "Everyone, put your noodle between your legs and we are going to all follow each other around the pool. After a few minutes, we will all turn and go the other direction."

"Meridith, you know how long it's been since I had a noodle between my legs?"

"Mother! Gross. I don't want to hear your noodle talk."

"Michelle, what about you? Do you want me to tell you how long it's been since I've had a noodle between my legs?"

"That's because you're single, Aunt Melba," Michelle says. "But what about me? I have access to a noodle every day and I still don't—"

"All righty, that's enough noodle talk, thank you all very much."

"It wasn't me. It was my mother!"

"Let's try an exercise that, hopefully, sounds a little more PG. Let's take the noodle that's between our legs, and lift our legs up and pedal like we're on a bicycle. We are actually going to ride our noodle. And we're going to need to ride that noodle hard."

"Seriously, Melissa? This was your attempt at PG talk?"

"Do y'all have any idea how long it's been since I rode—"

"STOP!" we all scream at once.

My Granny interrupts us from the steps: "Melissa Paige, that mole on your back is getting bigger and bigger. I can see it from here!"

"Thank you, Granny. You can't see your hand in front of your face any other day of the week. But you can spot a mole on my back all the way from the steps? That's nice."

"Why don't you swim over here and let me see if there's something inside it."

"No, Granny!"

"Not in the pool!" Meridith yells.

My mom walks out of the house. "Are you talking about that thing on her back, Mother? It looks awful, doesn't it?"

"Mom, if you're not participating, you can't stand out here and judge us. So either stop talking about my mole, or get in."

"Can we stop riding the noodles now? And that's not a sentence I ever thought I'd say," says Aunt Melba.

"See? Swim Gym is not easy. Water Aerobics is a very hard way to train. It's not for the faint of heart," I tell them.

"Yes, it is. That's why they invented it. Because it is literally for the faint of heart. We are the youngest people I've ever seen do water aerobics. Besides, I haven't had dinner and I'm starving."

"Fine, Meridith. Then we can all stop pedaling and let's just walk it out in the water. Just walk it out, ladies."

Michelle says, "If you're hungry, then don't walk in Melissa's house. I walked through her house to get to the pool and it smells good. What did you make for dinner?"

"I made chicken pot pie. It turned out so good. Let me see if David is in the kitchen...DAVID!"

David walked out the back door and glared at me. "Do you have to do that?"

"Yes, I want you to bring that whole chicken pot pie out here and let everybody taste it."

"While y'all are in the water? And supposedly working out?"

Meridith looked at him, disgusted. "Don't police us, David Radke. We're just walking it out right now anyway. Go get the pie, bring a fork, and nobody gets hurt."

David brought out a chicken pot pie wrapped in pie crust and we each took a bite. I could see the irony of what was happening here. These were my people. And they were never going to be tiny and I was never going to be tiny, and we were all going to love Southern food for the rest of our lives and probably die riding the noodle.

"Okay, y'all. Do you want to meet again on Thursday?" I asked.

We all agreed that we would meet on Thursday, after choir practice, at 8:15 p.m. Which was late for those of us who worked. As we were mulling it over, my mom walked back out of my house.

"Y'all sure are cute doing your little exercises and eating chicken pot pie."

"Annette, why don't you ever come and take the class with us?"

"I wouldn't exactly call this a class..."

"I beg your pardon," I replied. "I learn moves and I do a count and everything. Tonight we worked with water weights and we rode noodles."

"Ohhhh, well, if I knew y'all were doing water weights, I might've come."

"Really?" Michelle asked.

"No." she replied. "Y'all know I don't do water. My joints hurt too much…"

I had logic she could not ignore: "Water's the best thing for that."

"…my knees ache…"

"This puts no pressure on your knees."

"…and my back is so messed up."

"Your back will feel so relaxed."

"Melissa Paige, shut up! I don't do water and I don't have to explain it to you. I came over to bring my grandbabies some chocolate chip cookies. But I didn't bring enough for everybody."

"We'll be here Thursday night at eight fifteen. Can you bring some then?"

"Why are y'all working out if you're just gonna eat cookies afterward?"

This felt like the dumbest question in the world. "We work out so we *can* eat cookies."

"Fine, I'll bring y'all some cookies on Thursday night. Meridith, I'll leave some raw for you."

After she left, we all agreed to meet at eight fifteen. Since it was so hot, we'd let our kids come and swim in the shallow end. "But we won't tell them about the chocolate chip cookies and they cannot play with our noodles!"

"Melissa, do you have any idea how long it's been since I played with a noodle?"

Class dismissed.

But look, Swim Gym is just the latest thing we've tried. There have been so many other "things":

Programs

Meetings

Foods

Recipes

New stuff

Old stuff

Stuff that my cousin Randi Jean tried and lost twenty-five pounds

Gym memberships

Workout classes

Cooking classes at the Rec Center

Diets that my cousin Randi Jean tried after she gained back thirty pounds

Pills

Bottles

Shots

Weigh-ins

Hypnotization tricks that my cousin Randi Jean tried

Shakes

You name it. We did it. Or at least, we tried.

For years, my Granny was a card-carrying member of TOPS, which stood for Take Off Pounds Sensibly. She was the biggest loser in her class one month and was awarded a pig magnet, which went on your fridge and actually "oinked" every time the refrigerator door opened.

Meridith and I even decided once that we would sign up for a dance class at the Lufkin Rec Center. Dancing had helped my cousin Randi Jean lose twelve pounds, before she gained it all back on Nutrisystem. We went down to the Rec Center the first night of class.

"Welcome, everyone, I'm Miss Anita," a tiny woman in Spandex said to us. "Tonight is going to be so fun. We will be doing an old Southern style of dance called clogging. Has anyone in here ever clogged before?" Only a few raised their hands. "Awesome. We clog with taps on our shoes. Isn't that cool? I am now going to pass out some taps that you can easily stick on the bottoms of your shoes. I'll be coming around to help anyone that might need a hand."

How hard could it be to put taps on your shoes? But then again, except for Meridith and me, no one in the class was over twelve. Imagine, if you will, an entire class of prepubescent teens who weighed in at sixty pounds and stood maybe four-feet-five? Meridith and I looked like King Kong taking the city. We didn't know whether to tap our way out or beat our chests.

We should have tapped our way out. Miss Anita started teaching steps to the girls and they picked them up with ease. Meridith and I? Not so much. Twice I almost fell. The little girl to my right look terrified every time I stumbled. Once she put up her hands and said, "I feel like you're gonna fall over on me."

"Oh, please. Look at me, I'm light as a feather. Now quit looking at me."

The little girl behind Meridith whispered, "How are we supposed to see anything?" and unfortunately for her, Meridith has ears like a bat.

"What is it you wanna see? Huh? Me clogging the crap out of you? Because I can and I will."

Miss Anita made her way back to us. We figured she was going to teach us some more difficult, more advanced moves, but instead all she said was, "When we start the music and we begin to swing our arms, can y'all not swing your arms as far out as the others? I'm afraid your wingspan will affect the other cloggers. Thank you, ladies."

"Miss Anita can suck it," said Meridith.

"For real. Wingspan *this*, Miss Anita." I tried a trick move, but my tap was too slick on the cement floor and I fell. Meridith started laughing and tried to help me up. Y'all, I couldn't get up. The very absurdity

of the moment hit us and we started to laugh. I could not—even with the assistance of another grown, human adult—get up. Several of the tweens gathered around us and started trying to help me.

The way they looked at me. It was like when Naomi Watts finally sees Kong and although she's terrified, she also feels sorry for him. FYI: in this analogy I am not Naomi Watts.

"Is everyone okay back there?" Miss Anita called from the front of the room.

"Clogger down," Meridith replied.

I did that really unladylike thing where you lift your body up by planting your arms on the ground and you think about what you'll do when they just snap underneath you. You know that move? Yeah, I did that and made my way up.

Miss Anita put on a blues song called "Highway 101." Little girls all around us started to double toe, step toe, heel and drag. But Meridith and I didn't. We couldn't. The taps were tricky. The floor was slick. And circling our arms about three times in full rotation, we couldn't breathe. We clogged our way to the back corner of the room and out the door. But not before we heard the same little girl say, "Good! Now I can actually see the teacher."

"I can come right back, *ANNA CLAIRE!*" I grabbed Meridith's arm and dragged her out.

In 1994, my Aunt Melba was in a terrible accident and had to have reconstructive surgery on her face. Her jaw was wired shut for six weeks. She was on a steady diet of milkshakes and, well, that's it…just milkshakes. The doctor told her she was the only person he'd ever seen gain eleven pounds with their jaw surgically closed.

In 2002, my mom did Atkins. She lost twenty-one pounds. One afternoon, she turned on her television to see a new show premiering

on the Food Network. It was called *Paula's Home Cooking*. That night for dinner she made one of this Southern cook's recipes: something called Brown Sugar Bacon. She felt conflicted about this. The last several weeks of her diet, bacon had been good…so why did she feel so bad? She gained back eight pounds that night and quit Atkins instantly.

In 2017, Michelle raved about the newest Zumba class being offered downtown. "You need to try it, Melissa. You really need to try it. Have I told you how fun the teacher is? He is so fun and he can dance soooo good and you should try it. I really feel so much better every time I do it. You should go with me." ~~I am probably the worst dancer you will ever see.~~ My cousin Michelle is probably the worst dancer you will ever see. I couldn't take my eyes off her! She was right—I was so glad I had come to Zumba with her. Watching her dance to a completely different rhythm than the one in the song was the best thing I'd ever seen. In between the songs, she leaned over to me, wiped the sweat off her forehead, and said, "I can tell I'm already losing weight. I can see myself doing this for years. I love it that much." During the next song she overheated, fainted, and dropped to the floor like deadweight.

She never went back.

In 2015, Meridith and I tried a spin class. There were four people total in the class that night: the teacher, us two, and one other woman, who looked amazing in bike shorts. We had never been to a spin class before. After fifteen minutes, Meridith said she could not take another second of it. Her exact words to me were, "I feel like this bike is taking me out back and trying to get me pregnant." Right as the instructor said, "Let's kick it into high gear, ladies, because we are going up a hill!" Meridith and I slowly got off our bikes and walked out the door. We had to cross at the front of the room, past the other student and the instructor. When there are only three students in the class, this is a noticeable thing. The last words we heard him shout to us were, "Hey, I go to church with y'all! I knew I recognized you ladies. See you on Sunday!"

We canceled our membership the next day.

I currently go to a workout class every morning at 6 a.m. I wake up at 5:30 to get dressed, put on a sports bra the size of an SUV, and drive to class. I am not a morning person. I don't feel like this is something I have to tell people. I feel like it's something they would know just by looking at me, like you would know someone's hair color or whether they wore glasses. The fact that I've been attending this class for well over a year has not changed the fact that I am hardwired to be a stay-at-home dog mom who sleeps in until around 10:00 and then gets up to watch "my stories."

When I walk into the gym, the 5:15 a.m. class is just getting out. Those people are *gym people*. They like to tell you to have a great day. They like to say things like "Good job, Hank" or "You killed it today, Erin." And they do this thing where they fist-bump the people coming into the next class, as if to say to us, "Yay! You're here. Have a great workout." I refuse to play this game with them. I won't be manipulated. I won't fist-bump them, and if they tell me "Good morning, Melissa," I have been known to say, "Go butt a stump." Now I can go into my morning workout knowing that no one is congratulating me or encouraging me or even happy to see me. I can work out knowing everyone avoided me and wouldn't look me in the eye. And, I believe, this is how it is supposed to be for anyone working out before 10 a.m.

I work out with two of my best girlfriends. These two Chicken-Fried Women are named—well, I wouldn't want to *out* them in this book, so we'll just call them Janet and Heather. (Because those are their names.) One of them shows up happy to be alive, every day. She walks in smiling. She fist-bumps the first class, like some psychopath. She comes ready to work and she wears T-shirts from all the marathons she's run. I won't say which one she is but trust me...I hate her.

The other one is Heather. Heather is more my speed. She is rarely ever excited to get started. She does her warm-ups and her stretching while lying down on the floor. And when Casey, our trainer, yells out, "GIVE ME FIFTEEN GOOD ONES, HEATHER!" she will say things like, "I will give you whatever I want to give you. Quit yelling

at me." She has been known to sit on a rowing machine for three solid minutes without moving a muscle because she "doesn't like this part." I want to get a workout shirt with her picture on it. I think we can all agree that this is the kind of hero America needs.

Do you think my dad was right?

Is the wise thing to just accept who we are and what our DNA says about us—and let it take us over?

I don't know how I feel about this piece of advice. Part of me says fight it. Resist it. Do whatever you can to be better. Thinner. Healthier. Leaner. Able to tie your shoes without getting light-headed. Able to hold a small child in your lap because you have...a lap.

But the other half of me says, "Just lie back and enjoy the ride. Accept it. You don't have to know how everything is going to turn out." (But then again, that's exactly what David Radke said to me on our honeymoon night.) You are who you are. What God has joined together, let no man put asunder. People use that a lot in marriage ceremonies, but I like to think God was referring to our thighs.

Truth is, I have accepted who I am and how I look.

But I've also never stopped fighting for better.

Accepting that everyone in my family is shaped like a circle is one thing. Going down without a fight is another. I love who I am. And I love all the circles in my Chicken-Fried bloodline. And because of both of these truths, I will do my best to live as long as possible on this earth—with them.

Swim Gym is still going on in case you're wondering. We do it every summer. We may not lose a lot of weight and we may still pant at the top of a lot of stairs, but man, do we have fun.

Last summer, Aunt Melba came to our very last Swim Gym of the season with a little surprise. After we had ridden our noodles, splashed

half the water out of the pool, and almost drowned ourselves with the heavy wet skirts attached to our swimsuits, Aunt Melba pulled out what she had brought. I knew immediately what it was and ran inside and got five champagne glasses. Into each champagne glass, she poured wedding punch. No, that's not a misprint. She actually made the sherbet and 7 Up delicacy of the South—the punch that has been made in more church kitchens than VBS Kool-Aid.

We all took our glasses into the middle of the pool and raised them in a toast. "To Swim Gym!" I said.

"To Swim Gym!" they replied.

And we clinked our glasses and lay back on our noodles.

"Wedding punch AND a noodle? Now, this is heaven," Aunt Melba said.

Class dismissed.

"If y'all would save that ear wax in a plastic baggie, I'll drive it over to Mrs. Leonard's. She loves collecting ear wax from people and I told her I'd bring her some."

—Granny, while sitting at the table watching us all do ear candles

Mary Louise:
The Original Recipe

MY GRANNY DIED.

I'm writing these words on the heels of her death, never knowing if they will even see the light of day. It's okay. If writing is therapeutic, then Jesus heal me. Because I'm devastated.

Granny always told me that if I ever wrote one word about her, she would kill me. I just figured God took her before she ended up inside the state penitentiary, because she knew this book was coming and she knew she'd be the highlight. Which is funny because she always said she hated being the center of attention, but you have never seen someone become a peacock more than Granny when everyone's eyes were on her.

She was funny, and sassy. She had more one-liners than *Seinfeld*. We wrote down everything she said. She wrote down every one of our names on her prayer list. We adored her. She knew it.

And lest you think I am going against my grandmother's wishes, I am not. She said she'd "kill me" like she said a lot of things she didn't mean. Or at least we hope she didn't mean them.

When I first started traveling and speaking for a living, the sizes of my audience were small. My first big crowd—by my standards—was

a women's event with four thousand women. I asked Granny if she'd like to go with the rest of the women in the family who had seats right up near the front, and she looked me dead in the eye and said, "I have to listen to you talk all the time. I'm certainly not driving out of town to do it."

See why I think she said a lot of things she didn't mean?

That comment didn't offend me or hurt me. That was just my Granny. And she was Granny to so many other people as well, many who weren't even family. She was Granny to the mailman and the sheriff's deputy who she kept on speed dial becomes sometimes her cows would get out. She was Granny at church and to her neighbors. But then of course she was Miss Mary at Massingill's Meat Market (or as she so lovingly called it, "the meat hut") and at the public library in her genealogy class.

There was only one person who referred to her as Mary Louise, and that was my Pawpaw, the man who loved her until the day he died.

Mary Louise Robertson moved into a house down the street from Elbert Leroy Willmon when she was fifteen years old. She said the day that her family moved into the house, she got tired of moving boxes, so she set out on her bicycle to see this new town she now called home. She had driven by a few shanty houses, but mostly woods, when she drove by a house filled with kids and laughter and even music. She slowed her roll (as the kids say) and noticed a few of the boys out in the driveway working on the car. And to say they noticed her was putting it mildly.

Mary Louise was tall and built like a brick house. At first glance, you may have thought she was Hawaiian—though she'd never even been out of the state of Texas. Her jet-black hair accentuated her pretty smile and mischievous eyes. My Pawpaw says the first thing he noticed about her was how beautiful she was. He also said, "And I rarely had to tell her. Trust me, she knew it."

Day after day, Mary Louise rode down the road on that bicycle, and although he might have been fixing cars, playing basketball, or

sitting on the front porch, as soon as she noticed him watching her, he said she'd stand up on her bike and pedal away. By standing up on the bike, she could easily sway her hips, and well, that's pretty much all it took.

My Pawpaw had come from the kind of woman who could spank a kid and hang clothes on the line at the same time. Because of his mother, he never missed a meal, never had a hole in his pants, and never missed a Sunday singin'. But then he married my Granny.

Betty Homemaker, she was not. Even in 1947, Mary Louise wanted a career. She taught her kids to cook and clean and handle everything related to homemaking, so that when she walked in from working at the post office all day, she could relax. And it worked! At thirteen years old, my mom was making homemade meals and setting the table. But on the weekends? Granny cooked. Sorta.

Until the day she died, we enjoyed going to Granny's to eat because we never knew what she would make, and we were almost positive it would taste bad. One day I sat down to sliced peaches, a roast, four tomatoes, a block of cheese, and two broiled wieners. Can you believe we enjoyed this? But *she* was there...and she is really what we went for.

She did learn to sew...sort of. Mainly she just leaned in really hard to Velcro. If we ever took her anything that needed to be fixed, it had better be torn directly on the seam, or we were fresh out of luck. On more than one occasion, we would pick up pants that we'd brought her to hem for us, only find that she had just rolled the pants up and added Velcro to them. Don't even get us started on the glue gun she got for Christmas.

Is any of this reminding you of your grandmother? Probably not. Grandmothers make cookies and hot chocolate. They hug on their grandkids and tickle and cuddle for movies. Not mine. She was what you might call "unconventional." She didn't make us cookies as much as she would make turkey gravy and ask us if we wanted some of it over bread. She didn't make hot chocolate as much as she told us to stay out of her Dr Peppers. I don't remember her ever tickling us but

I do remember her spanking my cousin Bubba with a hairbrush. And she wasn't a big movie watcher, so she kept the Gaither Vocal Band on repeat. Twelve-year-olds just love the Gaither Vocal Band.

But none of that mattered. She was Granny. She was who we wanted to be with and listen to and laugh with. We loved her. But no one loved her like my Pawpaw. He loved that woman more than life.

One Saturday morning, when her kids were all grown and married, my Pawpaw woke up and walked into the kitchen, grabbed himself a cup of coffee, and sat down beside Granny at the kitchen table. She was sipping her morning cup of coffee and making her Saturday to-do list. She was concentrating on all the things she needed to get done when suddenly her coffee cup was empty. As she got up to pour herself a second cup, he slid the little yellow pad over to see what she would be doing with her day off.

Here was her list:

1. Run by bank
2. Pick up cleaning
3. Drop off at thrift store
4. Sell cows for funeral
5. Groceries

My Pawpaw, who was a rancher, lived on about thirty acres full of cattle. So obviously his eyes were drawn to number four.

"Mary Louise, what is this list?"

"It's all I have to do today."

"No, I get that...but what is number four? It says 'sell cows for funeral.'"

"I'm gonna try and sell your cows."

He sat quietly for a moment. "You're what?"

"I'm gonna try and get rid of all these cows. There's too many of them."

"What on earth for?"

"For your funeral."

"Am I dying?"

"Someday."

He began to laugh, "Mary Louise, do you know something I don't know?"

She never took her eyes off his. And she sat in stone silence.

"Mary Louise, you're not selling my cows."

"Well then, I'm not buying groceries."

And she didn't. Because the truth is, it's unwise to ever try and stop a woman who has determined a plan in her mind—and it was almost fatal to try and stop Mary Louise.

I think it's something that she passed down to every daughter and every granddaughter in her family. What we want, we are hell-bent on getting. We might have to work for it, write for it, or sell our husband's valuables for it, but this is the way of the determined woman.

I offer into evidence, Exhibit A: the morning David left for work and found a stranger on our front porch painting our door.

"I told you we were doing this!" I insisted.

"No. I think I would've remembered this."

"What's the big deal? This guy is here to paint our front door and shutters. Do I have to tell you every little thing?"

"Is this considered a little thing? When it involves our house, I'd like to know, but that's probably just me. I'm weird that way. What color are we painting it?"

"No, I want you to be surprised. He's priming it right now, and then he'll start putting on the color, and it'll be done by the time you're home. Okay? You're going to love it!"

He didn't love it. I didn't love it even more. When I pulled around the subdivision and saw my house, David was standing on the front porch waiting for me. I literally just kept driving. He saw me pull past the house and not make eye contact with him.

Y'all, it was the reddest red door and reddest red shutters that you have ever seen in your life. It was the reddest, shiniest, sluttiest lacquered red you have ever seen unless you've ever seen a dirty movie or bought anything from Frederick's of Hollywood.

I couldn't face David, so I cried as I drove through the neighborhood—and past my own home—two more times. With David standing on the porch glaring at me each trip around. On my third trip, he was at the mailbox waiting on me...

"Get out of the car, Heidi Fleiss."

"I am not Heidi Fleiss. She was a Hollywood Madam."

"Ten bucks says her office is painted this exact color."

"David!"

"I am going to Lowe's to pick out the same color that was on our home just eight short hours ago. Call the man and see if he can come out in the morning and change it back."

"I'm embarrassed to call him. He'll think he did something wrong."

"He did. He listened to you."

"No. I think it's great. I like it. It has grown on me. It'll grow on you, too. Just give it some time."

How could I call him back? Is that what determined women do? Do they just back down? No! They sell cows!

At 6:00 p.m. that evening, I called my Granny. She would remind me of who I was and what I wanted. Determined women, UNITE! I was Melissa Radke, dadgum it, and I wanted red!

"Red? What is with you and your momma liking red? She dyed her hair red two years ago and looked like a hoochie. It broke her daddy's heart. I can't tell you what to do, but people are gonna think you're easy."

At 7:00 p.m., I called the man.

I spent several years in my twenties and early thirties trying everything I could to *not* become like the women in my family. I wanted to be my own person. Pave my own way. Where they were outspoken, I wanted to be diplomatic. Where they were opinionated, I wanted to be open-minded. Lot of good it did me.

But why was this something that I ran from anyway? What was it I didn't want to become? What was it I was hoping to avoid?

Being strong-willed?

Stubborn?

Oblivious to good common sense and the ability to follow a budget?

Look, I can't outrun the facial hair, the flat feet, or the bad knees they gave me...and I can't outrun this.

And the same is true of you.

The women who we hoped we would never end up like are the women who have the gumption, the drive, the daring, and the *mettle* that make us proud in our forties, and make us just like them in our fifties. And make us tough as nails in our sixties. Don't run from this, my dear.

I decided a long time ago that I can forgo the gumption that runs through my veins, or I can hold on to it and let it put food on my table.

I can disregard my sense of determination and drive, or I can embrace it and let it make me brave.

I can do all I can to lead a terribly boring life as opposed to a daring one, but I ask you: where's the fun in that?

And when I describe the women in my life as having *mettle*, I mean it as it is described by Merriam-Webster as evoking "the powerful energy and dark themes of heavy metal music, communicating toughness, intensity, and general, er, badassery"; and I'm embarrassed I spent so many years thinking that was a bad way to live, to love, to lead, to be.

It is as much a part of me as they are. It's as much a part of me as she is.

I was asked to write the eulogy for my Granny. But how do you write words for a woman who has made up such a huge part of your life? In a complete touch of irony, it's hard to find words for someone who was never short on them. You'd think there'd be an endless supply of ways to memorialize her, but, in fact, there didn't seem to be any good enough.

One Sunday after church, I waited at the back of the sanctuary to walk my Granny out to her car. We did this a lot in those last years, when she walked a little slower, talked a little softer. I quietly stood at the back waiting for her to finish praying with a young woman. It was

a picture I don't want to forget: my Granny's hand lay softly on the shoulder of the young woman, who was wiping tears. You can be sure that if my Granny prayed for you even once, she prayed for you every single day. If you made it onto her Prayer List, you were set; this was a big stinkin' deal. Because my Granny was a prayer. *Blessed are they who Mary Louise prays for, for they will be written down on the back of a Christmas card from 1971 and taped to the refrigerator…forever.*

As the prayer time came to a close, she hugged the young woman, and they parted ways. Granny stood and I walked up to take her hand. The first words she said to me were: *"Bless her heart, you know her mother's trash."*

You're telling me I'm supposed to come up with words for that?

Just for kicks, I googled songs about grandmas. Do you have any idea how many songs have been written about grandmothers? It's an insane amount! I could wonder why that is, but I don't have to. These are the women who play such a huge part in our raising. They sit at the head of our families like Tony Soprano at the head of a table. They are firm and fiery underneath. They are purses overflowing with gum and receipts. They are Cadillacs, Marlboro Reds, and flyswatters. They are all the things we'll grow up to be if we aren't careful. And sometimes even if we are.

Sometimes when we think of a Southern grandmother, we think: polished, pretty, and poised. We conjure up images of genteel women sipping freshly squeezed lemonade and sitting out under the shade of an old magnolia.

My Granny was as far from that as you can imagine. She wasn't genteel as much as she was savagely opinionated, extraordinarily smart, and fiercely independent. She wasn't freshly squeezed lemonade; she was morning coffee. She didn't sit out under a shade tree as much as she held court from her recliner.

I personally love the fact that one Christmas she saved all of her Chick-Fil-A sandwich bags for an entire year and then turned them inside out, so that our gifts would be wrapped in shiny silver paper.

I love the fact that she asked me to return the house shoes my mom bought her for Christmas because they didn't fit quite right.

Come to find out, she'd been wearing them for weeks on the wrong feet.

I love that one Saturday she made a huge fuss over how much weight she was gaining because her favorite pair of pajama pants were getting so small on her…she had put both legs in one side.

When her family would gather around the piano and practice songs for Sunday church singing, Granny would scream out from down the hall: "Y'ALL ARE FLAT! AND NOBODY LIKES THAT SONG!"

When her great-grandson, Liam, graduated from pre-K in 2020, and COVID was so rampant, you couldn't keep Granny away. She would not have missed that little drive-through graduation for the world. As her car drove by the preschool graduates standing outside in their little caps and gowns waving at their family members, Granny rolled down her window and threw a dirty sock stuffed with dollar bills and quarters right at Liam's face. Taped to the side of it was a Post-it Note with his name on it, just in case he thought the dirty sock that hit him in the face was meant for someone else.

Whenever I spent the night with her, Granny would wake me up for school by throwing wet washcloths at my face from across the room.

Who needs money when we have these kinds of memories, huh?

One afternoon, not long after we had moved to Nashville, I walked to my mailbox to find an envelope from Texas. There was no doubt when Granny sent you a letter because she had the handwriting of a serial killer. And there, just underneath the stamp, was a bunch of Scotch tape. She had taped something to my letter, but I couldn't make out what it was. I took the letter in the house and here is what it said…

Melissa,

Be good to David.
I hope you are cooking for him.
Are you arguing a lot and wanting to have your way? I hope you
will behave.

I know things are hard for you, but do you see the front of this envelope? That is all you need to have.
Love,
Granny

I turned the envelope back over and began peeling away the layers of tape until I found what was underneath.

It was a mustard seed.

One.

Just one mustard seed.

Put there as a reminder that what we do not have—God has.

What we do not know—God will teach us.

What we cannot see—God will show us.

Out of all the things I acquired from her, and the list is long, this is the way I long to be most like her: I wish to have her faith.

My Granny, my Chicken-Fried Woman, was eighty-nine years old when she died. She died more in Love with Jesus than ever before in her life. Maybe it was because she knew how soon she would get to be with Him. She was such good friends with Jesus. And He, no doubt, adored her as much as we all did. Our original recipe.

Mary Louise Willmon
1932–2021

"You can't squeeze blood out of a TURKEY!"

— Granny, after being told a million times it was a turnip

Shaming by Naming and Why "Melba Joy" Is a Verb

WE CALL EACH OTHER NAMES IN MY FAMILY.

I don't mean like we say "you're lazy" or "you're crazy" or "you're certifiable." Granted, we say all of those things (and so many more…so *very many* more), but we also call each other names. Like, actual names of people we know or have known.

If you say your family doesn't do this, you're lying.

If you say you're not lying, then you have yet to realize they're doing it behind your back…*about you*.

We were sitting around having lunch recently with my mother-in-law. I mentioned that I was going to my Aunt Melba's that night to play games with the family, and I asked Remi if she wanted to go. She then took it upon herself to invite my mother-in-law, which is fine. I've never seen a ninety-year-old playing Reverse Charades, but hey! There's a first time for everything. "Grandma, you're welcome to join us. It's just going to be the family there. We play games and eat breakfast for dinner and the ladies all gossip."

I saw my mother-in-law clutch her pearls.

"Remi! We don't gossip. What would make you say that?" I asked.

"All the gossip that I hear. That's what would make me say that. Oh, but Grandma, don't get the wrong idea. They only gossip about each other. That's why everyone tries to go to Family Game Nights. If they don't—then *tag*—they're it."

She wasn't wrong.

I just think calling it "gossip" seems crass. We prefer to say that we are simply trying to "right all the wrongs in the world"…starting with whoever didn't come to Family Game Night…or the family reunion… or the summer barbecue…or to Christmas Eve. It's harmless. And honestly, it has done wonders for family unity. I haven't missed a single family event in forty-seven years.

Many years ago, David and I went to dinner and a movie with my parents and our pastor and his wife. This pastor and his wife were quite a bit older than David and me, and they were…how do you say…what's the word I'm looking for…thinking, thinking, thinking…*stiff*.

After dinner we headed over to the theater for a movie and popcorn. On the way over to the theater, my mom said, "Pastor Randy, Gene was mowing the yard today with that new mower we told you about. It was so funny, that engine backfired on him, and he about *shot his wad*!"

I'd like to take a moment and say that there was not one single part of me that wanted to write that sentence. It sounds horrible and perverse and completely X-rated, not to mention it has absolutely nothing at all to do with this chapter. But as a truth teller, I must tell the truth! That is what she said. No one in the entire van moved a muscle, certainly not my dad. Or poor Pastor Randy. We sat in complete, horrific silence. Except my mom. She never missed a beat. She just laughed at herself and kept on talking.

If you look up that term in the *Oxford English Dictionary* (and why on earth wouldn't you?), you will find that it dates back to the Civil War and refers to "a plug of tow, cloth…a disk of felt or cardboard to retain the powder and shot in position in charging a gun or cartridge." And if you believe that my mom knew that definition, then I have some land I'd like to sell you. But I digress…

We made our way into the theater to see the newest James Bond movie just as the trailers were starting when what should pop up on the screen but a trailer for a new film called *The Hangover*. No sooner had the trailer ended on a film that was about a drug-fueled weekend of debauchery, alcohol, and gratuitous nudity when my mom said as loud as she could, "THAT LOOKS LIKE THE KIND OF WEEKEND DAVID AND HIS CRONIES WOULD HAVE!"

We never went out with Pastor Randy again.

The weekend that *The Help* came to theaters, all the women in my family decided we would go together. We even got my Granny to go, which was no small feat, since the only movie she'd dared to walk into a theater for was *The Passion of the Christ*. But we convinced her that this was a good movie played by great actresses who were raised in God-fearing homes and all went to a Baptist church together.

One scene in the movie has Emma Stone walking into a room full of rich white women who are stuffy and pretentious and racist. All the Junior League women in the room suddenly get quiet and the music dies down, as the queen of them all, Hilly Holbrook, stands to make a snarky comment. And this was the moment my Granny decided to holler as loud as she could, "WE'VE SEEN HER KIND BEFORE, HAVEN'T WE? REMEMBER THAT FRIEND YOU HAD, ANNETTE? I THINK HER NAME WAS—" My mother elbowed her own eighty-year-old mother in the ribs. "Momma, hush," she whispered.

But that's the thing with my family. They get these ideas in their head about me, or David, or an old friend my mom had in high school, and that's it. It's a done deal. There is no changing their minds. Bring up the comment my mom made about David and his buddies, and she will swear that she stands by that statement because David "wasn't living for the Lord during his early years." So, clearly, he spent time in a Vegas casino while high on roofies and running from a small, nude mob boss.

My mom went to high school with a rich, spoiled socialite named Jackie. Now every time a rich, spoiled socialite graces the big screen,

the small screen, or any screen in between, my family refers to her as "*a Jackie*." Jackie might be bankrupt now. She might be an apprentice at the Mother Teresa School for Saints. Heck, she might be dead. Doesn't matter to them: once a *Jackie*, always a *Jackie*.

One time my Aunt Melba's house got broken into. A couple of weeks later a kid down our road was arrested for a random theft. No one knew his name, so my family called him *Fat Boy*. (Yes, he was heavy. But dare I point out that absolutely no one in my family is a featherweight? Does anyone at all see the irony in this?) We never knew if *Fat Boy* was the one who had broken into Melba's home. But he had been arrested for theft and that was good enough for them. Twelve years later—*TWELVE YEARS*—my cousin Michelle's house was broken into on the same street. My family had accused *Fat Boy* before the sun had even come up.

Fat Boy now lives in another town four hours away. Sometimes during the holidays, he will come visit his family, and he will bring his wife and twin boys. He is neither fat, nor a boy, anymore. Doesn't matter; they send out a text letting us know that *Fat Boy* is back in town, and we should lock our cars at night. Perhaps I should let them know that *Fat Boy* is driving a brand-new Lexus and is clearly doing better than any of us.

Can someone please tell me that my family is not the only one that does this? Do your people have names they use interchangeably with bad behavior? Do they use names as verbs?

Here's what I mean by that.

Do you like to shop? Okay, Belinda.

Have you been known to stalk an ex? Be careful, Jessica.

Get a little too turned up on a Saturday night? Calm down, Hannah H.

Have you made criticizing into an art form? We've heard enough, Effie.

Do you laugh with your mouth wide open? Shut it, Kristi.

And are you bougee on a budget? Well, look at you, Deb the Rodeo Queen.

My mother doesn't have to tell me why she is calling me *Suzanne*. I've heard enough stories about Suzanne to know that *Suzanne* is a verb; and when I'm doing this action, I'm going to get called out. Only my mom can look at me and say, "Let's take it down a notch or two, *Hannah H.*, whaddayasay?"

If anyone else tries it, buyer beware. But my mom can call me that because she and I know what *Hannah H.* REALLY means when she uses it as a verb.

My editor, Beth, tried to tell me that these aren't exactly "verbs" per se, but rather, codes exchanged between family members who have the full intel on said code words.

The next time I need someone to bring a party waaaaaaay down, guess what I'm going to call them? You guessed it! They're pulling a Beth.

Moving on…

I have called my mom: *Linda, Jackie, Jackeé, Claudette, Martha,* and *Donna.*

If I look at my mom and say, "Hey, *Donna*, how you doin', girl," my mom knows that she needs to go check her teeth. See? Donna is a verb. It means check yourself in the nearest mirror. ASAP. But hey, just in case my editor is right, and these aren't technically verbs, they are still words that call us to *action*. Maybe she's right (no one tell her I said that!). Maybe they don't count as action words as much as motivators that move us to action. Either way: DOES SHE REALLY HAVE TO SUCK THE AIR OUT OF MY MOMENT????

What a *Beth*!

Anyway, back to Donna and her teeth. Before anyone writes me an email and says, "Hi, my name is Donna. I went to school with your Aunt Melba in 1971. Are y'all talking about me? I had braces and couldn't help it." Absolutely not. In the South, we disguise our names. We *have to*. We don't have a choice. We whisper a lot of them during church service and we don't want to offend God. ("Did you hear her trying to hit that high note in the choir? She's gonna pull a *Martha* on

us if we aren't careful." "Why are you wearing a hat to church, *Deb*?" "Why do they ask her to pray with people when just last night she was *Hannah H'ing* all over this town?") So, see? We've gotten really good at disguising them so that we can all still go to Heaven.

When my Aunt Melba was asked to edit this chapter for me, she returned it with a few grammatical notes. But on the last page there was one question written out in her handwriting: *Do y'all use my name as a verb???*

And so now, if you wouldn't mind, dear reader, I am going to address my Aunt Melba.

DO WE USE YOUR NAME AS A VERB? No. Not according to my editor. But do we use your name as a motivator? Uh, is the Pope Catholic? Absolutely, we do. My mom has called me *"Melba Joy"* when I show up late without calling or when I don't show up at all, when I hit something with my car, when I have to be reminded who someone is a thousand times before I remember, when I forget the words to a song at an inopportune time, when I stick my foot in my mouth, or when I refuse to like someone based solely on their hairstyle.

But before you get mad, Aunt Melba, you should know I talked to your daughter. She said that she has been referred to as *"Annette"* whenever she comes to a party without offering to bring anything, when she leaves a party early without helping pick up, when she parks in the Fire Lane so she doesn't have to walk far, when she takes a nap in the middle of the day, or when she buys anything off of QVC. So I know you're no stranger to this phenomenon.

Personally, I refuse to believe we are alone in doing this. *Shaming by Naming* is not only relegated to the South. I think families from the North, South, East, and West do the same thing. And it's not unique to my family, so don't even go there with me. In fact, I asked some of the women who follow yours truly on Instagram and listen to what they had to say...

Chelle from Arkansas: My mother-in-law (God rest her soul) was a hoarder. So, when my husband or children start digging through stuff I've already thrown away I will say "alright *Virginia*, let it go!"

Kristina: My husband frequently gets called *Debbie Ruth*, and he knows exactly why I'm saying it!

Jill from South Carolina: When my husband tells a story he gives. every. single. detail. It drives me nuts! So, I have to say, "Get to the point, *Hilda*."

Wendy: "My mother-in-law thinks it okay to talk with her mouth full, but food falls out on her blouse every single time. So, in my house whenever someone spills, we say, 'Nice one, *Sharon*.' And when I'm acting hateful everyone calls me *Jean*. And trust me, no one wants to be called that."

I also heard from one of my girlfriends, Sharon, who lives in New Jersey. I texted her and said, "Hey, I'm watching the Sopranos for the first time. Are the nicknames in Jersey really this explicit?" She wrote back to me and said, "I've seen the Sopranos, and I can assure you, I'd rather be called any of those names than to be called *Marian*. The other day I told my daughter, 'Okay, *Marian*, put on your big girl panties and suck it up.' Marian was my mother-in-law and I assure you this woman would've made even Tony Soprano say his Hail Mary's."

I saw a meme the other day that said something to the effect of *Be careful what table you sit at. If you don't show up at noon, it might be you they eat for lunch.* I'm not quoting here, but you get the picture. Talk and gossip about people enough, and trust me, honey, before you know it—it'll be you on the menu! Well, the same can be true of this chapter. Because if you have to ask if your name is a verb—guess what? Your name is a verb!

I hate to break this news to you, and goodness knows, if you're sitting on the commode right now, you are in no way emotionally prepared—but I'm just gonna tell it like it is, okay? And this is from me, your bestie! Your people? THEY'RE TALKING ABOUT YOU.

Maybe your wig doesn't look as real as you think it does.

Maybe you smack your gum.

Maybe you never let anybody throw foil away because you're cheap and you want to reuse it.

Maybe you like older men.

Maybe you like younger men.

Maybe you only go to church on Christmas and Easter.

Maybe you spit when you laugh.

Maybe you refuse to tithe the church.

Maybe you tell people how much you tithe.

Maybe you ask people how much they made last year.

Maybe you owe $200 in unpaid library fees.

Maybe you sent a mean text about Aunt Hildy to the wrong text thread.

Maybe your bras aren't padded enough, and it always looks like you're going to take an eye out.

Maybe your bras are too padded, and it always looks like you're going to take an eye out.

Maybe you swear you didn't have Botox but you're seventy-three and can't frown.

Look, I don't know what the reason is. It can be big or small, it can mean absolutely nothing, or it can be from a moment that has gone down in the annals of your family's history. I once had an aunt who would needlepoint pictures for us every year because she was too cheap to buy anything. She wouldn't even provide the frame! She'd just yell across the room on Christmas Eve, "I thought that would look just lovely in your dining room, Annette." We called her "Hang-another-nail-in-the-wall" until the day she died. So, as you can see, it doesn't take much.

I had another aunt who drove like a bat out of hell whenever she was in a bad mood. If she hit a pothole, her car would fly ten feet up off the ground. You had to get out of her way quickly, or she would mow you down. Once, when my mom read a news article about a woman who killed her cheating husband by running over him, she said, "Sounds like he married a Sheila."

So let's just end this chapter realizing that we are verbs. All of us. Unless you're a Beth.

But it's up to us just what kind of verb we will be.

"I knew a man who was a preacher and a philanderer. You know you can do anything when you're a Methodist."

—Granny

Playing Bingo, Talking Crime

EVERY YEAR, IN OUR SMALL TOWN, WE LOOK FORWARD TO THE NIGHT of Designer Purse Bingo.

Designer Purse Bingo is a big deal. All the proceeds go to support a local charity, but if you think that's why all the women play, you're wrong. The winner gets a designer handbag. And if you think the designer handbag is why all the women play—you're wrong again.

Look, my town is extremely giving. Show them a need and they will flat *show up*. So I'm not here to tell you they aren't into charity. They are. And it's not like my town is exactly aristocratic; designer handbags are nice, and not everybody in my town carries one, so that's certainly a plus. But the real reason? The biggest reason women turn out for Designer Purse Bingo?

Winning a designer purse and walking back to the table with it to sit with five sore losers.

This is the most fun part. Hearing someone scream out "BIN-GOOOOOO" while eight hundred other women deep-sigh into their fruit tea is the real street drug. Ask anyone who has ever been to Designer Purse Bingo, they want to win—they really do—but what they want even more is to win while their besties *don't* win. Even typing that sentence is so satisfying.

And don't come for my town. This is true of any town that has women living in it. You know it and I know it.

So every year someone in my family gets a table and then all of us women show up and put on our serious faces. We aren't there to socialize. We aren't there to giggle and eat chicken salad sandwiches. We are there to win. We are there to gawk at the Chanel bag and the Louis Vuitton wallets. We are there to play four Bingo cards at one time. We are there for Bingo blackout, four-corner Bingo, one-line, two-line, outside edge, and the letter X patterns.

All except my *mother*.

My mother doesn't need another designer handbag. She doesn't carry the ones she currently owns! My dad gifts her these things, but she just looks at him and says, "I can't tote that thing around. What would people say?" So she carries her quarters in a ziplock bag and her debit card in her bra. I guess what I'm saying is: we all come to win and rub it in everyone's face, but my mom comes to chit and chat and ask, "Do y'all taste apples in this chicken salad? I never trust people who put apples in their chicken salad. They don't have enough chicken and they're just trying to make it go further."

My mom doesn't flaunt her designer bags; in fact, most of them stay in the top of her closet with a tiny orange sticker on the bottom that has my name on it, so that when she passes, no fighting breaks out because I've already staked my claim. Truth be told, it would be just like my mom to win a designer bag at Purse Bingo and, on her way back to the table with her Chanel Tote, to look at a stranger at another table and say, "Well, if this purse doesn't match your hair perfectly. That's the most beautiful color I've ever seen. Is that real? You don't have to tell me, but I sure would like to know. Here, honey, you take it."

So help me, if she ever did that, she would find her chair GONE when she got back to our table. I would *eat that chair* before I would offer it up to her again.

But so far, none of us, not even my mom, has ever been lucky enough to win at Purse Bingo. Not even my cousin Michelle, who has

the most luck with radio show giveaways and social media drawings of anyone I've ever seen. My mom says it's because Michelle didn't get to do a lot when she was growing up so God is making up for it, but I don't think God had a single thing to do with her Jelly Roll pit tickets.

As I was saying…

Every year we come together, hell-bent on winning, but making promises at the table like "Whoever wins, we will be happy for them, and we will congratulate them and we will not talk about them when they get up for more punch." And so far, we have held true to that promise. But it's only because no one in our family has won yet. God help us the day someone does.

But my mom? She has come to chat. She careth not about the winning, only the "fellowshipping."

"B-3."

"Did I tell y'all that I was watching *Homicide for the Holidays* and it was about a man who opened presents with his family and then went to his truck, grabbed a shotgun, and came back in and killed them all?"

"B-1."

"Well, I made Gene come in the room because I'm telling you this guy looked so familiar."

"Mom, you say that about every murderer you see on these shows."

"I-17."

"Melissa Paige, I do not. You're just thinking of the one man who was in my same church choir growing up, and then the homicidal nut that I taught piano to in the eighties. But both of those were true."

"G-48, G-48."

"Anyway, before I was interrupted…I could have sworn I knew his face from somewhere, so I called Gene in, and we think he might have gone to school with Gene."

"Annette, Uncle Gene went to fourteen different schools when he was growing up. How would he even know?"

"Meridith, you can sometimes look in people's eyes and see that they're a killer—and if anyone can spot a killer, Gene and I can."

"Yet you sang 'When We All Get to Heaven' beside one and taught 'Carol of the Bells' on piano to another one? That makes me think your radar isn't radaring."

"Melissa, hush. I hope you don't win a single thing tonight."

"B-13."

"Melba, do you ever watch *Homicide for the Holidays*? That's a good one. It's hard to watch because they all happen at what are supposed to be joyful times. But that kind of stuff really happens."

"No, I don't watch that stuff, Annette. I don't like to let Satan get in my mind like that."

"Oh, but you'll go to opening night of *50 Shades of Sin*."

"Annette, I did not go to the theater to see *50 Shades of Grey*."

No one says a word. We all look at each other awkwardly.

"Yeah, she watched it at home," her daughter said.

"I did watch it at home, and I waited until it came on free so that means all the sex parts were edited out."

"So, it was only an eleven-minute movie?"

"Melissa, hush. I agree with your mother, I hope you don't win anything."

"O-66. O-66."

"Annette, I came over to your house the other day and your playlist on your TV was weird."

"What do you mean it was weird? And what's a playlist?"

"Can you all be quiet? I can't hear him call out the numbers."

"You ain't gotta hear him call out the numbers; you're not gonna win. You never win anything."

"That's rude. I checked in at Weight Watchers the other day and I had lost a pound."

"That's not winning. That's not winning at all."

"I know. I thought they'd at least give me a cookie…"

"Meridith, what is a playlist? And why was it weird?"

"Annette, a playlist is what all you record on your TV so that you can go and watch it later."

"Oh, I know what that is. Yes. A playlist. I'm following you now."

"Well, it was filled with only two things: murder and preachers."

"Oh, it is not."

"Yes, it is. I took a picture of it. (Meridith pulls out her phone.) There was *Murder by Night, My Deadly Neighbor, The Rosewood Massacre, Homicide for the Holidays…*"

"I'm telling you, that's a good one…"

"*The Evil Next Door, When Kids Kill,* and *The Murderer Speaks.*"

"Well, that one is talking about speaking from the grave *thankyouverymuch*…and believe you me, that's hard to do."

I jump in. "Ahhh, my mother's playlist. And let me guess? It was followed by *The Potter's Touch with T.D. Jakes, The 700 Club, Billy Graham Crusade Classics, Gaither Gospel,* and *Turning Point with Dr. David Jeremiah.*"

"Yes! Exactly. I didn't know whether to get saved or turn myself in."

"O-73."

A voice from across the room screams: "BINGO!!!"

"Who said that?"

"That lady over there."

"That's the table full of everyone who works at my dentist's office. Considering how many root canals I've had, they should all be able to afford a designer purse."

"Oh, my word, that reminds me of something. That show *When Kids Kill…*"

"Annette, I cannot hear about kids killing kids."

"Who said anything about kids killing kids? This was a teenage boy who killed his dentist because his daddy was having an affair with said dentist."

"I've wanted to kill a dentist before."

"Why are we talking about this?"

"Because it happened in Louisiana."

"So?"

"And he killed the female dentist because he found out his daddy was having an affair with her…"

"And he was upset for his momma?"

"No! He had a huge crush on the dentist!"

"How many times did this family go to the dentist?"

"The dentist went to their church."

"Wait, was this the one—"

"Yes, yes, yes!" Mom quietly screams and points her finger.

"Is this the one where the boy killed the dentist because she came in and ruined their family, but he was also in love with her, but he found out his daddy was sleeping with her because she was a parishioner in his church, and they may or may not have had sex in the church van?"

Suddenly, none of us are playing Bingo. We all lean in.

"Yes!"

"Is he the mega pastor from Louisiana?"

"Yes. Runs about seven thousand at his church; if you count all the news crews that are now attending while he's on trial."

"Wait. Why is the pastor on trial?"

"Because everyone thought he killed the dentist, like a love affair gone bad—but he couldn't have. Because the night she was killed, he was home...killing his wife."

We all scream, "WHAT??"

"Y'all know me and I would never lay a finger on God's anointed and I don't plan on doing the prophets any harm, per Psalm 105:15, but when a pastor murders his wife...*I love that stuff!*"

"G-48. G-48."

"Annette, that's you! That's you!"

She leans in and whispers to the table: "God's probably blessing me because I'm going to get to the bottom of that murder, if it's the last thing I—"

"Annette!"

"BINGO!!!!" She gets up from the table to claim her prize.

"I had one left. One! They probably called it out, but I couldn't hear 'em for all that murder talk."

"Oh, you loved it."

"I did."

My mom walks back up to our table with the Gucci Marmont Super Mini in black leather. We wipe the drool from our mouths.

"What in the world am I going to do with this bag? I can't even fit a pad in here!"

"Mother, please tell me you're talking about a legal pad."

"Well, I'm not."

"Annette, why are you still using pads and why the heck are they so big?"

"Michelle, this looks so much like you. Baby, do you want this?"

"That bag looks like every single person at the table. It's a black leather bag. Why do you think it looks more like her than any of us?"

"Because she didn't get to travel very much as a child, Melissa."

I stand up and move her chair away from our table. She's not invited next year.

"Y'all, I found a picture of Abraham Lincoln's mother and I'm gonna tell you the truth—she looked just like him, bless her heart."

—My mother. No one knows what she was talking about.

Nick Jonas's Parents
Would Never Do This

One of my dearest friends, Kiara, is a doctor from India. I'd be lying if I didn't say I first thrust myself into her life for the complete and utter benefit of free medical advice. (Look, I'm not paying for someone to tell me my mole is suspicious when I can lift my shirt up in front of a friend—*who has repeatedly asked me not to*—and have them tell me for free.)

Over time she has taught me the beauty of her country in the way that she cooks, and in the way she speaks, and in the way she dresses up to go to weddings. I'm just letting you know ahead of time that if you go to a wedding with her, she will show up in a long, colorful silk sari and gold jewelry and you will feel pretty dumb wearing a maxi skirt and flip-flops.

Kiara and her husband, Aaron, have invited us into their home on many occasions for dinner. It's probably because they think inviting us into their home and teaching us about their culture will help us become better, more well-rounded people. *They could not be more wrong.* Because it won't. If anything, we will become worse people simply because we cannot cook like them or make money like them or talk about smart things like them. Every time we leave their house, I look

at David and say, "Do you have any idea how close I was to becoming a doctor? Any idea at all?"

"Not very close?"

"Right. I was not very close at all. That's not the point. But I could have! And then I would have the money to serve meals on real plates that sit on real chargers! *That coulda been me, David!*"

"No, it couldn't."

"I know. You're right."

I could see the sparkle in their eye as our friendship was blooming. I could see how they looked at us as people with potential. I could tell how hopeful they were that their class and intelligence would rub off on us. But now, after several years of close friendship, I can see in their eyes that they've given up. I see how sad Dr. Aaron becomes when he pulls in the driveway after a long day of saving lives, only to see me in their front yard trying to learn a dance off TikTok with his children. I see how he ushers them into the house while mumbling under his breath, "No TikTok. Back to coding." I mean, they love us. But they won't change us. Bigger people than them have tried. This hurts them, but what can you do? Once you see the hope literally drain from someone's face and they *still* invite you over for matar paneer, knowing all you are going to bring is a bottle of Coke, well, you've pretty much won. So yay me!

A couple of years ago, Kiara called me to invite us over for dinner. But let me tell you how she did it! She invited us over for free food, knowing full well I would accept. Then, and only then, did she utter the words that would make me wish I had never accepted: "We would also like to invite Mr. Gene and Mrs. Annette over as well."

"Awesome! The more the merrier. Who are they?"

"You know who they are. They are your parents."

"Wait. What? No, this must be a bad connection. Are you calling me from Dubai?"

"Dubai is not in India. I am not calling you from Dubai."

"First of all, learn geography. Yes, it is. Secondly, I would like

to revoke my answer—we will no longer be coming to your dinner because you are inviting people that we do not know."

"Melissa, I would like your parents to come as our honored guests and therefore you will need to come with them."

"Ki, hear me and hear me good: I will come. And I will eat your food. And I will probably bring some Coke, maybe a box of brownies, but I will not be happy about it." I hung up the phone and immediately called David, "Ki invited my parents, David. My *parents*! Do you have any idea what this will do to me?"

"No, I don't. I have no idea what this has to do with you or me or us in any way imaginable; it's your parents. We have your parents over for dinner all the time."

"*We most certainly do not.* They have *us* over for dinner. There's a big difference."

"How?"

"Here's how: Ki uses real plates. My mother will notice this and remind me every chance she gets that reusing paper plates is appalling..."

"It is."

"...she will notice that Kiara dresses, actually puts on clothes, for dinner. And she will shame me for wearing sweatpants and refusing to put on a bra when we have dinner at their house."

"And I will remind your mother that at least you *wear* pants at their house!"

"Ugh! You are no help. Oh, and finally, she has asked that my parents attend as the honored guests, David. *Honored. Guests.* I can't compete with that!"

"Why? Because you've never had your parents over as guests or because you've never honored your par—"

I hung up.

I called Kiara back.

"Ki, I just got off the phone with David and that night isn't going to work for us. We are doing surgery on someone."

"What do you mean?"

"What do you mean: '*What do you mean?*' We do surgery. You aren't the only person that does surgery on people."

"Together?"

"Yes, in America that's a thing, Kiara. Don't be racist."

"Okay, well, all I can say is that you are not telling me the truth. And I do not understand your humor, but I love you and you are coming. And—"

"Don't say it—"

"You are bringing—"

"Kiara Rose Jai, I forbid you to say it."

"Your parents as—"

"THIS IS ON YOU, KI! THIS IS ON YOU AND YOUR HOUSEHOLD!"

"—our honored guests."

I seethed.

"Kiara, with every ounce of love and respect and admiration I could ever have for the people who gave me life and bought me New Kids on the Block tickets when I turned sixteen, I say to you: That will be three hours of your life you will never be able to get back."

"Oh, I am so happy. It will be a beautiful night and I will make you all a special Indian dinner."

"No, you do not have to do that. Just let me pick up some chicken."

"Oh, I cannot imagine such things. No one should ever pick up a chicken."

"Okay, the plan wasn't to wander into our backyard and actually pick up a chicken. It was to drive through—"

"Yes, I know what your plan was. I am saying 'no' to it. I want it to be a special meal that I will prepare to honor your parents."

"For what?"

"What do you mean?"

"I mean, what are you honoring them for? Do you know something I don't know? Is it my mom's birthday again?"

"I do not know this. You should know your mother's birthday. I am going to honor them because they are our elders, and we would love to honor them in this way."

"Sometimes I literally do not understand the words you say. Are you speaking Indian to me right now?"

"No, these are words that you clearly understand."

"Uhhhh, no they're not. This is just like the time you told me processed foods do not promote healthy habits. I didn't understand that either."

"Well, I will be making a traditional Indian meal. I would love to have all of you there. We have planned it for next week, yes? Let us keep that date and hopefully you and David can reschedule your duel surgery."

"It's not a *duel* surgery. That would be like we're fighting each other with swords and in scrubs or something. This is at the same time. That's what 'dual' means! We will be doing these important hospital surgeries at the exact same time."

"Okay, I see. Well, I don't believe you so let us keep it at the date we previously decided on before I found out you do surgeries…"

"You guys are not the only smart ones."

"Yes, I know this. I will see you next week as I will need twenty-six hours to prepare the meal."

"See? Those are the kind of Indian sentences I just do not understand."

"Fine. Let me explain it to you in words you will comprehend: Lufkin, Texas, is not exactly the epicenter of Indian cuisine, so I will need to drive to Houston to pick up the ingredients and the spices that I use. Then I will take a day off from the practice, where I work, in order to begin preparing the meal. The meat will marinate, the naan bread will begin to rise, and I will work tirelessly for one full day to make a delicious meal and prepare my home for the honored guests."

"Fine. But you better make a lot of naan. And don't try to fight me on this part: I'm bringing the Coke."

I had called my mom a few days before, not only to tell her about the dinner but to let her know that they would be the "honored guests." I imagined my mom clutching her pearls and whispering in an embarrassed—but absurdly pleased—tone, "What in the world for? We don't expect that! This precious family should be the honored guests in our home!"

Personally, I cannot for the life of me imagine any situation where people would try to outdo someone else by throwing around the phrase "honored guest," but if it was going to happen, leave it to my mother.

"You are the honored guest!"

"No! YOU are the honored guest!"

"No, Miss Annette, I am not. YOU are the honored guest."

"I'm not! I'm not! I've never done anything worthy of honor or respect, I can tell you that. And so can my daughter. Trust me, she reminds me all the time. Tell them, Melissa, how they are more worthy of honor than me."

I immediately made a mental note that I would never make such a fuss about anyone coming into my home, and if by any chance there was ever an honored guest showdown, the title would always go to me.

So imagine my shock when I told my mom about her honored guest title and she loudly exclaimed, "WELL, IT'S ABOUT TIME! I hate that we have to finally be considered worthy of respect by two people who are not our blood, but I'll take what I can get. Their parents did something right. I cannot for the life of me figure out what they did that I didn't do, but at least—"

"All right, that's about enough."

I told her we were disconnected. But she knows I'm a big fat liar.

David and I, and the kids, picked up my parents, and we all piled into my car on the night of the dinner. The six of us pulled up to the Jais' house to find them, all five, waiting for us in the driveway. Dr. Aaron was wearing dress pants and dress shoes, and I punched David in the stomach for wearing an Astros jersey. Kiara, who was naturally stunning, was wearing a sari trimmed in the most beautiful colors, with a big gold barrette holding her hair in place. Beside them stood

their three sons, whose clothing all matched like a perfect picture. I looked around at my kids, and the first thing that came to my mind to say was, "Brush your teeth with your fingers! It works! Hurry! Brush your teeth with your fingers!" As my kids began running their dirty hands across their dirty teeth, I looked at my dad, who always looks like he just stepped out of a business meeting, his suit dapper and shoes polished, and my mom, who was grinning from ear to ear.

"What are you grinning at?" I said as I picked off the cat hair from my black sweater.

"Honored guests know how to dress. Which is exactly why I had my hair done today and am wearing close-toed shoes, Melissa Paige."

As we poured out of the car, the Jais greeted us with handshakes and hugs. The kids ran off to play and we made our way inside the house. Their home was immaculate, and the smell of Indian food filled the air. I was giddy. "Ki, it smells so good. Here's my two-liter." I handed Kiara my two-liter and followed her into the kitchen, where she promptly put it in the pantry and then shut the door.

My mother was about to make a speech. I could sense it. She does this thing where she wants to make sure that everyone can hear her and that she has their attention, so she holds both of her hands out to the side and then swats her hands back and forth like she's either doing the worlds daintiest dog paddle or she's helping schoolchildren line up. "Kiara, I wanted to thank you and Dr. Aaron for having us into your lovely home this evening. I wanted to bring you something to show my appreciation and I thought since you were delighting us with your cuisine tonight, I would bring you some of ours. So here is some homemade salsa that my sister Melba and I make every year and bottle up and people just seem to love. Enjoy it! Give it away! Either one. Won't hurt my feelings." Kiara took the salsa, hugged my mother, and strangely, did *not* put it in the pantry.

For the next few minutes, we stood around and chatted and ate some Indian curry dip that was out of this world. We listened to them tell stories of their trip to visit family back in India and looked at pictures lining their walls.

Finally, we made our way into their dining room. The table was lined with more food than you could imagine. Candles were lit in the middle of the table, and Indian music was playing softly from speakers. Considering the flight time to India is thirty-five hours, and I'm terrified of using the bathroom on an airplane, I have opted out of ever going there, so this was the closest I would ever get. It was gorgeous! Immediately Dr. Aaron began to take each of us to our seats.

"Mr. Gene, we would love for you to sit beside me, here in this chair, since you are our honored guest tonight. And Mrs. Annette, please come and sit beside Mr. Gene. David, would you and Melissa please have a seat here beside Kiara?" He pulled out our seats for each of us, and with each gesture he would say, "Thank you. We are so pleased to have you in our home."

After everyone was seated, Kiara sat at one end of the table and Dr. Aaron took his place at the other end. He explained what each dish was, and he thanked his wife for her work in preparing it. Finally, Dr. Aaron stood from his seat, walked down to the other end of the table, and stood beside his sweet wife, my precious friend. He placed his arm against her back and said, "We are so thankful that you all are here in our home tonight as our guests. David and Melissa have been here many times before, but we are especially grateful that Mr. Gene and Mrs. Annette are here with us tonight. In our country it is such an honor to serve our parents. To break bread with them is a blessed experience because we never know how long we will have them here on earth, so we revere them in this way."

How many times have I said this exact thing to my mother?

And now, fair reader, I will tell you about the next thing that happened, and I will need you to read the words slowly, because in my mind, it happened in slow motion. It will always—for the rest of time—be played out in my mind in slow motion. It's just better that way. Far more dramatic. Charlize Theron plays me. You get the idea.

"Now we will take a moment and say a prayer of blessing…" Dr. Aaron looked at me and nodded.

"…and gratitude. Not only for the food we are about to eat…" Dr. Aaron looked at David and nodded.

"…but also, for the family and loved ones who are gathered around this table…" Dr. Aaron looked at my father and nodded his head.

"…as well as for the elders God has graced us with in our lives to serve as our guides." Again, Dr. Aaron nodded, for emphasis, at the last person seated—*which was my mother.*

And it was then that my mother burst out in a prayer that was both loud and long and…well…how should I put this? NOT HERS TO PRAY.

The man had literally set up the prayer that he was about to pray when my mom took his nod at her as an invitation for her to bust out in the Synoptic Gospels.

Now, let me remind you, he had also nodded at me—and I didn't start praying.

He had also nodded at my husband—and he didn't start praying.

He had even nodded at my father—and he didn't start praying, and he's one of the revered elders they speak so highly of.

Yet none of those things were enough of a dead giveaway to Annette, who began to pray almost before he could even finish his sentence. David dropped his head and closed his eyes; afraid he would laugh. But I couldn't. My eyes stayed open and stared straight ahead at my mother, who was trying desperately to formulate a prayer that went with all of the things Dr. Aaron had been so grateful for. May I remind you of that list?

1. Food
2. Friends
3. Elders

That's right! My mom said grace over the food and my mom thanked God for good friends and then, because nothing thus far was awkward enough, my mom began to thank God for herself. And for

my dad. And for the wisdom and guidance that they brought to everyone in the room. The elders.

I couldn't look away. I know I should have, because in the South, when someone prays, you close your eyes and you bow your head or you risk being put on someone's prayer chain. But I continued to stare at my mom—mouth agape—when I saw my dad reach over and grab her hand. He squeezed it enough that she opened her eyes and looked at him. Only my mother could multitask in a moment like this; all at once she was praying, asking a silent question to my dad with her eyes, rolling her eyes, shaking her hand loose from his grasp, and let us not forget, giving an overabundance of praise for herself.

"And Lord, I ask that you continue to give those of us who are older and wiser, the years to share with them what we have learned..."

I looked over at the Jais, who were praying quietly, eyes tightly closed, and wondered what they were thinking about Americans right now.

Probably the same thing as me.

When the prayer was over, Dr. Aaron thanked my mom for her prayer and then took his seat back at the head of the table. Later on, during the meal, a discussion would come up about the new home that the Jais were building. My dad would later ask if they wanted my mom to come over and bless it. It should have gone down as one of those ice-breaker moments, you know? Where someone says something funny, and everyone begins to laugh and *Yay! We can move past the awkwardness.* Except that my mom took her steak knife and, jokingly, held it next to my dad's throat, which I'm pretty sure an "honored guest" had never done in this home before because both of my friends looked pretty shaken.

That night, when we were ready to leave, and all piled into the car, like *The Beverly Hillbillies*, my mom rolled down her window and began *The Long Goodbye*.

The Long Goodbye is this thing my mom does where she starts eighteen different topics in succession, while waving goodbye and exiting at

the same time. It's hard to pull off so I don't suggest you try it. I capitalized it because it's like a famous chess move that only Russians know about. So if you promise never to try it, I will give you a rundown of *The Long Goodbye.* Starring my mom, as herself…

"Good night, Kiara!

"That meal was incredible.

"I need to get that chicken recipe from you.

"Good night, Dr. Aaron!

"Kiara, do I marinate that chicken overnight?

"Aaron, your new home is going to be beautiful.

"Remind me to give you the number of my drapes guy.

"It was wonderful to see you guys!

"Kiara, how do you spell that marinade again? Ya know what? Email it to me!

"Thank you for having us!

"Gene spilled that sauce on his shirt and I'm never gonna get it out!

"Bye!

"Your children are so well behaved.

"These two in this car could take a lesson from your three.

"Thanks again!

"Good night!

"We are having you guys over next time!

"Yes we are!

"Yes we are!

"Gene will grill us some of his famous pork chops!

"Oh, wait, Aaron, you don't eat pork, do you?

"Is that a cultural thing or a religious thing? Or do you just not like…

"You know what? That's okay, that's okay, that's okay…we'll come up with something.

"But you will be *our* honored guests!

"Thank you again!

"Good night!"

My mom rolled the window up. We sat in silence for exactly 6½ seconds when my dad finally said, "Why in God's name did you pray, Annette?"

"What do you mean, why did I pray? He nodded at me."

"He nodded at all of us. He's a *nodder*. It's his thing."

"I've never met anyone, Gene Lee, who would consider nodding 'their thing.' You aren't making a lick of sense."

"He wanted to pray, Annette. He got up from one end of the table and stood to welcome us into his home and then pray over us—"

"I don't remember it like that."

"—and you busted out in a prayer that spent four seconds on the food and two minutes on how honored of a guest you were!"

"You're crazy. Melissa, tell your daddy he's crazy. Melissa. Melissa?"

I stared out the window and kept my eyes on the road.

Like I did for much of my childhood.

My dad would tell me later that my mom cried the rest of the night out of pure embarrassment and that she was really sorry it had happened, and she did not want to ever talk about it or mention it again and it was off limits to even joke about.

There's no fear of her seeing it here.

She has no idea I write books for a living.

How to Divorce Your Girlfriend

I'M GOING TO LET YOU IN ON A LITTLE SECRET. THE CHAPTER I'M ABOUT to write is a hard one for me. I don't know how to write about it without being really transparent. You see, I have divorced a girlfriend. And as luck (and probably karma) would have it, a girlfriend once divorced me. This subject has hurt me, shaken me, embarrassed me, and matured me. Knowing that, you might want to ask me the obvious question: *Then why are you writing about it?*

It's because I couldn't write a book on relationships between women and not include this chapter. That wouldn't feel honest. So without further ado, and with an immense amount of vulnerability, let's discuss how to divorce your girlfriend.

When I was growing up, it was nothing for me to overhear my mom talking about two women who'd had a "falling-out" and had not spoken in years. And in the South, that's what we always called it: a "falling-out." It wasn't until I started watching *Oprah* in the afternoons that I learned it had another name: estranged.

Estranged—*having lost former closeness and affection, in a state of alienation from a previous close or familial relationship.*

I know you're a grown-up and didn't necessarily need the definition, but it makes me feel better when we're all on the same page.

When I was a teenager, my parents and I would go and spend time with some of their friends from out of town, Kay and Mike. I loved going. They had a girl only a little older than me, they had a cute son, they had a pool. But they also had family. Just down the street from Kay and Mike lived Kay's sister and brother-in-law. If you thought it was fun with just Kay and Mike and their kids, imagine when the other family came over! We kids could barely hear ourselves talk because our parents were laughing so hard in the living room. It was so fun!

And then, it wasn't.

We quit going. Suddenly, one summer, we just quit going. After a couple of summers, I just had to ask. "Why don't we go visit them anymore?"

"The sisters had a terrible falling-out. They don't speak to each other anymore."

"But what does that have to do with us?"

"Each asked me to have nothing to do with the other, and I just cannot stand that kind of stuff, so I'd rather not see either of them. The whole thing is so sad. Hopefully it'll pass."

"It'll pass": how Southern women explain kidney stones, a colicky baby, and relational estrangement.

But what if it never passes?

On a whim, as I was typing this chapter, I looked up Kay on Facebook. In over a dozen pictures she is surrounded by her grown kids and grandkids, at weddings, around Christmas trees, at retirement parties, and holding newborns in the hospital. And in not one single photo—is her sister.

I looked up her sister, too. They aren't friends on Facebook, their children don't follow each other, and there is not a single trace of

evidence that would connect those two women if someone were searching for it. It's as if the other never existed.

Poof!

Sisters.

Memories.

Childhoods.

Just *gone.*

One time, many years ago, I divorced my best friend.

I called her over to my house for what she assumed was a low-key girls' night. We got comfy, and whereas I would normally turn the television on and we would enjoy *The Bachelor*, I decided to tell her that I didn't feel our friendship was a healthy one and that I didn't want to be friends anymore.

I would like to say as a side note that toxicity in relationships is a real issue. Drawing boundaries around ourselves and our children because our mother-in-law is toxic? Real thing. Deciding not to spend Christmas with an aunt who is toxic? Real thing. Deciding to leave your job because your boss is toxic? Real thing. Me deciding that my relationship with this friend was toxic when I had never once complained about this or even brought it up to her? Utterly made up and not at all a real thing.

This wasn't an issue of a healthy-unhealthy relationship. This was me deciding that this friendship didn't *serve me* anymore. It didn't make me feel good. It wasn't all laughs and good times. We were growing up. And whereas most of our years had been fun and outrageous and memory-filled, we were in different seasons now. Our marriages were hard. We were dealing with kids and heartaches and debt. And I wanted her to be fun, fun, fun. And when she couldn't be that for me 100 percent of the time—I determined that worthy of destroying our friendship.

I think there were also some moments of jealousy in our friendship. My friend is funny and creative and beautiful. She lights up a room. And I wasn't confident enough in myself, at that time, to be okay with

that. So I deemed it "unhealthy," when clearly, it was just me who was unhealthy.

For the rest of my life, I will never forget the look in her eyes when I said these things to her. She was blindsided. She was devastated. She cried and asked "Why?" And if memory serves, I never shed a tear. I was righteous and indignant. I sat high on a throne of my own making. I was a tornado leaving brokenness in my wake. I was so pious, it makes me physically sick to think about.

Now, looking back, I wish I would have fallen from my man-made throne, all the way back to earth, bumped my head, and come to my senses—but I didn't. Because jealousy and bitterness, self-righteousness, and pride don't work that way. They do whatever they can to destroy us. Those tiny, intrusive thorns like their pound of flesh, and that's exactly what I gave them. Instead of fixing myself, I decided to fix the one I assumed was the problem. Of course, the problem was never me. Not me. Not ever.

Two years went by without a word from her. We never crossed paths. We never ended up in the same room. We had divorced. Officially.

After some time went by, David and I moved back to my hometown in East Texas and I was faced with the task of making friends all over again.

Doesn't God have a sense of humor?

I could not make friends. I clicked with no one. I tried! I really tried, but I had no luck. There was just not a true connection to anyone, and for one whole year, I was lonely. In Tennessee, I had been surrounded by girlfriends. But here, in this town where I had grown up, I felt so alone. I longed for female relationships; I longed for nights away from the kids and laughing over chips and salsa. I longed for girl talk and secret sharing. And I realized how difficult it can be to make adult friendships.

And for someone like me, it can be even harder to hold on to them.

A year after I moved back to Lufkin, I faced the reality of what I had done to my friend. I saw it so much more clearly. I was so ashamed of my actions. I was so embarrassed at my pride. And my friend? Every

day I missed her more. I also missed who I was when I was with her. I missed laughing with her and confiding in her. I missed that she held me accountable for things I had no desire to be held accountable for. I missed the fact that she had been a much better friend to me than I had ever been to her. On the path to learning how to become a good friend, I had to realize that there was no bridge that could be built in my life until I restored the one I had torched so long ago.

We lived far apart by this time, so I wrote her a letter. And in it I didn't just apologize, I groveled.

Who had I thought I was?

What was I thinking when I spoke those awful words to her?

Who had made me God?

What basis had I had for ending our friendship other than a rogue moment of resentment toward her that I let take hold in my life, my head, and my heart?

Was I better off these two years later? No.

Had I learned hard lessons on friendship? Yes.

Had I learned how to control my mind and not let momentarily fleeting thoughts of anger, resentment, or jealousy uproot an eight-year friendship? I certainly had.

Would she forgive me? I hoped.

I mailed the letter and didn't hear anything back from her for almost six months.

And then one day, out of the blue, my phone rang.

And she forgave me. Like she had always done before, and like she has probably had to do many times since, she forgave me. Now, don't get me wrong, she asked tough questions, which required uncomfortable answers. But in the end, she opened up her arms and her life to me, when she had absolutely no reason, except mercy, to do so. To this day, she is not only one of the best friends I've ever had, but also a beautiful example of what forgiveness really looks like. Ours is a friendship that I think more highly of than most because divorce is not for the squeamish, as she and I both know.

I couldn't go two years without her. How in the world have Kay and her sister lasted half a lifetime? How do people die knowing that there still has been no fixing what was broken? How do we allow an offense to negate years' worth of memories? How do we allow anger to uproot a family?

How do we move on without those we once loved, when those we once loved are still here?

Grief is one thing. Losing a family member or a best friend because death has separated us, okay, I get that. But when the only thing that separates us is miles and mistakes? Misspoken words and misplaced rage? I just can't make sense of it. It seems to fly in the face of everything we believe about God and all He has done for us. I don't ask this question to be manipulative or judgmental to you and your feelings, at all, and I hope that you believe me when I say that. But how do we accept a mercy we did not earn and then refuse to extend the same thing to someone we once loved?

It's like accepting a coat when you're freezing—but then refusing to turn around and give one away.

How do I accept mercy but then refuse to turn around and extend it?

And even if we were not servants of Christ, and even if we had absolutely no understanding of the mercy and grace that has been bestowed to us, what about the memories? What about the love? What about all the fun you used to have?

Don't you miss them?

Don't you wish you could see their grandkids?

Don't you want to go on one more vacation with them before it's too late?

Don't you want them to see how wonderfully your children have grown?

Don't you want to spend one more afternoon laughing until your drink pours out your nose?

I'm not talking about toxic people. Don't write me emails reminding me that you tried to make things right with your sister-in-law but

she's hateful and still wants nothing to do with you. I know these stories are out there; I've heard them. I've read your emails. They break my heart and I wish that wasn't a part of your family's history, but you and I both know these examples are not what I'm referring to.

Look, honey, I'm Southern. I can spot a toxic woman before she gets up and puts her makeup on. And I've gone around the sun enough times to know that God will have to change her because I sure ain't got the time. So, yeah, I know they exist. And if that is why you had to divorce a girlfriend and you feel like the peace it's given to you and your home has been worth it tenfold, then I support you.

But again, this isn't what I'm talking about.

I'm talking about two sisters who exchanged words at the holidays—and they haven't spent another one together since.

I'm talking about when a parent dies and suddenly money comes between the bonds of a sibling relationship.

I'm talking about your college roommate and maid of honor who didn't come to your daughter's wedding and you've yet to forgive her.

I'm talking about cousins who took sides and it cost them every memory from their childhood.

I'm talking about sorority sisters who have had each other's backs for twenty years, but one went through a divorce and nothing about her was ever quite the same. So you quit her and walked away.

A couple of months ago, I had a friend tell me that she needed a break from me. This didn't surprise me. I was prepared for it. Not because I'm a terrible friend. Truth is, I'm not (anymore). But the minute I decided to write a book on female friendships, it was not lost on me that I might have to experience *all the things* a female friendship can afford. I knew (and more importantly, God knew) that I would be writing this very chapter. And I needed to understand this pain from both sides.

So I swallowed my pride and I took it. Like my friend did all those years ago, I sat back, let the tears flow, and felt my heart break into pieces. I thought I might die from the pain for the first few weeks. But

then I did this thing I have gotten really good at over the years: I asked God to teach me the lesson.

What can I learn in this season?

What do You want to show me amid this pain?

How can I grow through this?

And then I waited. He is good to speak and teach and lead. And today, as I'm writing these words to you, I'm waiting and learning so much.

Look. I love my women. I love every memory I have with them and every one I've yet to make. I love that I have been friends with my Golden Girls since we were in the church nursery together. I have not always approved of their choices, nor them, mine, but it has never changed the love we have among us. Is it because we are perfect and have perfected the art of friendship? Hardly. It's mainly because I divorced a friend once and I'll work diligently to make sure it never happens again.

I have sat, as a mediator, between two friends on more than one occasion. All of us working toward putting away the past and pressing into the future; working hard to move past years of pain and heartache that could have so easily been avoided if we had just stepped up to do this work sooner. I have sat as they both cried and forgave and came together. I've left them with sloppy, wet noses and eyes that were so puffy, they could barely see out of them. But they were together again. And they were happy. They had missed each other. Divorce would not get the final say.

And I have sat in on one or two conversations that didn't turn out like we had hoped. Pride wouldn't budge. Knees wouldn't bend. Tongues would never admit defeat. And they left sad, depleted, and unhappy. Because they missed each other. But the enemy won. And once again we find him doing what he does best: stealing, killing, destroying.

Listen to me, dear Chicken-Fried Woman. I could not live with myself if I wrote a book on the women that make up our worlds—on the laughter and the hilarity and the messes (oh, the messes) that we get

ourselves into—but then did not address the heartbreaking elephant in the room that I have a feeling some of you are thinking about right now. And that is this…

Someone is missing.

Someone should be in your memories. Someone should be on your girls' trip. Someone should be at your Christmas Cookie Exchange. Someone should be holding back your hair when you're six weeks along. But she's missing. And you can feel it. You feel her absence deeply.

Then do something about it!

Don't waste another minute. Don't let another day go by that you don't chase after peace and make friends with reconciliation.

When you die, it will not matter who said what.

When you die, it will not matter who got what in the will.

When you die, it won't matter that she did the hurting and you felt the betrayal.

None. Of. It. Will. Matter.

When you go to your grave, your children won't know her children and that part of the family won't come to your funeral. They will not know you died because you haven't spoken to them in years. Your family was dismantled. Are you happy? Will you feel that you won? If so, congratulations. What did you win?

There is a beautiful story in Scripture that paints the perfect picture of forgiveness. Oh, how I love the story of Joseph. His brothers hate him because he is so loved by his father and they throw him in a pit and sell him. They SELL HIM. I'm guessing there wasn't a word for "trafficking" back then or that is the word that would have been used. So I'm asking you to take a second, Sheryl, and consider that THEY TRAFFICKED HIM.

Kind of makes the fact that your cousin Darlene won't bring you back your Tupperware pale in comparison, doesn't it?

Hey, Hannah, I know you haven't spoken to your best friend in three years because she married your high school boyfriend. But Joseph was TRAFFICKED. *Mmmkay?*

I know, Nancy, I know. You refuse to speak to your sister-in-law, who you used to adore, because they took their kids to Disney before you could take your kids to Disney and y'all had agreed to go to Disney together, but my man Joseph? Trafficked. Trafficked into slavery, so…if you could gain some perspective, that would be great.

If you know the story of Joseph and his brothers, then you might remember that Joseph winds up in leadership and authority over them. Joseph serves a king, while his brothers are still shepherds. Joseph calls the shots. And his brothers find themselves in a predicament that really only Joseph—and forgiveness—can solve.

The moment I said Joseph winds up in leadership and authority over them, some of you began licking your lips. Sounds enticing, doesn't it? (Insert maniacal laugh here.)

Oh, Melissa, let me tell you: If I could be in power over Marci, then I could guarantee she would never decorate her third grade classroom exactly like I was going to decorate my third grade classroom—because I'd fire her before she could.

I'm not gonna lie, Melissa, it would feel so great to be in authority over my Aunt Gladys because then I would make her pay for all the times she showed up empty-handed at Christmas dinner. And Thanksgiving dinner. And Easter dinner.

But, Melissa, do you have any idea how good it would feel to see my former best friend begging me for help? Then she would know how I felt in 2003 when I begged her to help me out by going on a work trip with me, but she planned her stinkin' baby shower on the same weekend. I'd show her!

These examples might sound absurd to some of you. But they're not. They are real. There are really women who have been closed off to ever rebuilding a bridge to someone they used to love because of reasons just like this.

And they aren't crazy, petty, *Single White Female* kind of women. They are women just like us. Just like me.

And Joseph is, as far as I can see, the only person—out of all of us—who actually has a legitimate right to be angry and hostile and

scream to the heavens, "THAT REALLY DILLS MY PICKLE!" But he doesn't. Instead, he chooses family. He chooses forgiveness. He chooses reconciliation. And the blessings that God bestowed on him came in the form of healing, freedom, and generational promises for his children and his nieces and nephews for generations to come. The brothers weren't ostracized or publicly shamed. They weren't required to give a pound of flesh. They were brought in, held close and wet with Joseph's tears.

An entire family that would have just been a blip in Scripture. An entire people group that we may never have even heard about if the story had ended, like so many family stories do, with jealousy and retribution. But instead, this family becomes the example of what happens when forgiveness replaces rage, and freedom replaces grudges.

Every misunderstanding needs a Joseph.

Every betrayal needs a Joseph.

Every angry word needs a Joseph.

Every offense needs a Joseph.

Maybe once, a long time ago, you chose to divorce a girlfriend. You chose who would get what memories. You chose who would get what friends. You contacted attorneys and told them your stories. You pled your case. You swore you were innocent. And years later, when the trial was over and only ashes remained, you went on with your life. And she went on with hers. But then you got married and had a baby. Now you have a senior about to graduate high school. Maybe you have breast cancer. Maybe you are a widow now. And you find yourself thinking of her from time to time. Wondering how she is. Wondering how she would care for you and love on you; she was always so good at that. You wish you could talk to her, ask her questions, get the great advice she's known for. You look at your daughter and think how fun and cool she would think you are if she ever saw you and your friend together. Your bestie did always bring out the cooler side of you. You want to talk to her. But you feel like if you call her, then that would be admitting that…

STOP.

Stop right there.

Don't think about it. Just do it. Don't think about what it will feel like and what it will sound like. Just pick up the phone and do it. Too many years have gone by. Too many days. Don't waste another second, not one more minute. There is still time for God to restore all that has been lost. This is the kind of work He specializes in. So stop! Stop reading this book.

Put it down. You can pick it up later when you go to the bathroom.

But right now. You have a call to make, a letter to write, or a drive to take.

Because every relationship—heck, every divorce—is just waiting on a Joseph.

I wanted to end this chapter with a beautiful bow of reconciliation between my friend and me. I wanted to tell you how it all worked out and how we are so much the better for what we learned during this time. I wanted, desperately, to finish this chapter off with these words: "AND THEN SHE CAME CRAWLING BACK..."

But that hasn't happened. Not yet anyway.

But it will.

Not because I'm such a great friend and she will miss me too much. Not because I'm so fun and how is she enjoying one minute of her life without me in it? And not even because she will read this book and it will guilt her into calling me up.

But because she has some Joseph in her. I generally try to only pick friends who do. Women who forgive and move on and pick up right where we left off, those are my favorite kinds of women, and when she and I became friends some fourteen years ago, that was one of the things I loved about her then. It's one of the things I love about her

now. We are human. We fight. We stomp off. We cross our arms and go to our corner.

But I have been a receiver of grace. I have sat on the phone with a friend who I divorced, asking her to forgive me and accept me, and I listened as she said, "I do. I do forgive you. I missed you, too. I missed us."

I do.

From *divorce* to *I do*.

I do forgive you.

I do want to be friends again.

I do want to do life with you.

I do want to meet your family.

I do want to pick up where we left off.

I do want this friendship in my life.

I do want my sister back.

"Then Joseph threw his arms around Benjamin's neck, sobbing… With tears streaming down his face, Joseph kissed each brother, one by one. And after their tearful, emotional embrace, they took time to speak brother-to-brother" (Genesis 45:14–15 TPT).

Everyone needs a Joseph.

"She sprayed me down like a cockroach."

—Granny, about her hairdresser's
overuse of hairspray

The Side Dishes Have
Already Been Covered

IF YOU ARE EVER INVITED TO SPEND A HOLIDAY WITH MY FAMILY, there is something of great importance I think you should know. And before I tell you what it is, you need to know that the word "holiday" is not relegated to Christmas and Thanksgiving around here. What I am about to share with you is true of Easter Sunday, the Fourth of July, Mother's Day, Father's Day, Memorial Day, Labor Day, Earth Day, Women's Day, and the occasional Arbor Day.

Let's get into it...

Upon receiving the invitation to a gathering with my family, you should look long and hard at your calendar and your contact list and make absolutely sure that you will not be invited somewhere else. I know this sounds rude, but I'm telling you this for your own sanity.

Will you get a better invitation than the one to our home? Probably not.

Will you get a more fun invitation than the one you will have at our home? Definitely not.

But will you get an invitation with as many rules, decrees, guidelines, and statutes than the one you must be prepared to comply with at our home? Without question, no.

So yeah, I'd pray about it.

Now listen, my family is fun. They are a lot of fun. And you will be tempted to say "yes" almost instantly…*but don't*. Tell them you'll "look at your calendar and let them know." Saying this won't bode well for you; I'm not gonna lie. They will instantly wish they hadn't asked you because in their mind "who in the world could say no to such fun people and such great food?" You'll see this in their faces, and you'll sense it in their breathing. That's okay: don't be scared.

Walk away with confidence.

Hold your head up.

Pretend you can't hear them saying things like "he's skin and bones…and he thinks he's going to get a better meal somewhere else? I want to see him try."

"She'll let us know? Who does she think she is? *She'll* let *us* know? *We'll* let *her* know."

"They said they'd get back with me. Get back with me? I've a good mind to rescind my invitation. But I loved his mom, God rest her soul, so I won't…this time."

Look, they don't mean these things. My family is full of truly wonderful people. But saying no to one of their meals is like Kim Kardashian asking out my mailman and him saying he only dates postal employees. That's just foolishness. You're not going to find anyone hotter or more famous, Mr. Mailman. And in our case, you aren't going to find a home during the holidays that makes more dishes with butter or bacon as the main ingredient.

And who says no to that?

But like I said, there are rules. Statutes. Unspoken edicts that we don't feel we have to come right out and say, but are understood nonetheless, kind of like my Uncle Richard's sexuality. So here are some long-standing, utterly unspoken, hard-and-fast rules—in no particular order—in case you decide to eat with us.

And I sincerely hope you do. *Sorta.*

Rule 1

If you are from the South, OR ANYWHERE THAT RAISED YOU CORRECTLY, you will want to know what you can bring. This is best handled with a simple "Will you please let me know what I can bring?" Ask this question and then walk away. They will assign you what to bring, you will bring that exact dish and absolutely nothing else, and there will be peace and harmony throughout the land.

What you don't want to do, *what you don't ever want to do*, is offer to bring a specific side dish. Maybe you are famous for your mac and cheese, or your seven-layer salad. No one cares. Don't even mention this. They won't even listen to the words coming out of your mouth. Why? Because the side dishes have already been covered. They were covered back in 1981, and they're still covered by the same people today.

You might think that offering to bring baked beans to the Fourth of July swim party is nice. But not to them, it's not. It's not nice at all. You're implying that that matriarch of the baked beans is falling down on her job—and she's not. She's been making baked beans the way the family eats them for forty years and that's that. Bring Popsicles, you dummy.

Besides, no one knows how you make baked beans. You might not add mustard. You might not add enough brown sugar. Do you caramelize your onions before you add them in? Do you make enough? Which leads me to...

Rule 2

GOD HELP THE MAN OR WOMAN who offers to bring baked beans and then doesn't make enough. I have an Aunt Theresa who I rarely hear from anymore. She brought a small casserole dish of baked beans for Christmas and then she moved away. In that order. She never writes or calls. And every Christmas when we write down baked beans on the menu, my mom inevitably says, "Remember when Aunt Theresa brought enough baked beans to feed maybe two people? I learned my lesson that year! I learned my lesson!"

There are currently twenty-one people who come to our family gatherings. But you must account for the fact that they are growing up, getting married, having babies, and gaining weight every single day. We shouldn't have to point that out. We shouldn't have to say, "Bubba doesn't eat baked beans, but Jimmy does and he eats enough for three people." This is math you should be able to do in your head if you want to come to one of our family gatherings, bless your heart.

I'm not trying to be difficult about all of this, I'm just telling you how it is. I *would* say you just figure out how many beans will feed twenty-one people and then multiply that by two, but if you do that, my Aunt Melba will follow you around the kitchen saying, "You brought enough for an army! Why would you bring so much? You must think we eat a lot. Annette, she thinks we eat a lot, doesn't she? Because she brought enough for an army." So be careful there. "Bringing enough for an army" can be insulting but "Just enough" gets you zero invitations back. The last comment my Aunt Theresa heard around the Thanksgiving table was Meridith saying, "Are the baked beans good? Aunt Theresa made them. I may have to go steal me a bite of them; I just wanted to make sure everyone else got the amount they wanted." I'm telling you, this is why we never saw her again.

"Enough for an army" is insulting, but "Just enough" will not make you any friends. Personally, I would pray to the good Lord that you end up somewhere around "plenty." Plenty is a good word in the South. It means everybody's happy, most had seconds, Uncle Jimmy had thirds, and you may get invited to the Fourth of July barbecue.

Rule 3
And while we're talking about how much to bring...No matter how much you bring, know this: You will not, under any circumstances, take the rest back home with you. Don't even try it.

What? You brought them in a casserole dish that has been in your family for generations? No one cares. Leave the dish and drive!

Leftovers will be divided among households at the end of the celebration day. Everyone will leave with the same amount of leftovers. We

don't care if your family has three big teenagers in it; we don't care if your family is just two newlyweds. The same amount goes to everyone. If you were to say something like, "Can I take a little extra pie because you know how David loves chocolate pie," you will be met with, "And I really like green beans but we barely have enough to give everybody, Melissa. Think about that next year when you make something other than green beans."

Once the leftovers have been handed out, all dishes will be washed and put away in my mother's cabinet. This is her reward for hosting. You brought a pineapple dump cake in your great-grandmother's cake pan? It's Annette's now. Did you ever see anyone ask Tony Soprano if he could get their dish back from Carmela and bring it to the next Mafia meeting? No, you did not. Move along.

Rule 4

In the South, we season. We season everything. And we season a lot.

Maybe you've seen someone on TikTok making a recipe and you notice they are pouring garlic salt out of the open end of the canister. They're probably from Tennessee. I don't even have to look.

Ever seen someone pouring garlic powder, onion powder, salt, pepper, and celery salt into some homemade chicken salad? That's Houston.

Salt, pepper, cumin, oregano, garlic powder, onion powder, chili powder, onions, and minced garlic for chili? Oklahoma.

Salt and a touch of pepper? Delaware.

The famous "Everything but the Bagel" seasoning should've been called "Everything but the Mason Dixon Line," and everyone in the American South knows it. So if you bring a side dish and all we can taste is the side dish, that's a problem.

Rule 5

We will know if you pour them directly out of a can. Or a box. Or a tub. This is a type of voodoo magic that I am not on a professional level with yet. But I'm working on it.

Several years ago, our church had something called Food Truck Sunday. After the service, at the height of perfect spring weather, everyone would file out of the service and head for any and every food truck our small town had to offer. But we found out that there was not going to be any barbecue. *How disappointing to Jesus, y'all!*

Since David Radke makes the best smoked brisket I've ever tried, I begged him to rent a huge smoker and smoke a brisket for the church. We would add my mom's baked beans and my Granny's potato salad. We'd slap some white bread on the plate and voilà! We'd offer a barbecue plate for a fair $10.

The weekend of the food truck event, my Granny got sick and the potato salad suddenly became my responsibility. So I went to Costco, bought eight tubs of potato salad, came home, opened them up, and seasoned the heck out of them. Who would know? I added some more mustard, extra mayonnaise, East Texas pickle relish, more red onion, and extra salt. I even threw in some Old Bay Seasoning. Just *more, more, more.*

My Aunt Margaret, the grand dame of Southern cooking, walked up, got her plate, and went and sat down. After a few minutes, I walked over to her picnic table and asked if she needed anything else. She looked at me through her sunglasses and said, "You drove all the way to Houston for this Costco potato salad?"

"No, I didn't. I made it."

"Don't lie, Melissa. People go to hell for less."

One of our favorite side dishes at both Thanksgiving and Christmas is the corn casserole. Corn casserole is made a couple of different ways, according to the vast internet. But it is made only one way according to Melba and Annette. I make good corn casserole. They rise up and call my corn casserole *blessed.* And when they do, I feel like it's the

closest I'll ever get to being a Proverbs 31 woman. I make the same recipe every time. They know what to expect. I never freak them out by putting in pimentos because my family believes an item should never be put in just for color, and what value does a pimento really serve in a corn casserole anyway? And I can't trust the recipes that say to add sour cream; even Paula Deen says to use sour cream but who can really know for sure? Paula never had to cook for my mother.

Over the years, other members of my family have put their name down for making corn casserole and that never has a happy ending. Just trust me. I've seen those corn casseroles go missing from the buffet table before my dad can even finish the prayer. Everyone plays dumb and then for the rest of the afternoon one of my cousins who "fixed it and tried something new" will seriously think they're losing their mind. I once saw my mom offer my cousin a lorazepam to calm her nerves, saying: "It's okay, honey, sometimes we leave things back at our house when we feel certain we put them in the car. Here, have a nerve pill." I love my momma but she knew good and well she walked that casserole pan out to the dogs.

Please know that it is not because I am some incredible cook that I am the preferred corn casserole maker. It's not that. It's because many years ago I felt the women in my family sidle up next to me, hand me Aunt Margaret's corn casserole recipe, and whisper into my ear, "This is the kind of corn we like. Don't deviate. Follow the instructions closely and we won't have any problems." I did that one year and now I have to make it every year or they'll cut my hand off and send it to Aunt Margaret, the originator of the recipe.

This year, I kid you not, I made it exactly like the recipe says, but instead of two sticks of melted butter, I only had one and three-quarters sticks. They each took turns looking at me across the table and saying, "Your corn casserole tastes unusually dry this year." I rolled my eyes, but inside, I was terrified.

You may have noticed that I've mentioned a few dishes within these last few pages. That's because there are certain dishes that are very important to my family. I'll give you some examples.

Annette makes the baked beans. And we *always* have baked beans.

Melba makes the spinach salad because she adds a true pound of bacon to it, and we don't like it when people skimp on the bacon.

Michelle makes the green bean bundles because none of us really like green bean casserole and Michelle wraps each bundle in a full piece of bacon. And you know where we stand on the bacon.

And Meridith makes the potatoes. And you do not, ever, let anyone else make the potatoes. She adds just enough butter, just enough cream cheese, and just enough…you guessed it…bacon.

And I make the corn casserole.

But what about desserts? Well, my family isn't the biggest on desserts, shockingly. We will eat them and we rarely say no to them, but we don't get quite as picky about them. Unless you're talking about one dessert in particular. The golden calf of desserts. The pinnacle of dessert choices. The zenith of sweets: *The banana pudding.*

Why. WHY. WHY???? Why did I offer to bring the banana pudding one year? What was wrong with me? Was I ill at the time? Did I have a concussion? Everyone knows my Aunt Melba and my mom make the best banana pudding, but I swore I could do better. And I could. Because I knew a lady across town who made a banana pudding that would make you want to slap 'em naked and hide their clothes. *Miss Dorothy.*

I put in a call to Miss Dorothy and placed my order. Thanksgiving morning came and I drove across town to pick up my masterpiece. Oh, my word, it was beautiful. Meringue as high as you could see, and it was warm…*so warm.* Miss Dorothy's glass trifle dish was filled to the brim with bananas and custard and wafers, and honestly, it was stunning. I could not wait to walk in with it and hear the praise and adulation for bringing such a beautiful banana pudding.

But adulation is not what I heard.

Instead David and I were interrogated throughout the entire lunch as to who made the banana pudding. At one point my mom fake-cried in an attempt to break me. But I was like that man in that movie about that thing. I was Unbreakable.

But my kids weren't. Probably because they were eight and ten. And probably because money was involved.

Around 3 p.m. my mother walked up to me. "You ought to be ashamed of yourself. Miss Dorothy? You had sweet little old Miss Dorothy make a banana pudding for you?"

"Who gave me up?"

"I pulled my grandchildren into the pantry and paid them ten dollars each. They folded like a card table."

"Why is it that big of a deal?"

"It's not a big deal. It's a huge deal! And you know exactly why it's a big deal," my mom said and stormed out of the room.

Friends, that was 2017. Since then, my cousin Lisa has bought cookies, my cousin Michelle has bought pies, and my cousin Kylie has never *not* bought anything she's brought to Thanksgiving—and my mom seems perfectly fine with all of it. But that banana pudding? She literally did not speak to me for one solid month. It is a sensitive subject to this day.

I once asked my Granny why she thought it was such a big deal. "Can you explain to me why I'm written out of the will because I paid someone to make a banana pudding instead of making it myself?"

She replied, "I don't know, Melissa. I think your mom has a hang-up about bananas."

I have no idea what that means. And you know what? I'm not gonna push it.

It's been eight years and I'm still trying to get Miss Dorothy's trifle dish back.

"True Forensics" Just Doesn't
Have the Same Ring to It

As I'm typing this chapter, my head is caught somewhere between what I *should* be doing and what I *want* to be doing.

I should be focused on this chapter (Momma's got a due date!), but I want to be watching the latest true crime series on Netflix called *American Nightmare*. Maybe you've seen it? I haven't even started it yet, but considering I have seen two thousand hours of other true crime documentaries, I have a feeling I can sum it up for you right here:

Something tragic happens.

An old police detective is forever changed by the case.

Somebody the victim trusted did it.

Look. I know true crime. My family was crimin' before crimin' was a thing. And if you want to know what that word I just used is, it's what we say when someone is trying to get a hold of my mother and she isn't picking up her phone. She is either "pulling an Annette"—which means taking a nap in the middle of the day—or she is crimin'—which means she's at the tail end of a *48 Hours* and she'll have to call you when it's over.

When I was writing this chapter, I got a call from my mother.

"Melissa, I know this is going to sound silly, but I don't think I want you to write about me watching crime shows. Would it be too big of a deal for you to take those parts out?"

"Well, I've devoted almost three chapters to the subject, so yeah, kinda."

"Well, I just don't want people thinking I'm a psychopath. Because I'm not. Why don't we do this? Why don't you just change the word 'crime' to 'forensics'? That doesn't sound nearly as bad. It also makes me look like I like the science behind it."

"Do you like the science behind it?"

"What do you mean?

"Which do you like better? The murder part or the science part?"

"Well, Melissa Paige, I don't *hate* the science behind it."

I think I proved my point. My mom is no different than all the rest of us who are completely wrapped up in anything having to do with true ~~crime~~ forensics. We set our televisions to remind us when the newest one is coming on Netflix. And if it's disturbing? Don't worry, there are podcasts dedicated to breaking down the case even after the show is over.

A woman falls down the stairs.

Netflix does a documentary about it.

HBO does a series about it.

Podcasts break it down even more.

And my girlfriends and I break it down even further than that, over salmon Caesar salad and iced tea. They didn't need a jury in a jury box. We are the real jury!

So see, Mom? It's not just you. And no, you're not a psychopath. Unless we all are, because it's all of us.

But if you were a child growing up in the eighties? It was awful. True ~~crime~~ forensics wasn't nearly as big of a deal as it is now because there was no internet. So you had to crime the hard way…by book.

And let me tell you why this was terrifying…

Back in the seventies, the eighties, and even the early nineties, murder was written about in paperback books that were available at every checkout stand in the supermarket. And in these books—right in the very middle section—were black-and-white pictures. I don't have definitive proof, but I think the pictures were placed in the center of the book so that you could get to them easily. The pages were thicker, they were a glossy black-and-white, and they were easy to find. And these weren't pictures like *Oh, look, here's a picture of Christian Slater playing Dan Broderick.* Are you kidding me? No, no, no, no, no.

They were pictures of the *real* Dan Broderick or the *real* Ted Bundy or the *real* Diane Downs. And there wasn't a "scene" where you see a gurney rolled out from the house but it only lasts three seconds because of *network violations.*

This was a real picture of a real gurney and a real body in a bag, and sometimes, if I could look at the picture long enough without getting scared, I'd see a foot or hand hanging off the stretcher and out of the body bag. Needless to say, coroners or medical examiners were foot-loose (no pun intended) and fancy-free back in the eighties because sometimes they didn't even pull the sheet up enough to cover the hair. I could see their hair! Talk about traumatized.

And so I would find myself staring at those pics while I used my mom's bathroom, even though she would specifically say, "Do not go in there and pick up that book, Melissa Paige. You are not sleeping in my bed again!" But I couldn't help it! And if you were a child of the eighties and nineties, I'm doubting you could either. Because these books, the kind that were in my home, were written by Ann Rule. And if you know who I'm talking about, then you know that Ann Rule was Satan's Storyteller.

Ann Rule books were all over my parents' house. And my dad hated it. He never was a fan of scary movies, scary books, or even a scary story. My mom, though? *Holy cow.* She could read them and never miss a second of sleep. Nothing fazed her. She would never let me read them, but she had no problem telling me all about them while saying

things like, "I'm not going to tell you all that he did to her, Melissa, but suffice it to say, she died."

I began putting the pieces together when I was about fifteen that, if necessary, my mom could kill someone, hide the body until after a good rain softened the soil, dispose of said body, erase all fingerprints, and concoct an alibi within minutes. She would never be accused of it—she had too many volunteer positions at the church! I used to ask my dad every six months if his will was updated. Bless his heart, anybody could tell you that he'd be the first to go. (*Insurance money.*)

And boy, did the woman have her opinions. She rarely ever disagreed with Ann Rule; you were foolish if you did. But more than once she disagreed with a jury. She would say things like, "They got the wrong man, Melissa. I'm tellin' you. They got the wrong one. Somethin' in my gut tells me—and my gut is never wrong." I believed her!

When I was sixteen years old, I attempted to sneak out of the house at midnight one night. And by "attempted," what I mean is that I put my clothes on under my bathrobe, washed my face, said my good night to my mom, and waited for my friends to pull up at the end of my driveway with their lights off. And they did. Yet at 11:50 p.m., she was still up reading. At midnight, she was still up reading. And at 12:30 a.m., she called me into the living room and said, "Melissa, I am so tired. Please tell your friends at the top of our hill to go on home. And take off the clothes underneath your robe and go to bed."

"UGH! How did you know?"

"The Lord tells me things, Melissa. And there is absolutely nothing you can do or get away with that He will not tell me about. Now go to bed."

So, yeah, this is the kind of woman we were dealing with. When she believed someone was guilty and got away with murder, she could not, would not, be persuaded differently. Take the case of Darlie Routier. You can google her if you want to. I only mention her story because in 2023 new evidence was brought to light in her case and I made the horrible mistake of bringing it up to my mother. "So what do you think about them saying there is new evidence in the Darlie—"

"I'm going to stop you right there. You know how I feel about this case. So I don't care what updates to the case there have been. I don't care if Johnnie Cochran himself comes to my home and tries to change my mind. There is only one update I need and that's the Holy Spirit. And what I felt then—I feel now. That woman did it."

My mom and my Aunt Linda used to put their true crime books in grocery bags and trade with one another. Before they would even buy one at the grocery store, they would call the other to see if they already had it. I can remember my mom asking the woman at Kmart if she could borrow the store's phone for an emergency. I thought something had happened to my dad until I heard my mom say, "Linda Carol, *The Phantom Killer* is out. Yes, you do. It's the one about the killings in Texarkana, Texas. Remember that movie *The Town That Dreaded Sundown*? Yeah, it's that same crime. You know our church secretary lived there during that time. She was a teenager then. Oh yes, she was. You can't even bring it up in her presence, bless her heart. You want me to get us one? Okay, bye." The lady at Kmart looked at my mom and said, "I just finished it. It was sooo good."

One time she walked behind the deli counter to use the phone. This was because there were no cell phones in 1984, so a woman had to do what a woman had to do. Looking at the stunned clerk, she said, "Honey, I'm gonna have to borrow your phone for a minute. *Dead by Sunset* just came out and I need to know how to plan."

When my mom and Aunt Linda found out that a woman named Candy Montgomery was accused of killing her friend with an axe after working at Vacation Bible School, I had never seen anything like it. They pulled out maps. They called people who knew someone who knew someone who had once sung in the same church choir as her. They never missed the news and they took the *Dallas Morning News* the entire year of the trial.

A couple of years ago, two movies were made about the Candy Montgomery case. One night, all the women in my family got together, spread out Mexican food on the coffee table, and spent six hours watching them both. Between Episodes 3 and 4, I asked my mom and my Aunt Melba

what they thought about Candy. They looked at each other, laughed, and then my mom said, "I've worked Vacation Bible School with a thousand of 'em!"

Women?

Axe murderers?

I didn't ask.

One of the things that my mom loves more than life itself is when murders happen in Texas and when murders are committed by preachers. Not when preachers were murdered but, strangely enough, when preachers do the killing. She also loves crimes that happen in expensive neighborhoods and when prison guards fall in love and run off with guilty convicts. These are the stories that absolutely fascinate her.

In 1987, a pastor in Dallas named Walker Railey was charged with choking his wife to death. In a note, the pastor wrote he said that he had a "demon inside his soul." Well, this was all my mom needed to know. He was judged, convicted, and hung in the court of Annette before *20/20* could even finish their program on him. Many years later, this same man was acquitted. My mom could barely speak that night. She sat completely stunned while my Aunt Linda read her the judge's verdict from the *Lufkin Daily* newspaper. On top of all that, Peggy Railey didn't die, but lay in a vegetative state in an East Texas nursing home.

Wait…A pastor. Living in a wealthy subdivision in Dallas. Allegedly tries to kill his wife. He claims the devil made him do it. And now she is unresponsive and living in East Texas. Where we also live?

Twice I heard my dad say to my mom before she left the house, "Don't you dare try to find that nursing home, Annette. I mean it."

But my mom and my Aunt Linda hearing a story like that? It was tantamount to saying, "Sic 'em, Fido!" They were all teeth. They were like dogs after a bone. I know this about them because I had witnessed it firsthand.

I woke up from the back seat of a car I had never been in before. I was seven years old and I was terrified. I almost started to scream when my mom, sitting in the front passenger's seat, turned her head to me and said "Hey, sleepyhead. Lay back down."

"Where are we?"

"We're in the car with Aunt Linda. Just talking. Now lay back down."

"I don't want to—I'm not tired."

"It's not about being tired, baby. It's about them seeing your head. Lay down flat on the seat."

"Who is gonna see my head?"

"Melissa, I don't have time to explain this…"

"Whose car is this?"

My Aunt Linda turned to me, and for the first time, I saw that she was holding binoculars. "It's my momma's, baby. Aunt Margi. You know her. She let me borrow her car." She handed the binoculars to my mom. My mom put them up to her eyes and looked into the second-story window of an apartment complex I had never seen in my small town.

"Why can't we be in your car?" I asked my Aunt Linda while trying to look out the window of a yellow AMC Pacer.

"PUT YOUR HEAD DOWN! Quit looking out the window, Melissa! This is why you don't bring kids to a stakeout," Mom muttered under her breath.

"What's a stakeout?" After all, I was only seven.

Thankfully, my Aunt Linda had pity on me. "Here, baby, scoot up between our two seats." I scooted. "So I go to a different church than your momma, and so I have a different pastor. Well, I think my pastor has a crush on a lady that lives in this apartment we are looking at. That's all."

"That's all? He has a crush on someone?"

"Well, a little more than a crush. At least your Aunt Linda thinks so. So we are sitting here in a car he won't recognize because the woman

that lives in that apartment, you see, well, when her blinds are closed, it's a signal. If they're closed, then that means that she does...not"—she began to stumble over her words—"want to...love the pastor...but when she opens the blinds...she is ready to have him ove...uhhmm... love him...again...we think."

I lay back down and started picking at the thread in the seat that was sticking up—just to have something to play with.

"Oh my gosh, she's opening the blinds! She's opening the blinds! Look, Linda!" Mom handed back the binoculars.

Linda slumped down in her seat at the exact second my mom did. "Now we wait and see if his car drives by."

"And you know for sure what kind of car he drives?"

"Absolutely. A red Cutlass Supreme."

From the back seat I said something to the effect of, "I think people that love each other are sweet like Joanie and Chachi."

"Not always, baby," my Aunt Linda replied. "This Chachi we're watching is married with three boys, and the Joanie in this apartment dresses like a whore." My mom started laughing.

A red Cutlass Supreme turned on to our street and drove about eight miles an hour. It drove past the apartment and past the open blinds. It made a U-turn at the end of the block and began the route again. The ladies in the front seat were freaking out. Their seats were laid all the way back while my Aunt Linda kicked her feet, screaming, "I knew it! I knew it!"

Their play-by-play was all I needed to hear. I didn't bother to look out the window.

"He's parking. He's parking. Okay, he's parked."

"Why is he taking so long to get out?"

"He's probably making sure his toupee is on straight." They roared!

"Look, he's opening the door. Oh, my word, he's wearing sunglasses and a coat. It's eighty-eight degrees outside!"

"He's an idiot. He's an absolute idiot."

The preacher walked up to the second floor, went to door 2D, and knocked. It opened quickly and he rushed inside. I saw all of this

happen. Then I saw the blinds close again, just like they had been moments earlier. Man, big people really do fall out of love so fast. Joanie and Chachi are forever.

This was the first time I realized my mom and Aunt Linda were "in cahoots," as my dad would say. During my childhood they tracked down a wayward pastor, his mistress who worked at a place called The Beauty Hut, a husband of my mom's friend who—come to find out—had a gambling problem, a woman who stole $4,800 from the only funeral home in town, and the blue Camaro of a man who killed his mother-in-law for burning the turkey at Thanksgiving.

This kind of white lady espionage would start to seem common-place for me. I would ask my friend if their moms drove around with binoculars looking for bad people, and when they said, "no," I felt sorry for them. What did they do for fun?

One day I heard my mom ask my Aunt Linda if she ever felt guilty that they tracked down bad preachers. "I only feel bad that I can't kick the crap out of them," Aunt Linda answered. She had such a way with words.

My Aunt Linda died before podcasts were a thing. She never got to see a woman walk into a Starbucks wearing a T-shirt that said, "I JUST WANT TO TAKE NAPS AND WATCH SERIAL KILLER DOCUMENTARIES." This kind of true crime obsession our culture has would have warmed her heart and given her goose bumps.

I promise you, just like there were men who struck gold and built frontier towns, and women who sewed flags and bandaged men in the war, there were women who tracked down normal people in small towns doing shifty stuff. In that way, my Aunt Linda was a pioneer. Today, if she were with us, she'd have her own podcast alongside my mom and it would be called something like *Two Old White Women Who Know Who Did It...Don't Try to Convince Us Otherwise*. It's an unconventionally long title, but it fits them. It would have a canary yellow AMC Pacer as their logo.

To this day, there is rarely a true crime documentary that comes on that my mom doesn't watch the first five minutes of it and then say,

"I already know what happens. Don't get me wrong, *she's a nut*. But he gets what's coming to him."

I was over at her house for dinner the other night when I told her that A&E had released a documentary with never-before-seen images and never-before-heard-accounts of Scott and Laci Peterson, and that all of it had led to some of his attorneys asking for a retrial.

She stopped stirring her dumplings, abruptly dropped the spoon, looked up to the heavens, and said to absolutely no one, "You aren't gonna convince all of us who lived through it, A&E. Scott Peterson, not guilty! Not hardly. *WE LIVED THROUGH IT!*"

In the back of my mind, I knew who she was talking to.

I guess I just found it odd that she would say we "lived through it," since we don't know any of the Petersons, or the families involved, and are in no way connected to the case. But ask my mom where she was the night she heard about Laci Peterson, and she'll tell you. Ask her what she was doing the day the BTK killer was arrested in his home, and she will know down to the second. And for the love of all that is good and holy, do not even bring up JonBenét Ramsey, okay? There are not enough hours in the day, I promise you.

But how did this become a thing? True crime, I mean.

How did we become so fascinated with it?

How did it become a pastime?

How did it become this "thing" that brings us together?

Other than waking up in the back seat of an AMC Pacer, I never really saw true crime bring women together...until the world met Lorena Bobbitt. My mom said you couldn't bump up against a woman in 1993 that didn't have a pretty strong opinion on a woman who chopped her husbands' privates off. How did she do it? Why did she do it? Did he deserve it? What did you carry it to the hospital in?

I attended a Halloween party several years ago that was themed; it was Famous Pop Culture Moments. That could have been anything from Michael Jackson to the cast of *Friends*. But I'll be darned if there wasn't a Lorena Bobbitt, a Scott Peterson, and three JonBenét Ramseys.

I recently had a girlfriend ask me to drive out of town with her to go see a true-crime show. A podcast that is insanely popular in the world of true crime was coming to a town near us and putting on a live show. So the hosts sit onstage and talk about more murders and cold cases and serial killers, and we sit out in the crowd and *ohhh* and *ahhhh* and take notes and buy T-shirts and coffee cups and then go back home and sleep restfully. David thought it was the weirdest thing he had ever heard. "That's sick! Why would you ever drive out of town to sit in a room with five hundred other women and talk about murder?"

"We don't just talk about MURDER! We talk about *MURDER-ERS*. We talk about cases that need to be solved and will now probably be solved because of us! And we talk about how we can spot psychopaths in our own neighborhood."

"Last week you couldn't find your phone. You left your purse at an Outback Steakhouse, and I distinctly remember you saying you couldn't come to my Fantasy Football Family Cookout because you couldn't find the directions. We host it. It was in our backyard."

"What's your point?"

"But I'm supposed to believe you can find a killer from a cold case in 1987 that happened in Michigan? Or a psychopath in our own neighborhood? You couldn't find your pants if it wasn't for me."

"Pants aren't bringing people together, David! Murder is! No one cares about fantasy football until someone on your team is found dead clutching the trophy in their hand. Invite me to that cookout. I'll come to that one!"

Just another thing men cannot understand.

Last spring Remi Radke went for several college tours. Actually, she visited every SEC campus, per her dad's request. And even though this is going to make a lot of people mad—because y'all are fiercely loyal to your favorite university—she really loved the University of Tennessee. Sadly, I didn't get to go with her on this visit so I was eager to hear everything she loved about it. What was it?

The campus?

The dorms?

The majors they offer?

The school spirit?

Remi and her dad walked through the front door, and as I went to greet them, he walked right past me, furious.

"What happened? Why are you mad?" I asked after him.

I looked at Remi. "Why is Dad mad? What did you do? Did you raise your hands and ask if dorms were coed again?"

"No. Nothing like that. He's just mad that I don't care about their football schedule or their SEC ranking."

"I am not mad at that," David said as he walked back into the room. "I am not mad at anything. I am just disappointed that none of that matters to her. There was only one thing that she was absolutely enthralled with. Tell her, Remi. Tell your mom."

I looked at Remi, waiting on her answer.

"Mom, they have a state-of-the-art body farm. A body farm. Mom! A BODY FARM. Bodies are laid all over, in different degrees of decomposition, and we can study them and find out what happened to them and—"

I stopped her. "Remi, have we found your school?"

"Mom, I think we have!"

By the time you read this book, Remi will have chosen her college and I cannot say for sure where she will end up. But I can say that, on that day, I will have never been so proud of her. Just think, my daughter, growing up like the women who came before her. Longing to fight the good fight of serial murderers, rapists, stalkers, ne'er-do-wells, homicidal maniacs, deranged killers, and if we're lucky, guilty-as-sin preachers.

And all God's crime junkies said, "Amen."

"I put on that perfume and Gene was on me like a monkey on a Cheeto."

—My mom. I'm pretty sure you can guess what this is referring to.

These Double D's and Another Verse, Please

Once upon a time, I was a singer.

It wasn't that long ago actually, and sometimes, late at night, if you listen really closely, you can still hear me singing "Love Will Lead You Back" by Taylor Dayne into my mirror.

I grew up singing. And I don't mean that sentence like a little girl who learns the National Anthem and then sings it around the Christmas tree *one time only* for her grandparents so they can video it. I mean I grew up going to revivals and *singin'*.

We would have *singin's* and I would be the youngest in the quartet—my Aunt Melba and my mom and my Pawpaw all standing around me, singing their harmonies. We would sing for tent revivals and Pentecostal revivals and Baptist Bible studies and Rotary Club meetings. We sang on the stage for school convocations, Christmas on the Square, and the Fourth of July Hometown Fireworks shows. We once sang "I'm Gonna Take a Trip in That Good Old Gospel Ship" at the opening of a new speedway near our house.

My Pawpaw sang bass and so did my Aunt Melba. Not really, that's a joke. She sang alto. But she sang it so low that sometimes my mom would pull down my Aunt Melba's shirt and say, "I'm just checking to

see that you ain't got any chest hairs since you're able to sing that low, Melba Joy." No one ever really knew what my mom sang. Melba said she sang a special harmony called "whatever-the-heck-she-feels-like" because my mom has always been a little bit of a maverick. But me? I sang the lead. Because trust me, there is nothing cuter than a chubby little round-faced, curly-headed, blond nine-year-old girl singing "There's Power in the Blood" at the top of her lungs.

There's also nothing creepier than continuing to make her do it at sixteen. Or twenty-two.

I used to sing a song called "Come On, Ring Those Bells…"

Come on, ring those bells, light the Christmas Tree
Jesus is the King, born for you and me

No offense to the writers of this song, but singing it at nine with a slight lisp is a very different thing than singing it at seventeen with acne and a Flock of Seagulls hairstyle. I told my mom that I better not die before her, because if she has her way, she'll put "Come on, Melissa. Ring those bells! Just one more time for us!" on my gravestone.

But singing and wavin' and fake laughing at a joke I'd heard my Pawpaw tell one thousand times was how I was raised. I knew exactly when to raise my hand in "When He Was on the Cross (I Was on His Mind)." My Aunt Melba taught me the beauty of raising your hands to Jesus and crying if you ever forgot the words. No one can blame someone who has been overtaken by the Spirit.

In the eighties and nineties, there weren't CDs or CD players or anything remotely like that. There were cassette tapes, but those could never be trusted. So my momma played the piano for us at our shows. Occasionally we would whip out the cassette player for some hip new song like "Our God Is an Awesome God," but most times—she was the band.

I'm not going to lie—we weren't bad. This chapter would be much funnier if I told you tales of how awful we were and how people had to get up and leave whenever my mom hit a high note, but that wouldn't be true. We were good. We had what my mom called "family harmonies."

She said you couldn't get better harmonies than that. And if you'd ever heard us, you'd be quick to think she was right. Our sound was legit. But we weren't exactly showstoppers on the stage.

It was that darn stage we had a problem with.

Problem 1: My Pawpaw refused to move. Not an inch. He would not, could not, should not ever be caught dead moving on a stage. God had called my Pawpaw to use his voice, not his hips. He didn't like to see Elvis gyrating and he wouldn't be accused of it, either. The stage was for "delivering a message, not raising a ruckus." I loved my Paw-Paw dearly but comparing himself at sixty-eight to seventeen-year-old Elvis Presley was going a little far. My mom once asked him if he could at least unbutton his top button and show a little chest hair and he walked out of our rehearsal.

Problem 2: My mom worked the stage like it was her last shift at the saloon and she needed to leave with carriage money. To this day, I can mimic my mom onstage and everyone seems to love it and laugh at it, except her. Ask me to do it sometime. But the truth is my mom has a beautiful smile and a huge personality. Asking her not to turn and sing to the people on the left and then turn and sing to the people on the right was a travesty she could not abide. My Pawpaw asking her not to sway? Don't sway? You might as well have asked her not to breathe. And yes, she was going to raise her arms and create signs with her hands. If the lyric said, "We are looking at the time"—then she would lift up her hand and pretend to look at her watch. If the lyric was "spreading His love"—then you could expect that she would pretend to throw seed out onto the ground and then point upward as if to say, "Did y'all see that seed I'm sowing? That's God's seeds." This is called *working the stage* and she came out of the womb doing it.

Problem 3: This left my Aunt Melba right in the middle of the madness. Should she stand still? Should she move like a crazy person? She never really could figure it out. And whereas you might have thought my Pawpaw standing stick still was weird looking, or my mom miming "Jesus on the Mainline, Tell Him What You Want" with her left hand looked awkward, it was really the girl stuck in the middle of

them both that took the cake. My Aunt Melba decided she would err on the side of crying. So she sang every song with her hands lifted and tears streaming. Rotary Club meeting? Cried. East Texas Speedway? Cried. Dr. Dennison's Orthodontics Open House? Cried. She would start off fine, but by the time we hit "It Is Well with My Soul," she would cry like a baby and everyone would chalk it up to what Jesus was doing in her heart. Everyone but us. She said it worked for her because it meant she got to keep her eyes closed most of the time and didn't have to see what a lunatic her sister was.

I guess you expect there to be a Problem 4 for the stage, because I was up there, too. But I assure you, when it comes to the stage—I've never had a problem. (Mic drop.)

Well, if you don't count these things that have happened:

I once wore a shirt that was completely see-through because I had no idea we would be in a spotlight.

One time a boy I went to middle school with walked in during our first song, and when it was time to go around and introduce ourselves, I couldn't remember my own name. When I looked at my mom like a deer in the headlights, she said, "Are you mute because that cute little Landon walked in? Hey, Landon, good to see you, buddy! We're glad you're here tonight. I think you got this one right here a little gun-shy."

My mom once had the most awesome idea and rewrote all the words to "Somewhere Out There," the theme song from *An American Tail* about an immigrant mouse that comes to America. I had to sing this song in front of people. The entire time I could see people looking around and asking, "Isn't this the song from that movie about a mouse?" That was the year I hit a low socially and have honestly never recovered. I tried to recall the words of this song to share with you here, but it turns out none of us remember what they were. So you see? Trauma therapy does work!

We were asked to sing at a fair for my school. My dad stood up in the middle of everyone, videoing all my solos. He never once took the lens cap off. Not once. Everyone noticed but him.

I once wore a skirt completely see-through because I had no idea we would be in a spotlight.

My Pawpaw once introduced a song we were about to sing by saying that it had once "been recorded by the legendary Southern Gospel group Gold Titty. My goodness, I mean to say Gold Titty. What is wrong with me tonight? Let's try that again...Gold Titty. I think my tongue is frozen up. Melissa, introduce this song because I cannot find my words."

"He means, Gold City."

A lot of the times we would practice at my Granny and Pawpaw's house. They had a piano and we would all gather around it and sing and my Granny would say things like, "Try a different song. People are sick of that one!" The other women in the family would be at the table cooking or canning or making their famous jarred salsa and they would yell things like, "Why don't y'all do a song by Tom Jones? Maudelle Henderson told me he just got saved and baptized." The night my Aunt Velma yelled this, it started a domino effect of shoutouts and requests.

"If Tom Jones got saved, I'll be a monkey's uncle," said Margi.

"I like 'Step into the Water,'" shouted Linda.

"We can't do 'Step into the Water,'" my mom replied. "It has a distinct beat and Melba doesn't do well with beats."

"I hate it when you say that. If someone can tap it out on their leg, I can find it," Melba moaned.

"Y'all sing 'He Touched Me,' that's the one Roy sounds good on," Granny answered.

"Don't sing 'Daystar' unless you want to get me to cryin'," my Aunt Margi threatened.

Unfortunately, "Daystar" was next on our list. Aunt Margi sat at the table with her hands raised and tears rolling down her face for the 3 minutes and 12 seconds of the song. She sang along, at the top of her lungs, keeping us from ever really finding our pitch. At the end of the song, she picked up a napkin, wiped her face, and said, "I shouldn't have said that about Tom Jones. God forgive me."

If we couldn't find a night to practice at my Granny's house, then Wednesday mornings at 10 a.m. at the nursing home were the next best thing. Whatever event we had coming up that weekend, we would practice the songs on our 10 a.m. crowd. They didn't care what we sang or even how we sounded, they were just happy we were there. Sometimes my Pawpaw would ask if anyone had a request and the same man, every single week, would raise his hand and say, "More applesauce."

On one specific Wednesday morning, I had just finished up the solo on "Sweet Beulah Land" when my job was to close down the song with prayer requests. One little woman in the back row raised her hand. I called on her and here's what she said: "Every week, I pray that you all will come in here and sing and bring Patsy Cline with you. I just wanted you to know I'm going to stop praying for that because I don't believe you're doing anything about it." No one had the heart to tell her that Patsy had been dead nearly twenty years.

Ohhhh, but the Wednesday morning that I told them it was my last week singing for them because I was moving to Nashville...man, were they excited...all of them rolled their wheelchairs up next to me and asked me questions:

"Are you going to work for Loretta Lynn?"

"Do you think you could tell Ronnie Milsap something for me?"

"I've got a bone to pick with that John Denver!"

We haven't sung in that nursing home in years. It makes me sad because those people were very forgiving and most of them didn't even remember us from week to week anyway. It didn't matter if things went wrong there.

Outside of the nursing home, I can tell you this: If something could go wrong onstage, it would. Every single time.

Like at the Ellen Trout Zoo's *Fireworks, Families and Fun on the Fourth* event, when my mom got so hot, she passed out on the piano and we had to finish the song a capella while my dad poured ice water on my mom's head.

Or the biggest night I ever sang in Nashville.

Every year, at the end of the school year, Belmont University holds a concert and anyone who is a student can audition to be in this concert. They only choose four students. And you want to be on this stage, trust me. Because every music producer and manager and hit maker in that town is invited to come out and watch the best of the best.

The competition to be on that stage on that particular night was very difficult. You weren't just dealing with students in the School of Music, where I studied; you were dealing with every student from every place on campus, and students of every age. And back in the nineties, Belmont was packed to the brim with students who wanted to be in the music industry. This was equivalent to scouts coming to the College World Series. This was big.

And I was chosen.

You were provided with an entire orchestra, background singers, and whatever songs you wanted to sing to make your twenty-five-minute set the absolute best it could be.

I had carefully chosen my songs over the course of the last three months. I would open with a killer number called "Just When You Think It's Over," then go right into a medley that I had heard Whitney Houston perform onstage to honor Aretha Franklin. It was a medley of "Since You've Been Gone," "Think," and "Ain't No Way." I would then say a few words, and end with a song that I had to ask God's permission if I could sing: Whitney Houston's "Queen of the Night," from *The Bodyguard*.

This was a big deal for me, y'all. It had the word "damn" in it and all of my family was coming to see me. No one in my family said words like that. I didn't say words like that! My Pawpaw and Granny would be in the front row and what would they think about me saying a word like that? But this was a big night and I had to do all I could, sound as good as I could, and look even better.

All of my family landed in Nashville the morning of the show. Everyone piled into my house like we were on an episode of *Hee Haw*. It was really hard to get ready for a concert on Music Row when my Granny was using my hair dryer to dry the insides of her Naturalizers.

When I couldn't find my hairspray, it was because my Uncle Donald was trying to get the static cling out of Aunt Melba's clothes, and we blew the downstairs fuse three different times.

I wore a purple pantsuit. That's right. I found a slick purple pantsuit at a place called Saks Off Fifth, which is where all the ugly things that didn't sell at Saks Fifth Avenue go to die. But I found it and bought it and was very sure I looked amazing in it. And as I had tried it on in the Saks Off Fifth mirror, I had made a public declaration to myself that I would lose eight pounds before I wore it so that it would fit me perfectly and zip all the way and not pull open at the buttons.

But then I walked right out of that dressing room and forgot I was supposed to lose eight pounds.

The night of the show I put the suit on and noticed that it was a little tight. Not too bad. I got the pants zipped up. But pants have never been my problem. My DDs have always been my problem. I put the shirt on...*uh-oh*. I put the jacket on...*no, no, no*.

I called my mom into the bathroom and she immediately called for all the women in my family. This was an "all hands on deck" situation. Everyone was walking around me, looking at the pantsuit. Having me put the jacket on, then take it off. Then back on again. Could we change the shirt? Could we let out a seam on the jacket? Did Granny have any Velcro? It went on like this for about ten minutes when Meridith finally said, "Let's just tape her down. It's her boobs that are the problem. No boobs. No problem."

That night I became intimate with my family in a way that I had not been since I was fifteen years old and standing in front of Mrs. Pratt getting fitted for a 24-hour Playtex. I took off my shirt and my bra. I held both hands in the air. Meridith placed a small hand towel around my boobs so that when they ripped the tape off later, it wouldn't hurt. My Aunt Melba brought in the electrical tape. My mom held my breasts down as flat as she could get them. They spun me.

For the next seven minutes I spun. They taped up every inch of me. I went from a 38DD to a 24A. I could not breathe. I could not bend

over at the waist. My mom said neither of those things were important when it came to singing. She said, "We sing from our gut, and no one wants to see you gyrating at the waist anyway. I didn't fly your Granny all the way to Tennessee to see you dance like Gloria Estefan." I guess I had to agree with her. Of course, what choice did I have? When I sat in the car, it was the most upright I have ever sat in my life. My dad said the entire time he drove to the performance hall, it looked like I was one move away from opening up the door and jumping out of the car.

A week before the performance, I had found out I would be the opener for the night. It's an honor to be the opener and the closer, so I was happy. And considering my posture, there was no way I wanted to stand upright for the next hour and a half while everyone else went onstage. I wanted to get this thing over with as quickly as possible. The orchestra was warming up. All the seats in the room were full. I peeked out the curtains to make sure my family had been escorted to the front-row seats I had reserved for them. I gave myself a once-over in the mirror and waited for the curtain to open.

The music started, my introduction was made, and the curtain rose.

I finished my first song, and if I can be so bold in this book...*I killed it.* I made a couple of quips as the music for my medley started up, had the people laughing, you know how I be, and then I dove off into song number two. The Aretha medley was long. The pantsuit, hot. I started to sweat. I could feel sweat pouring down my forehead, my neck, my back. But this was my College World Series. I would not wipe my forehead, I would not worry about sweat. I would carry on like the consummate professional I...

And then I felt it.

The tape moved.

Not a lot. Not even enough to worry about. But I felt it move and that was something it had not done at all since I had gotten taped up. Not a big deal. No need to worry, just keep singing. Just keep singi... it moved again. The tape just kind of moved side to side. As I was

finishing up the medley, and bending over to really belt out those last few phrases, the tape moved. But that's probably normal, right? If I move, it moves? It's just loosening. C'mon girl, give it all you got. Belt out the final phrases of this song and you are on the home stretch. Hit that note! Hit it!

I hit it. The crowd roared. My parents were beside themselves. My whole family was watching and clapping and smiling. Now, all I had to do was belt out "Queen of the Night," somehow sing the word "damn" without my mother's head rolling off and my grandparents combusting, and then my night was done.

The music for "Queen of the Night" started up. And if you know this song, then you know that when that music hits, there is no doubt what song you are about to hear. But this was a fitting song for me because I was going to be the queen of this night. This was my night and this was my song and...

The entire circular tubing of tape began to move. Suddenly I was like a sausage in its own casing. I could move around in it, I just could not move out of it. It twisted with my body. It was stuck to absolutely nothing now except for a towel that I had sweated through eleven minutes ago. I did not care. I could not care! I had one verse, two choruses, and an instrumental breakdown left.

Oh God. Why? Is it because calling myself the Queen of the Night is arrogant and pride always cometh before a fall? Is it because my family are good Christian people and I have never heard them utter a bad word in my life and I'm about to sing "damn"? Is it because my momma told me just before I went onstage that she's proud of me but that she "didn't raise me to sing pop music, she raised me to sing songs about You?" Is that why this is happening? Is she right and this is my punishment?

The circular tubing of tape began to slip. It was no longer around my boobs. It was, at best, covering my nipples, but one more chorus and it wouldn't even be doing that much. How do I continue to walk and strut and sing this song? I'm supposed to own this stage! That is what my voice instructor said: "Own the stage, Melissa! Use your hands, Melissa! Move around, Melissa!" All I could do was hold a mic in one

hand and keep my left hand completely down at my side. I looked like I had just had a stroke.

Dear God, all I can ask You for at this point is that You put it in some-one's mind that "Dang, this girl has just had a stroke on the stage and she is still pulling this song off." Can You at least do that for me? Amen.

The tape slipped down past my boobs. My boobs were free, y'all. I don't know if you know this, but if you release two DDs in the woods—they don't come back to you. They are free and they are LOVIN' EVERY MINUTE OF IT! The buttons on my shirt began to pull apart. I bent over. It made the shirt just lax enough so that the buttons didn't pop open and the entire performance hall got to see Laverne and Shirley close up. This was a free concert and no way were the girls coming out without at least a cover charge.

The tape and the towel and the sweat moved down past Laverne and Shirley and onto my stomach area. No big deal. This is the place singers breathe from. This is where we get our strength and our stamina from. It's how we make sure we are hitting the correct notes. It's where our big belt comes from for those high notes, not a big deal. Soooooo not a big deal. I could handle it. I could handle anything.

I am kidding. I could not handle this!

I could not even stand upright!

You've got a problem with the way that I am
They say I'm trouble and I don't give a (My button just
popped.) *DAMN*

I had meant to pass through that part pretty delicately for the sake of my family. But I didn't get to. The bottom button on my shirt popped and I was pretty sure all you could see through there was towel. I stayed bent over. But it was working. People were on their feet because they thought I was getting into it so much.

The song ended. Standing ovation.

And I was standing on a spotlit stage with fifteen instrumental musicians, four background singers, and zero bras.

My mom told me later that after everyone had finished clapping and people sat back down, the room got really quiet, and my Granny looked across the row to my mother and said, "I couldn't understand one word she sang all night."

David told me that if I had not told him about the tape falling down, he wouldn't have even noticed. But he has to sleep with me for the next sixty years, so what's he supposed to say? He said the only thing that looked odd to him was that during the last song, it suddenly looked like I was wearing a bulletproof vest around my midsection.

The next morning, eleven family members woke up in my small house that comfortably slept four. We sat around the table and had coffee. My Aunt Melba started singing and we joined in picked harmonies. It was a Sunday morning and we sat there singing "Just a Closer Walk with Thee." It was the happiest I had been singing in the last month. My mom was right: there's nothing like family harmonies.

Then my Granny walked into the kitchen to refill her coffee. "I'm so sick of hearing that song. Pick something new for once," she said. "And Melissa, go put on a robe. You're gonna take someone's eye out with those things."

Annette: The Tenderest One

THIS PAST VALENTINE'S DAY, MY MOTHER AND I WENT AND GOT Botox together. *Just let us live our lives, okay?* We don't need to know your thoughts on injecting our face with poison. My mother and I have drunk enough Diet Coke and eaten enough Velveeta cheese to sink a military submarine, so we aren't scared of anything you throw at us.

For the last couple of Valentine's Days, we have gone and had this done. It's both a gift *to* us, and a gift *from* us. We think the men in our lives should thank us for this type of dedication. Imagine if we were as committed to our belly fat as we have been to our faces? We'd be too close to perfection. Which is why we refuse to do anything about our midsection; we want to remain approachable to other women.

This year when we walked out, I looked at my mom and said, "Dang. How does it feel to spend that kind of money and still be told you need a facelift?"

"She didn't tell me I needed a facelift."

"Mom, she literally said, 'Annette, what you need done, I cannot do.'"

"Shut up and drive."

I could say a lot of things about my mother, but I cannot say that she is not a good sport. She certainly is. I've been picking, teasing, pulling

pranks on, and laughing hysterically at my mother for as long as I can remember. And 99 percent of the time, she's a great sport about it.

Oh, but that 1 percent...

Once, when David and I lived in Nashville, we flew in to see my parents. They picked us up at the Houston Intercontinental Airport, and after we hugged our hellos, we hopped in the car and headed out for some lunch and a little shopping. At the first stop we made, my mother got out of the car and immediately tripped over a curb. And when I tell you she tripped, I mean she fell face down on cement. Every single one of her fake nails were broken down to the quick. Literally! All ten of them! But y'all, I could not stop laughing. I tried to. I wanted to. But I couldn't.

My dad, who was running around the car to help, yelled at me from the other side, "Melissa! Stop laughing at your mother! She's hurt!" But I could not stop.

Didn't he see what I was seeing?

Did he not notice anything?

"Dad! I'm sorry. But look! Look at her!"

My mom was lying vertically ACROSS a bright yellow curb. And in what would turn out to be such an unfortunate choice of clothing, she was wearing a bright yellow short set. Her shirt and her shorts were the exact same color as the curb. Honestly, if it had not been for all of that blood, I don't know that we would have even seen her!

When my dad finally made it around the car, he stopped for one second, looked down at my mom, and said, "Annette, where are you? Where did you go?"

I think David was the one who finally helped her up, but even he had tears rolling down his face.

After she finally stood up and gathered herself, she said, "Gene Lee, you're taking me to get every one these nails fixed. And Melissa, I've got three words for you: hell is hot."

Someone asked me the other day if I got my humor from my mom or my dad, and without much hesitation, I told them my dad. Because my dad is funny. He is very funny. And I think I always saw him as

being funnier than my mom because he was less of a disciplinarian. Mom was very funny. Hysterically funny. But once, when I was eight, she threatened to spank me every single day until I could go a full twenty-four hours without being a smart aleck, and she held true to her word. It's hard to see the humor in anyone who kept a switch in their purse.

How could I not give my mom props for her humor? This is the woman who once dressed up as a fortune teller for my high school Fall Festival. She had me peek out of the curtain and see who was in line, and then run back in and tell her absolutely everything I knew about the person. This was a small high school in a small town, so it wasn't hard. She wore a turban on her head and giant glasses with diamonds on them. She had on fake eyelashes and long fake fingernails. She wore costume jewelry on every finger.

Kids would line up in droves once they found out that some woman in the fortune teller booth was telling all their business. No one could even tell that it was my mom in that costume.

"Your name is Erica, isn't it?"

"Yes, ma'am."

"Erica, my magic ball is telling me you have a boyfriend. Is that right?"

"Yes! Oh my gosh, how did you know that?"

"Ahhh, I am The Divine Mrs. A, and I shall not tell my secrets. Does your boyfriend have a white Ford pickup?"

"Yes, he does. This is really freaking me out…"

"Well, everybody knows he hit Amy Steiner's car with it in the school parking lot last week so you better tell him to confess or I will call his mom and tell her what my crystal ball is telling me."

"I told him he needed to tell the truth! I told him! Okay, I'll go tell him. Bye!"

In that one fortune-telling event alone, my mom ended three unfaithful relationships, got one guy to stop being rude to the Spanish teacher, and got one girl a date to Homecoming. She freaked them out just enough.

Which is pretty much what she did with me throughout my childhood.

My mom played the piano and led the singing at our church for my entire life. I don't know how many of you can say that your parent sat at the front of the church every single service, giving them a bird's-eye view of everything you did and said. But I can.

Imagine hearing your mom sing...

When the roll is called up yonder, I'll be there

And I'd like to call a little roll myself if you all don't mind and ask that my daughter Melissa come sit right here beside me on this piano bench for the remainder of service because she likes talking better than singing it seems to me...

Let's take that one from the top, shall we, church?

When the roll is called up yonder...

She quit doing things like that by the time I was a teenager, thankfully. I told her once that I appreciated her not calling me out on a Sunday night during service anymore, but she said it was only because we both couldn't fit on the piano bench. Instead, she did something far scarier.

During Sunday night services the Spirit would fall, and that's when people would go ahead and get comfortable, because Annette was on the piano singing, and it was going to be a while. No one minded, though, because they loved to hear my mom sing and play.

But I don't think you will ever understand the sheer panic that goes through a person when they see their mom sitting at the piano, playing and singing so beautifully, but then she stops mid-phrase to look right at you. It feels like you've crossed over into some evil stuff. My mom could somehow manage to sing:

Great is Thy faithfulness
O God, my Father
There is no shadow of turning with Thee

Then find me in the sanctuary, look right at me, mouth the words *SHUT UP*, and then go right back into her verse:

> *Thou changest not*
> *Thy compassions, they fail not*

Look squarely at me again just to say *OR I'M GONNA TAKE YOU OUTTA HERE* and then back to:

> *As thou hast been, Thou forever will be*

Her face would contort. Her mouth would get huge and dramatic. There was no trying to figure out what she said; I knew without a doubt. And then she would just go right back into her singing. Even my girlfriends would shut up after that. I don't think a single kid in the entire church would move an inch after Mrs. Annette had looked out into the crowd and threatened her daughter. There was a presence in the room all right.

But no one didn't love my mom. My friends may have been scared of her on Sunday nights, but on Friday nights, everyone wanted to sleep over at my house because Mrs. Annette was so funny and because she was easy to talk to. Some of my closest friends say that they learned about sex and marriage and relationships and life more from my mother than from their very own. My mom had a way about her; she always has. Everyone has always adored her.

Most of all, me.

My mother and I were very close. I had more fun with my mom than anyone on this earth.

But there were parts of my mother that always seemed a little bit of a mystery to me. Parts of her that seemed a little off-limits. As I see it now, these were the parts of her that made her the most mortal. But

in my eyes, my mom wasn't human; she was superhuman. Larger than life. My mom was recipes and smack talk in the kitchen. She was hilarity and shenanigans. She was dramatic stories and tall tales. How could she be so huge and so human at the same time?

I grew up hearing stories of her old boyfriends and her girlfriends and the circus of a family she grew up in. But she never told me she often felt lonely.

I saw how talented she was and how funny she could be. She was voted Most Beautiful and Homecoming Queen. But I was never privy to her lack of self-confidence.

I watched her sing and teach and write and lead; I watched her walk into every restaurant in town and never meet a stranger. But I rarely ever saw her small and broken.

I bet if she were to put pen to paper, she would write this chapter completely different; she may tell you that I was just so self-obsessed that I never saw those things. She would probably argue that she was never anything but open and honest and I just didn't want to see those things in her. And I suppose it doesn't matter who's right. The things I never noticed about her became the things that in my own life I could not hide.

Because they were in me.

They were in me—and they were from her.

And the woman I had most idolized gave me gifts I most hated.

The parts of me that are outgoing and flamboyant can often suffer from loneliness. The parts of me that are confident and brave can more times than not feel unequipped for the job. The parts of me that come off strong and opinionated, well-spoken, and comedic, have oftentimes—sometimes even on the same day—been small and broken.

And I have my mom to thank for this. As I grew up, the woman I most idolized on earth became someone human and with feet of clay. I wish someone had warned me. But because no one tells us that the people we love are, in fact, just people, I spent a lot of my adult years at odds with my mother. And at odds with the parts of her I saw in myself.

What wasted years those were—the years I spent trying to be everything I saw in her but didn't want to be. There are some things you are not strong enough to outrun, my friend. You can train yourself to eat healthy, even if your family never did. You can teach yourself to be a good listener, even if your parents never were.

But there are some things that are a complete waste of your time trying to change. I'm not going to follow a recipe. I can't. I'm a better cook than that recipe thinks I am. I get this from my mom. And that new product that you swear will change my face? I'm going to buy it. I don't need it. And you and I both know it won't work, but I'm still going to try, gosh darn it. I get that from her, too. Here's another thing I get from her: If I have ever loved you, for even one day or one minute, then I will have to love you for the rest of my life. It's that simple. You are loved. Forever.

I wasted so much time and so many days and so many therapy sessions trying not to be someone that now, at this stage in my life, I consider it high praise to be compared to. Somebody explain how that happens!

When my mother was forty-nine years old, she found out she was pregnant. She had never been able to have children after I was born, so can you imagine the shock she must have felt when in 1994 she was helping me plan my wedding and experiencing back aches and swollen feet at the same time? Certain that she was headed into early menopause, my mom saw a doctor, who informed her that she was eight months pregnant.

My little brother, Christopher Barron Lee, was born soon afterward, and he left this world as quickly as he had come into it. My mom, unable to wrap her head around her pregnancy, was left reeling again at a loss she had no time to even grieve. Because how do we grieve what we did not even know we had?

My mom told me about a prayer that she prayed during this time. She said that she told God…

This grief is so deep and painful that I only have one request. You don't have to heal me from this pain. But you do have to keep my daughter from

ever going through it. Please. If you do nothing else for me, that is okay. I'll be fine with that. Let me hurt. Let me lay here. Let me feel every bit of this I need to feel. But do not, ever, let her go through this kind of pain. Please, God.

My little brother would have been eleven years old when I found out that I was pregnant with Elisha Cooper Radke and that he was sick and had very little chance of survival. Christopher would have been eleven when my parents walked in my front door in Tennessee and found me lying in bed without a baby in my arms. Christopher would have been eleven when we buried my son two days after Christmas. He would have been eleven when my mother snuck into my room hours after Elisha's funeral, lay beside me, wrapped her arms around me, and wept. He would have been eleven when I heard her crying under her breath, *"But I asked you, God! I begged you, remember? Remember what I asked of you? I asked you to spare her. That's all I asked. Did you even listen to me?"* Christopher would have been eleven when I turned to my mother in bed, and buried my head in the spot on her neck that had held so many of my tears in years past.

If my mother had never walked through pain, she would have never been able to bring such comfort to me.

If my mother had never been human, she would have never been able to be broken alongside me.

The things about her that I never wanted to be were, on that day, the very things that healed me the most.

That's how it has always been with my mom. I think she may be the most Chicken-Fried of us all. She has been broken, but she has not stayed fractured.

She has been scared, but she has not played small.

She has been destroyed, but she has also been restored.

And I am all of those things, too. Once upon a time, I hated what she gave me. But I believe I am alive today and writing this book because of those very things.

I want to end this chapter with an email that my mom sent to me years ago. It was sent to me in August 1998, but it's important that

you know it was written two months before that, in June 1998. Let me explain...

In June 1998, my mother flew to Nashville to visit David and me. The morning of her flight, she had gone in for a doctor's appointment in Houston. Nothing major. Just a checkup. (Isn't that always the way that it is?) Her doctor noticed a lump in her breast, and she had just enough time to have a biopsy run on it before her plane was scheduled to leave. She flew to Nashville without a care in the world.

She spent three days with us and we relished every second. But I was not home the morning that she received a call from her doctor's office in Houston. She had breast cancer. David and I walked in the door from work to my mom and her roast and a table full of homemade sides. We talked and laughed, and all watched a movie together. I had no idea that she had received a call that had rocked her world. In fact, she would not tell me that news until many weeks later. Once she had more answers than questions. Once they had a plan in place.

In the midst of my mother's treatments, I opened my computer one day to find an email she had written me. And I'm sharing it with you today because it's as true today as it was in 1998. Here is what she wrote...

Dear Melissa,

I am not sure when I will send you this letter. I have to wait until God releases me to do so. I am writing it on the plane. You and David just dropped me off at the airport and I am flying back home to be with your daddy. You don't know this yet, but I have breast cancer. Dr. Solini called me at your house and told me. I'm sorry that I didn't tell you. I needed to tell your daddy first and I wasn't going to tell him over the phone, so I am headed home to see him and tell him. I need to be with him so badly when the bottom falls out. It's always been this way for he and I. But I am writing this letter to you because something just

happened at the airport and I wanted to tell you about it so that neither of us ever forget it.

When I was hugging your neck and saying goodbye to you and David, I told y'all to just drop me off and let me walk in by myself. That is because I didn't want you to see me crying. As I was hugging your neck I heard a voice, Melissa. And it said to me, "You will never see them again. Hug her tight because this will be the last time. Cancer will win. You will lose. It's as simple as that." So, I held on to you so tight. Do you remember that? I stood inside the glass doors and watched you and David as you drove off. Because I had been told it would be the last time.

But fear is a liar, Melissa. And that was all that was. That was satan and I don't believe a word he says, I never have. He has wanted to kill me for about as long as I can remember.

When I found out I was pregnant with Christopher I was so embarrassed and ashamed. How did I not know? And then when he died, I thought I would too. But he was a liar even then.

When I found out I had kidney cancer I was so scared because it was the first time I had heard my name and "cancer" said in the same sentence. But he was a liar even then.

But this time, I heard him so plainly. This time he has every intention of taking me out. But Melissa, I will live and not die to declare the works of the Lord. So, this will not be the end of me, of us or our family.

Our family is made up of a lot of things. Here are some words I use to describe our family: strong, fun, loved, Velcro, glue guns, permanent waves, Granny, board games, memories, life. (Sometimes I can use Velcro, glue guns, Granny and permanents all in the same sentence.) But words that don't make up our family are: scared, death, lies, fear. So why would they start now?

Melissa, I learned a long time ago that I am not a perfect person—but I am a strong one. It will take a lot more than this to keep me down. And you are a lot like me, which I'm sorry for most of the time, but not in this instance. Don't believe the enemy, Melissa. Only listen to the voice of God, He is all we have ever had and all we have ever needed.

I WILL see you soon.

<div align="right">

I love you,
Mom

</div>

Today my mom is in her seventies. She is the grandmother of two adopted grandbabies who she prayed into my arms. She is as funny as she ever was. She has been spoiled rotten by my father. And yet she'd give her house away if someone told her they needed it. She likes to cook for her family, tell us about her ailments, and make me fix her hair (otherwise she says it looks like she's got a cat stuck on her head, and she's right). She has lived—and not died—to declare the works of the Lord.

She is Chicken-Fried. Through and through.

She is soft.

She is tender.

She is my favorite.

"The wages of sin are not frozen."

—Granny

Dear Robin

When my Granny died, we began the long, complicated process of cleaning out her home. If you have done this because someone you loved left too early, then you know about all the things you might find tucked into their photo albums, journals, and attic boxes.

You find junk, sure. But if you look closely, you might also be fortunate enough to find treasure.

We came across a treasure during this process, and every woman in my family asked me to please put it in this book. It seemed to be one of the best ways to honor my Granny and the kind of woman she was. If she were alive, she would be absolutely thrilled that we put this in my book. So lest you think we are sharing something personal—are you kidding? She would have told everyone in town about this! This would have been HER MOMENT.

My Granny wrote letters until the day she died. She kept a small yellow legal pad beside her recliner, and she wrote pen-to-paper letters to people she missed, people she loved, people she knew, and people she had never even met. We knew that she wrote letters to city administrators, councilmen, local sheriff's deputies, and mayors. She didn't usually write to complain, but rather to tell them a story she had heard or share something she appreciated about them and the work they did. On more than one occasion, Granny would call and ask me for the

updated address of a childhood friend of mine. It might be someone that I, myself, had not spoken to in years—but it was safe to say that if Mary Louise met you even once, you were a friend for life.

However, there was this one letter that caught our eye. It had been mailed on August 17, 2018, but had been returned. It was likely returned due to the fact that she addressed it simply to Times Square, New York City, NY. I guess she assumed everyone knew where ABC Studios was. But Granny had written this letter to someone that she adored. And I mean that; she *adored* this person. She spoke about her as if she were a member of the family. And here is why that is such a wonderful, unique thing.

- I don't think you could find two more different women.
- One is a New Yorker and the other, an East Texan.
- One was black. One was white. (While this might not seem like an issue to some, keep in mind my Granny was born in the 1930s. So for the majority of her life—and in the region where she lived—color was, sadly, a big deal.)
- They loved differently.
- They probably voted differently.
- They may have even worshipped differently.

But none of that mattered to my Granny. She always saw people. She rarely saw much else. Money, status, jobs, or position—that never mattered to my Granny. Why should it? What people do for a living makes them a human-doing, and my Granny was much more interested in who they were down deep, in what made them a human-being.

Please be reminded as you read this that my Granny wrote like she spoke; in short sentences that rarely flowed easily into one another and oftentimes didn't made a lick of sense. We never cared. We followed along with her quite easily.

Here is the letter she sent to her dear friend, Robin Roberts.

Robin,

So glad you are still smiling!
I meant to write you for 6 years.
You encourage us every week day. Hope you get this. I have been
a widow for 11 years. I am 87 this week.
My relative had the same myeloma and she would not go to
Houston and get a transplant. She passed away.
Tell the crew Hello! I never miss G.M.A.
You look younger!!
I live in East Texas and see some that act like they fried their
brain.

Love,
Mary Willmon
P.S. I have attached a great picture of you and a clipping from
our paper so you will know about our county.

I like to think there are a million other things she could have told
Robin about Lufkin and the surrounding counties besides the article
she enclosed, which was entitled, "Church Gunman's Wife Says He
Bound Her to Bed Before Deaths," but hey, Granny knew best.

You also have to appreciate that she had cut that clipping out of the
newspaper almost one year before sending the letter (per her handwrit-
ing at the top). Apparently, when you cut out a clipping that dramatic,
you want to wait for the best moment to play that hand. Good on you,
Granny.

How lucky you are, Robin Roberts, to be someone my Granny
would have called a friend. This not only meant she had her morning
coffee with you, but it also meant you made her Prayer List. This list
sat right beside her chair, too. Robin, throughout your cancer journey
I can say with 100 percent certainty that your name was taken before
God. She prayed for you, and your healing, and your wedding for the
last many years of her life.

Because to her—you were family.

If no one else reads this book, *man*, I hope Robin Roberts does. So that this letter will finally reach her. So that she will know how prayed over and loved she was by one of the finest women I have ever known.

Robin, if somehow you do find your way to this book and you are reading this:

Hi, Robin.

Any friend of Granny's is a friend of mine.

Love,
Melissa Radke

Politically Incorrect Recipes

IT MAKES NO SENSE TO ME TO HAVE A BOOK ENTITLED *CHICKEN-FRIED Women* and then not have a recipe for something *chicken-fried* in it. What a tragedy that would be! So, welcome to the recipe chapter.

If you were to walk into any of the houses that my Chicken-Fried Women live in, you would be met differently by each of them, because they are all so different.

My best friend Janet would greet you with a huge smile on her face and talk in a really high voice and welcome you in and offer you a Coke Zero, because that is all she drinks. She would plop down beside you and want to chat and chat and she would never look at her watch or her phone, only you.

My mother, on the other hand, would look at you like you came to rob her. Her eyes would get really big and she would say, "What in the world are you doing here?! I didn't know you were coming. Why are you here?" and then she would pat her head because she would have rollers in it and she'd apologize and run back to her room to put on a bra. You'd see her ten minutes later because she would have snuck a call in to my dad saying, "Gene, come home. We have company and I ain't fit to entertain all by myself."

You could try to walk in my cousin Kylie's, but she'd stop you at the front door and ask you what you want. If you said you wanted to come inside and visit, she'd say something like "Here? Right now?

How about Starbucks two weeks from now?" No one knows what the inside of her house looks like, which has raised quite a few speculations around the old Chicken-Fried kitchen table, as you can imagine.

If you walked into my friend Karli's house, you would instantly feel like they were expecting you to come, but they were kind of sad about it. She's from North Dakota and I just assume that is how everyone there reacts to visitors. It's like, "Oh, okay. Sure. Sure. Come on in. We weren't expecting ya but we can make the most of it, sure. Sure. How about some pop? We have some Dr. Thunder and Royal Mountain. You never heard of those? Those are the pops you get at the back of the store. I'm not paying $2.07 for a bottle of pop when I could pay $2.03, ya know? But you're here now, so what can we do, right?" (All of this is said like the cast of *Fargo*, by the way.)

My Aunt Melba will have her purse in her hand. Mark my words! She will not be going anywhere, but she wants it to look like she was—in case she has no time for whatever you came for. Did you come to tell her a juicy story about someone down the road? She'll put her purse down, take her shoes off, and not move. But if you are a census taker or trying to get her to donate to the Fireman's Benevolence, she was just on her way out the door.

I saw a woman on TikTok say that the very first thing you should say to anyone who walks in your home—whether it's a repairman, a girlfriend, a family member, or a painter—is "Hello. Welcome. What can I get you to drink?" Don't say, "Would you like anything to drink?" because this gives them the option to think they're putting you out and therefore refuse. Instead, ask them what they'd like; this way they know you mean it.

I'm gonna be honest…I may ask what I can get you to drink, but there's still a fifty-fifty chance I won't mean it. I need to know why you're popping over. If you're popping over because my kid said something rude to your kid, *Get in line, lady*. If you're coming over to play Bunco, or any game involving me taking your money, I'd be happy to get you some tea.

No matter how any of these women answer their door, they all have one thing in common: every single one of them will offer you food. I don't think I could even be friends with someone who did not

offer me food when I went to their house. That seems so weird to me. I bet someone in England is reading this and thinking how rude it would be if they went to a friend's apartment and weren't offered a cup of tea. I think it would be criminal if I went to a friend's home and wasn't offered some pork chops or a bowl of chili.

Now, as to what the aforementioned women would serve, let me run this down for you really quickly...

Janet—I would advise against it. It's probably old and it's probably from Wing Stop.

Mom—Take it. It will be good. Every single time.

Kylie—You won't make it anywhere near the kitchen so it doesn't matter.

Karlie—It will be weird. She is from the North. It will be a "bar" of some kind. Say yes but then just scoot it around your plate.

Melba—Always. It will be good. And she will continue to feed you until you leave, so it's really a win-win.

Because this is what these women do. The women I love feed people; whether you are hungry or not, whether you just ate or are on Ozempic, you will be fed and you will like it. It's what they do...they feed. And, of course, they eat. Our lives are made up of memories and within those memories are our dishes. And our homes. And our recipes. And our plates and cups and dessert. They say the kitchen is the heart of the home, and for my people, it could not be any truer. When I tell you that our holidays and heartbreaks were all experienced in the kitchen, I'm not lying. So yeah, it was important for me to welcome you all in to just a few of the recipes that make up my family's most memorable moments.

And don't worry—we invite Karli and Janet over as much as possible so that they can eat and their families can eat. I will just never understand these girls that don't ever learn to cook because "eating is just not that big of a deal...I mean, we eventually do it when we're hungry." It sounds blasphemous from where I sit. And you Northerners, my goodness, it's really wonderful that your people have made it this far in your lineage without ever using paprika on anything.

Y'all come on in. I wasn't expecting you, but that's okay. Let me run go put a bra on and then we can sit and look over these recipes and see what sounds good to you. Because this is the chapter! This is it. This is the place where you will finally...

Find out how to make baked beans the way Annette makes them.

Exactly how we fry our chicken.

The way we like our corn casserole.

And all the other goodies we bring to the *fellowship*.

But let's get one thing straight, and I bring this to you in full transparency: **WE ARE NOT "COOKS." WE ARE EATERS.**

There is a big difference.

You cannot judge this chapter by the way we measure ingredients or the caloric content. Once you have made the dish, sit down with a fork and eat it. Then, and only then, will you understand who we are. Promise?

Lastly, I want you to know that I am going to write these recipes out for you exactly as they were told to me. I sat down with each Chicken-Fried Woman and wrote out her recipe. The recipe is the way she told me: her words, her ingredients, her way. If anything is *off color*, *off handed*, *off topic*, or *off on the ingredients*, that's on her. I'll give you her phone number.

You are truly so lucky to get these recipes. Some you could have found for free on Google, but look at you paying like $28 to get them in this nice bound book. Some have been around for generations, and some are from the back of a mashed potato box. Don't write me an email and tell me The Pioneer Woman did it better. *Duh! We know this!* That is why she could buy us and sell us. That's why she has a line at Walmart and we just *stand in a line* at Walmart. (But long live our motto: Can you really trust a cook who's smaller than a size 12?) Just know that we eat what we eat, and we don't apologize for it. As my Granny once said, "Who cares if it has too much butter in it? You wanna go to Heaven happy, don'tcha?"

She makes a good point.

In other words: You get what you get—and you don't throw a fit. Here we go.

Aunt Linda's Fried Chicken Strips and Gravy

As told to me, in the kitchen, by my Aunt Linda McBroom

How many people are you serving? Times that by three because everyone will have at least three of these tenders. If they have less, don't invite them back. If they have more, they're our kind of people.

I'm a fan of chicken thighs almost always, but use chicken breasts for this. They're just prettier.

Pound out your chicken breasts. This will make them fry quicker and you won't have to worry about that gross pink middle. Don't pound them so much they fall apart. Use common sense!

Slice them up and I want you to put them in a huge bowl, pour buttermilk over them until it covers the top of them. Sprinkle in some Tabasco or any hot sauce of your choosing. Just 4 or 5 drops. Mix it all up. Cover with plastic and keep in your fridge for 24 hours or overnight is fine.

The next day, make yourself a mixing bowl full of flour and I want you to season this flour to your heart's content. I always use salt and pepper, some Lawry's Seasoned Salt, onion powder, garlic powder. I may throw in some Tony Chachere's if I'm in a good mood. I may not. And then I throw in about a cup of breadcrumbs, flavored or not, makes no difference.

In another bowl I want you to take about 6 eggs (now that's how many I have to take because I'm cooking for a crowd; a normal person might just use 3), and I beat them to death and then I pour them into the buttermilk and chicken bowl. Remember the one that's been sitting in your fridge for 24 hours? Yeah, that one.

Here's where everybody gets crazy...what do we cook 'em in? I don't give a crap what you cook 'em in. As long as it's not cheap. Don't cook this chicken in some $8 skillet you saw on a clearance rack at Target. I use either my cast iron skillet or my Le Creuset skillet, which is just enameled cast-iron. Personally, the Le Creuset is much easier to clean so I tend to go that route. Best cookware, ever. (Tell them I said that! Maybe they'll give me a freebie.)

Add you some lard to your skillet and turn the heat on. (So help me, if you fry these in sunflower oil or avocado oil or something, I will come find you. That's ridiculous. If you're gonna go so far as to eat fried chicken—fry it in

lard. When God is ready to take you home, you're going home. Lard ain't gonna change that.) Get that lard nice and melted and hot. Okay, here we go. It's a shit show from here on out. Things are hot. Grease is flying. Flour is everywhere. It's a mess!

Grab you some tongs, take out a tender, and dip it in that flour. Dredge it real good. I like to double dip; you dip it back into the buttermilk-egg mix and then back into the flour. This makes it double crispy. But it's a mess, I'm telling ya. Put you about 3 or 4 tenders in that skillet at a time. Don't overcrowd them! Turn your oil down to about medium; you don't want them coming out black. And I only want you to turn them once. Got it? Do about 3 minutes on each side, or at least that's how long it takes on my stovetop.

Remove them one at a time with the tongs. Personally, I always like to use two sets of tongs. One to place the chicken in and one to take the chicken out. Two sets of tongs is a tongue twister. Get you a big serving plate and put some paper towels down. Set your chicken on that. It will cool and drain some of that grease off at the same time.

If you're making for just your family, you probably won't have to pour out the grease and put new in, but if you are making for a crowd—you might have to. Usually, my grease starts getting black and that can make your chicken darken up really quick, might even give it a bit of a burned taste. So, you'd want to stop halfway through, cool your grease down, pour it out (don't pour it down the drain like a dummy, pour it outside), and add more lard. And just go through that whole drill again. It's a pain to do this, but it's a worthwhile step if you're cooking more than 12 to 15 strips.

Sometimes, when that chicken comes out hot onto that plate, I will sprinkle a little more Lawry's Seasoned Salt on those strips. Not always, but Rocco likes that—so I will do it for him. You can salt them a little extra if you want, but you don't have to. Now, let's get into the gravy, because if you dip these chicken strips in ketchup, you oughta be strung up by your toes.

The Gravy

I want you to pour out almost all of the grease in your pan. Notice I said "almost all." This is where it gets tricky, because I want you to leave all those drippings that are in the bottom of that pan and then maybe like a third of the grease. But those drippings are what make this gravy so good.

Once you've poured the rest of that grease out, keep what's left in the skillet, on the stovetop. And keep that heat on, okay? Don't let this cool off. Keep it hot.

I want you to add a cup of flour to the mixture in the skillet. Just dump it in there. Now, take a whisk and whisk it all together. It should look like a roux. A dark, gray roux. Does it? Good. If it does, you're doing good.

Now I want you to take some milk; just use whole milk. No skim. No almond. No soy. No whipping cream. Just good old milk and fill that skillet about halfway up. Stir with that whisk. Stir until all the lumps are out. Stir until you think your hand is gonna fall off. Nobody likes lumps in their gravy. The minute that gravy starts to bubble, and it will, turn the stovetop completely off. But keep stirring. What's going to happen is your gravy is going to start to thicken. The cooler it gets—the thicker it gets. If it gets too thick, add more milk. Once I ran out of milk and used chicken broth, just as good.

Give it a taste. Does it taste good? Maybe it needs some salt and pepper. I always go heavy on the pepper in my gravy. Milk gravy needs a lot of pepper. How do you like it? Now, I'm gonna tell you one secret that I do for my gravy. It's not good for you, but hey, eat this gravy and you'll go to Heaven happy, if you know what I mean. I put in a couple tablespoons of butter. It just makes it taste richer and creamier to me. Try it. You'll like it better. Don't tell anyone, though.

Take one of those chicken strips. Dip it in that gravy. How does it taste? It's amazing, ain't it? If it tastes amazing, tell them it was mine. If it's bad, tell them it was Melba's.

Meridith's Potatoes

As told to me by Meridith, in her kitchen, while her kids kept interrupting

Get out of this kitchen! I'm working with Melissa right now. Stop running through here or she'll talk about you in her book.

Okay, I buy a 5-pound bag of Yukon gold potatoes. I also buy one 4-ounce pouch of the Idahoan Roasted Garlic Mashed Potatoes. (Who da hoe? Ida hoe. Put that in the book. That's funny.)

I get some Philadelphia Garlic and Herb Whipped Cream Cheese (7.5-ounce tub). And Melissa, do not put in there that I use cream cheese in everything I make. Because I don't. I use cheese in everything, but not cream cheese! Cream cheese makes these potatoes so much creamier. Put that! And don't say anything about me being on keto. You know I'll be off of that in a few weeks when I bottom out and give up, so just shut up about it. Crap. I shouldn't have told you not to write about me being on keto because now you are 100% going to write about me being on keto. *Jerk.*

1 stick of salted butter

8-ounce block of sharp cheddar cheese

1.5 pounds of Wright Brand Applewood Thick Cut Smoked Bacon. I don't get people who buy cheap bacon. Don't put that in there because it's rude, but I would never want to be friends with someone who said, "I'm just gonna get this bacon, it's on sale for three dollars." Sorry, ladies, that's a deal breaker.

They're gonna use heavy whipping cream, to taste.

1 bunch of green onions

Salt, pepper, and paprika to taste

Peel, wash, and quarter the potatoes.

Boil the potatoes for 20 minutes or until soft.

KIDS! GET OUT OF THIS KITCHEN! I'M NOT PLAYING!!

Grate the entire block of cheese.

Wash and chop the green onions.

Place the bacon on a parchment-lined baking sheet, and bake in a 400-degree oven for 10 to 20 minutes.

Crumble the bacon and save 2 to 3 tablespoons of the grease.

Spoon the potatoes out of the water, and add to an 8-quart Crock-Pot.

Using the potato water, fix the instant potatoes according to instructions.

Melt the stick of butter, add in the bacon grease, pour in the Crock-Pot over the potatoes, and mix with a hand mixer.

Add the whole tub of cream cheese and half of the shredded cheese. Continue mixing.

Add the instant potatoes and mix further, adding the whipping cream to thin, if needed.

Salt and pepper to taste; sprinkle the top with paprika.

Top with the remainder of shredded cheese. It looks pretty.

Serve with crumbled bacon and green onions for topping.

Turn the Crock-Pot on low or warm to keep them heated until you are ready to serve them.

And lastly, when your idiot cousin walks up to you at Thanksgiving and says, "Dang, all you bring are mashed potatoes, can't you cook anything different?" remind her that it's her fluffy butt that keeps this Crock-Pot in business. And yeah, I'm talking to you, Melissa. You always say that potatoes are easy. Hopefully you can see that I put a lot of work into my potatoes. Are you going to put that in there? You better. Don't make me look bad. Don't make me look like a bad cook. You're not, are you? And don't make me look whiny either? Okay? Please? Melissa? Puhleeeeeze? Ugggghhhhh...you are. I know you are. *I hate you.*

Aunt Melba's Spinach Salad

As told to me, by Melba, while I sat in a bubble bath and she came into my bathroom without knocking and stayed for an hour

Annette is going to be so mad that you called this Aunt Melba's Spinach Salad because she gave me the recipe years ago, but I think I make it a little better than her, don't you? You know your mother never follows a recipe and not all of us can measure with our heart. We need to know specifics.

Do you remember when she first made this for me? I was thirty-six and had never tasted salad. And she said I was going to die early if I didn't eat something green, so she made me this and now I eat spinach like a champ. Well, not just any spinach. Only the spinach in this recipe. And only if it's covered in the dressing, cheese, and bacon.

Dressing

½ cup ketchup
1 cup Wesson oil (It has to be Wesson oil. I don't know why.)
¾ cup sugar (Don't use anything weird. Just use real sugar.)
1 teaspoon Worcestershire sauce
¼ cup apple cider vinegar
1 chopped purple onion

Mix up your dressing in a blender the night before because it needs to sit in the fridge for several hours.

Salad

Mix salad in a large bowl:

1 bag of spinach

4 hard-boiled eggs, sliced (I've been asked to leave these out because they give Granny heartburn, but I'll just make her her own little salad without the eggs because everyone else likes them.)

1 cup fresh bean sprouts (I know. I thought I was going to hate them, too, but I actually don't. So just try them before saying no.)

1 whole package bacon, cooked crisp and crumbled up (Do not skimp on the bacon. I will come and find you. No one wants you skimping on the bacon. They will talk about you behind your back if you do.)

2 cups sharp cheddar cheese, grated (Fresh is better, y'all. I know everyone is in a hurry, but if you can grate up your own—that is the best.)

Stir the dressing into the salad and toss it all together just prior to serving.

Melissa's Corn Casserole

1 can whole kernel corn
1 can cream-style corn
1 box of Jiffy brand muffin mix (Only use Jiffy. I'm telling you. Only Jiffy. Trust me.)
1 stick of butter, melted
½ onion, chopped fine
½ bell pepper, chopped fine
1 jar of pimentos (People are gonna be so mad if you put these in there, but it's mainly just for color. I don't care if you use them or not; you don't even taste them.)
1 whole bag of shredded cheddar cheese, a 16oz bag
2 tablespoons sugar
2 eggs, whisked

Mix all of this together in a big mixing bowl and then pour into a casserole dish. Bake covered at 400 degrees for 45 minutes. Then uncover and bake for another 15 minutes.

Annette's Baked Beans

As told to me by my mom over the phone because she "didn't feel like company"

4 or 5 cans of baked beans, drained (Does everybody know what baked beans are, Melissa? Lord, I hope so.)

1 whole onion, chopped

1 medium-size bell pepper, chopped (Of course green—who uses orange?)

Some Worcestershire sauce (I don't know, jerk your hand down 3 or 4 times. How much is that? I have no idea.)

²/₃ cup brown sugar (I don't care if you use light or dark; don't make me no difference.)

½ cup honey or molasses (What do you mean, I need to be specific? They can use whatever floats their boat. I guess if I had to pick, use molasses; it's sweeter. Melissa, don't start with me.)

Fry up bacon and chop it up (I have to tell them exactly how much? That's ridiculous. They can guestimate how much bacon they like. If they're normal, they'll want to use half a package. If they're my sister, they'll want to use 3 pounds.)

2 tablespoons mustard

I'm gonna be honest, it's not the healthiest thing to do, Melissa, but if they want to fry that bacon up and then put the bacon on a plate and throw that onion and bell pepper in that bacon grease, God wouldn't be mad at 'em. Ooooh, it makes it so good and just go ahead and pour all of that onion, pepper, and grease into that baked bean mix. Be naughty about it.

Melissa, tell them that sometimes I add in some barbecue sauce if I have some that I need to use up, just hanging out at the bottom of a bottle. That always makes it a little better for barbecue days.

And one time I threw in some soy sauce and that gave it a little kick. I liked that. Tell them that.

They just need to throw all of this in a big pan and bake it at 400 degrees for 2 hours.

Annette's Oriental Salad

As told to me in her kitchen while she was making it

First of all, Melissa. Why are you asking me for my Oriental Salad recipe? What about my Spinach Salad? That's the one that's the most famous around here.

What do you mean, Melba used it as her recipe? I taught her that recipe! She eats spinach today because I taught her that Spinach Salad recipe. Melissa Paige, that makes me so mad! Why did you give that to her?

Now I have to make the Oriental dish.

What do you mean, I can't call it Oriental anymore? Who said?

I most certainly am not going to change the name of this dish, Melissa. It's been my Oriental Salad recipe since God was a boy. Why do I have to change it?

Fine. Asian salad. I hope you're happy. Sounds like a million other recipes out there. No one will even know the difference anymore. I'm just another Applebee's. "Oriental" made it stand out from everything else.

Oh, so now that's a bad thing??

Salad

2 bags of shredded cabbage

2 chicken breasts (cooked and shredded) but I don't put chicken in it very often because we usually always have other meat, so I just make it as a plain Orienta...*Asian salad*, without meat. But I bet it would be good as a whole meal if you added the chicken.

Bunch of green onions, chopped up

1 package of ramen noodles, broken in pieces (Those cheap ones, Melissa. What are they called? Top Ramen? Okay, whatever. I don't care what kind you get; you're not using the flavoring packet.)

2 ounces of sesame seeds. I like to toast mine lightly; it really makes them more flavorful.

2 ounces of sliced almonds, toasted. This is a must.

Now, just pour all of this into a bowl and mix it up.

Dressing

½ cup canola oil

½ cup rice vinegar

2 tablespoons sugar

1 tablespoon soy sauce

2 tablespoons sesame oil

Ground black pepper to taste

Mix all of this dressing up and then add just before serving. This is one of the only salads that actually gets better the longer the dressing sits on it, which is why I always make it for days when we are cooking out and it's gonna be sitting out awhile.

"Why does he do that? Is he signaling for drugs?"

—Aunt Melba, on why Justin Timberlake
moves his hand up and down to
the crowd while he sings

Last Woman Standing

I WANT TO WRITE MORE BOOKS, I DO. BUT I DON'T KNOW IF I WILL EVER write another book that came as easily as this one. Where words and stories and memories just flowed. So if I decide to write another book and it is hard, in any way at all, I will probably just put it down and stop. Who needs the pressure?

But this book...This book has been coming out of me since I could walk. This book was born in me when I woke up in the back of an AMC Pacer spying on a preacher being anything but holy. This book has been my life for the last fifty years. Because these women have been my life. They have been so much a part of my life that I sometimes cannot tell where I end and they begin. Maybe this is unhealthy; I don't know. I've brought it up to a few different counselors, and so far, no one has tried to do an exorcism on me. *Yet.*

When I'm beginning a book, I like to keep a notes section on my phone for jotting down things that come to my mind at inopportune times, during church, in the middle of the night, during a kids' soccer game, etc. I'm looking at that list of notes on my phone right now and I didn't get to half of them. Memories still not shared. Stories still untold. I don't know if I will ever get another chance either. What if I have told the stories in this book and then that is all God has me do? How do I close the pages on these women who are larger than life to me?

And what about my daughter?

Will she know what kind of women they have always been to me?

Will they mean as much to her?

Has she, without my knowing, felt drawn into their world?

Has she, in her back bedroom, heard our laughter from the kitchen table and subconsciously felt the draw to live a life with them so ever present in it?

Will she someday, like me, wish for it to be summer so that we can all visit the farmers' markets and then take home what we bought and cook together?

When it turns cold, will she automatically wait for Aunt Linda to come over with soup?

When she lies out by the pool, will she want to do it with her older, cooler cousin, like I did with Randi Jean?

When she wants to hear stories about her Granny, will she want to sit next to Aunt Nelda?

Will she want to listen to them tell how they raised their kids, loved their husbands, and served their God?

Will their words make indelible marks in her—just like they've done in me?

What if I didn't make them important enough to her? What if I didn't share them enough with her? Will this circle of family, this tribe of women, end with me? How will she know what she has? How do I make her understand that even though Granny died, all of this, all of us, must go on?

Because the truth is, if you reached inside me and pulled out my memories with these women…if you then removed my conversations with them…if you peeled off the layers of thick skin that I had to grow to survive them…if you whittled away at the laughter and the tears and the arguing and the making up…and if you took out the faithfulness of God that has flowed from her to her to her…I would be like a shadow of who I really am.

They made me.

Good or bad. Better or worse.

I am who I am because of them.

And you are, too.

Aren't we?

Who are your Chicken-Fried Women? What are their names? What do they look like? What is your memory with them? Have you told them? Don't let someone run a stream through your life and then not even share the benefit of it with them. Write down the memories. Keep track of the stories. Tell your daughters the importance of the women. Make sure she knows who kept the whole thing running.

Don't get me wrong. Men are wonderful. The men in my family cannot be replaced. But so many of them have left us now. They have gone on. Heaven is sweeter with them there, yes, but we are here. Still going. Still living. Still working. Still planting. Still raising. Still making a home. Still loving a family. Still. We are here, still.

And the women remain.

Not perfect women. Maybe not even beautiful women. Certainly not thin ones or rich ones or even celebrated ones. But women who are scarred and scabbed. The wounded and, yet, the whole. Women who show signs of this tired old life on the outside but hold love on the inside. The ones with both a rolling, raging temper but also tender and gentle hands. The salt and spice and everything nice. (Well, maybe not *everything*.)

To the women who I wrote about in this book: Thank you for bringing me into this world and making sure I made it through it. Thank you for making me tough and brave and fiercely independent. Thank you for making me funny. Thank you for telling me I could write and then telling me I could write about you. Thank you for feeding me when I was sick and broken and even when I was well and loved. Thank you for making sure there was always room at the table for me, even when I was seventeen and my mom said I had the personality of a satanist.

When God says it is time for us to go, I bet it will be Granny who meets us there. Who takes our hand and leads us in. She will be mad that

we are late. She will tell us we've missed so much. She'll catch us up by telling stories and never taking a breath. Won't she? And how fortunate will we have been to have left one world with each other—only to move into the next one, together, as well.

Because the women remain.

ACKNOWLEDGMENTS

THIS THE PAGE WHERE I SAY THANKS TO ALL THE PEOPLE WHO HELPED me with this book, but writing a book is such a weird, isolating thing. You don't really *write* your book with a lot of people. At least I don't. I write it alone at my desk in my room, or alone at the Kurth Memorial Library, or alone in my dad's office. So, really, the people I'm about to thank didn't so much help me *write* the book, as they helped me not go insane *while writing* the book. They listened to my ideas or laughed at my stories; they said things like "You have to get out of the house, so let's go get Mexican food" or "You need a movie break." They let me bounce ideas off of them or let me text them a million questions like "Y'all, do we call it Shipley Do-Nuts or Shipley's Do-Nuts?" They asked me how it was going and feigned interest when I would talk about it too much. They encouraged me to keep going and said things like, "Put that story about your mom in there. Just don't tell her. Better to ask forgiveness than permission." I'm so grateful to have each and every one of these people in my corner.

To my Chicken-Fried Women...Thank you for letting me make money off your stories. Thank you for reminding me of things I'd long forgotten. And thank you for making my life so fun.

To the rest of the "Willmon" family...Aren't we so lucky to come from such a heritage? The story of our family is precious and is a testament to the goodness of God. This book only scratches the surface.

I love each and every one of you more than I tell you and I'm sorry for that.

To the Golden Girls…You all are my earliest and sweetest memories of what friendship looks like. What we have forty years later is so rare. Aren't we blessed? I love you.

To the Steel Magnolias…I miss y'all so much. Being with y'all is literally life-giving for me. I wish you understood it. You fill my tank.

To the Radke Family Online membership group…Doing life with y'all has been such a sweet, wonderful surprise. Thank you for your sarcasm. I hope we stay friends (and family) forever.

To Jeremy and Janet Yancey…Whenever I hear someone talk about a pastor who hurt them or a church that wounded them, I just cannot wrap my mind around it. I want to rush them to you guys and let you lead them and love them like you do for so many. First, you were my pastor. Then you became my friends. And now look at us, e-biking and screaming at Cade!

To my editor, Beth, and the whole team at Worthy…Thank you for thinking my book was special and then working like it was the only thing you all had to work on. I'm sorry I was late on literally every single deadline that you gave me. Beth, I once randomly texted you and told you I was so glad you were my editor. I meant that. I love, respect, and appreciate you so much.

To my mom and dad…So, here is what I am going to do. Since I just drafted an entire book about my mom, I'm pretty sure no one is questioning my love for her. I *adore* the woman. Therefore, this dedication is for my daddy: my biggest fan, my constant cheerleader, and my best friend. World's Best Poppy. Most generous man I know. The heartbeat of our family. I love you, Dad.

To my mother-in-law…who I love so very much and know full well that anything good I have is due to her prayers.

To David and Remi and Rocco…*the absolute loves of my life.* When someone who uses words for a living cannot come up with any, that should tell you something. I'm sorry for not being a morning person.

Acknowledgments

To those of you reading this book, thank you. I hope you enjoyed reading it as much as I enjoyed writing it. I wonder if other authors ever expect anyone to read their words? I never do. Whenever I write I do it feeling fairly confident that only my family and like thirteen friends will buy the book. So, seriously, HUGE shout-out to you. I know that sometimes family is a hard lot and maybe you found yourself wishing you had family stories worth sharing, memories worth reflecting on, laughs worth recounting. You're not alone. I know a lot of people that feel that very same way. But it's like I told a lady at a book-signing in Mississippi: a new, healthy, memory-making, vacation-taking, cookie-baking family can start right this minute...*with you.* You don't have to wait for scores to be settled or apologies to be given. You can forgo all of that and just decide today that a healthy, happy family, a family that—like mine—puts the "fun" in dysfunctional, will start with you. You won't carry on the rage or the abuse or the addictions. You'll start the whole thing over. And you'll do it your way.

I know you can.

And I believe you will.

Leave it to a woman.

ABOUT THE AUTHOR

Melissa Radke is a bestselling author, speaker, and television personality who has charmed audiences worldwide with her hilarious and candid insights on life, love, and the complexities of the modern world. Known as the HGIC—Head Girlfriend in Charge—Melissa has been cheering women on since 2016 and sharing tips on what to buy, what to wear, how to LAUGH, and how to do your hair with her online community of over 1.1 million followers.

Originally from East Texas, Melissa spent over fifteen years in Nashville, Tennessee, having graduated from Belmont University with a bachelor's degree in commercial music performance. With a love of writing about real life, parenting, and the importance of learning our identity, Melissa published her national bestselling book, *Eat Cake. Be Brave.*, in 2018, released by Grand Central Publishing/Hachette Book Group. She was also the star of the family-friendly television show *The Radkes* on the USA Network. The show was an unscripted sitcom that focused on her big, loud Southern family and all of their charm.

A mom to two and a wife to one, Melissa embodies the perfect Southern blend of sweet tea and hairspray. She married her college sweetheart, David, in 1994. Melissa, David, and their teenage children, Remi and Rocco, live in the small East Texas town where she was born and raised, Lufkin, Texas.